BRITAIN'S COASTLINES
from the AIR

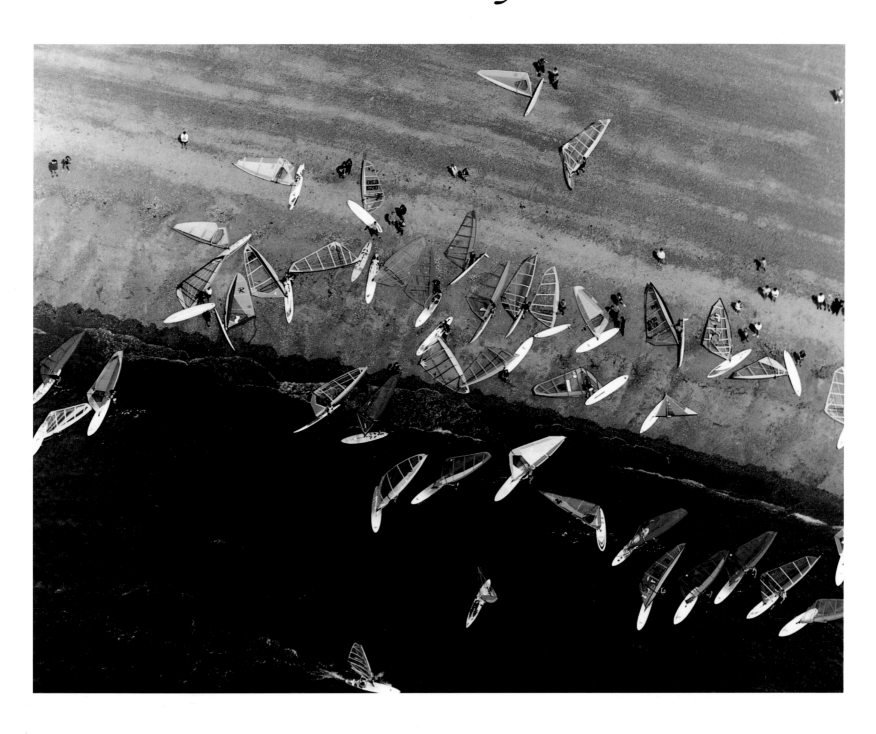

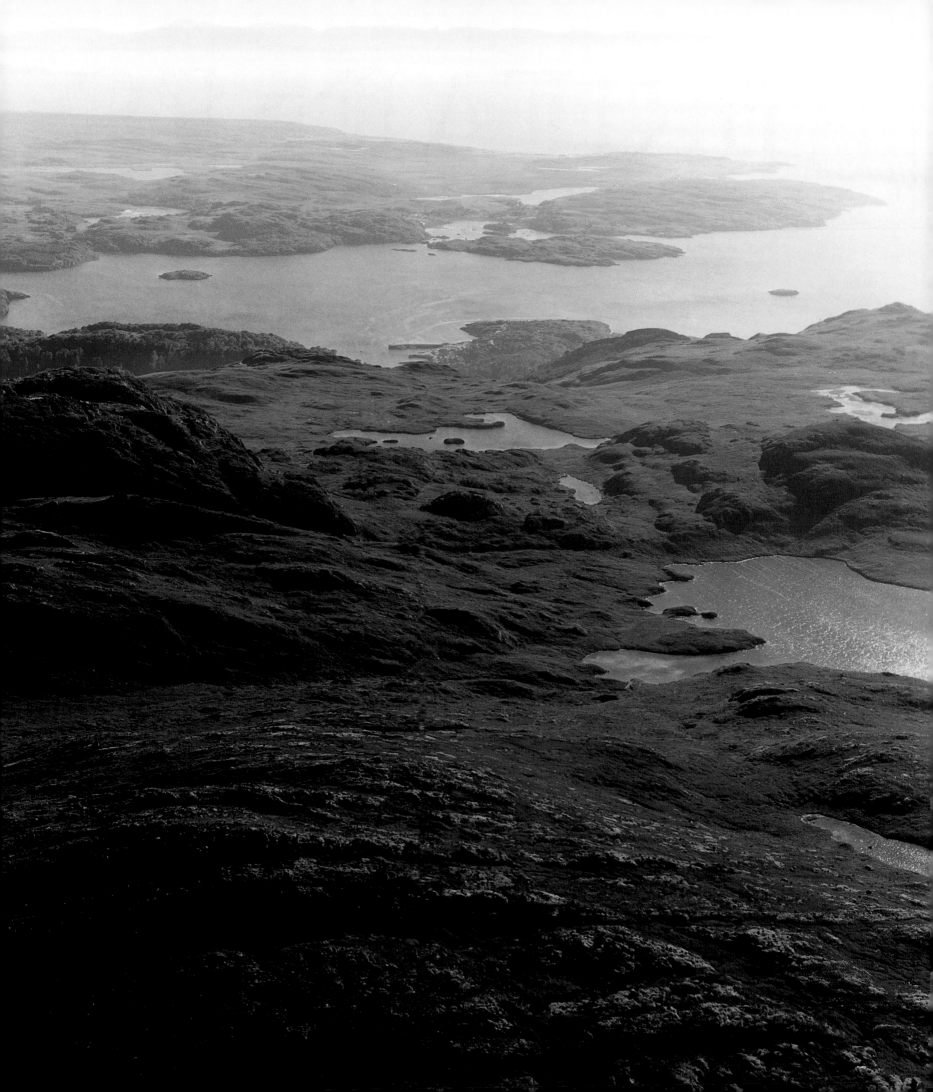

BRITAIN'S

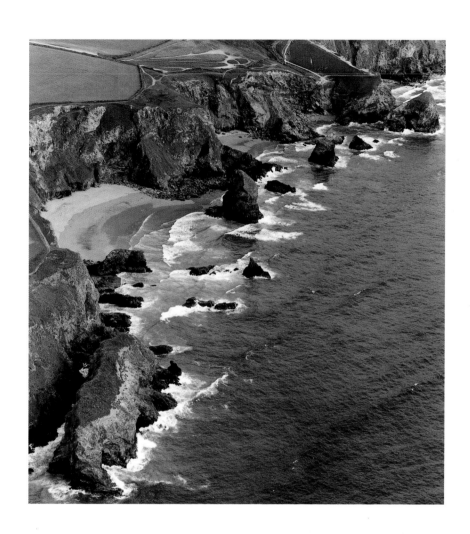

COASTLINES *from the AIR*

Text by Jane Struthers Photographs by Aerofilms

EBURY PRESS
London

FIRST PUBLISHED 1996

DESIGNED BY DAVID FORDHAM

PUBLISHED IN THE UNITED KINGDOM BY EBURY PRESS LIMITED
RANDOM HOUSE, 20 VAUXHALL BRIDGE ROAD, LONDON SW1V 2SA

RANDOM HOUSE AUSTRALIA (PTY) LIMITED, 20 ALFRED STREET,
MILSONS POINT, SYDNEY, NEW SOUTH WALES 2061, AUSTRALIA

RANDOM HOUSE NEW ZEALAND LIMITED
18 POLAND ROAD, GLENFIELD, AUCKLAND 10, NEW ZEALAND

RANDOM HOUSE SOUTH AFRICA (PTY) LIMITED
PO BOX 337, BERGVLEI, SOUTH AFRICA

RANDOM HOUSE UK LIMITED REG. NO. 954009

A CIP CATALOGUE RECORD FOR THIS BOOK IS AVAILABLE FROM THE BRITISH LIBRARY

ISBN 0 09 180763 8

10 9 8 7 6 5 4 3 2 1

TYPESET BY JULIA WARD

COLOUR SEPARATIONS BY
TRACK GROUP, LONDON

PRINTED AND BOUND IN ITALY
BY NEW INTERLITHO ITALIA S.P.A. MILAN

Half-title page: Windsurfers, at Exmouth, Portland
Title page: (full page) Gairloch, Hebrides
Title page: Bedruthan Steps, Lundy
Page 5: Lifeboat at Newhaven, Wight
Page 6: (top left) Lighthouse near Alford, Humber; (top right) disused lighthouse near Barry, Lundy; (bottom left) St Mary's Island, Tyne; (bottom right) Happisburgh, Humber
Page 7: (top left) Bardsey Island, Irish Sea; (top right) Cape Wrath, Hebrides; (bottom left) Trevose Head, Lundy; (bottom right) Hartland Point, Lundy

FOREWORD

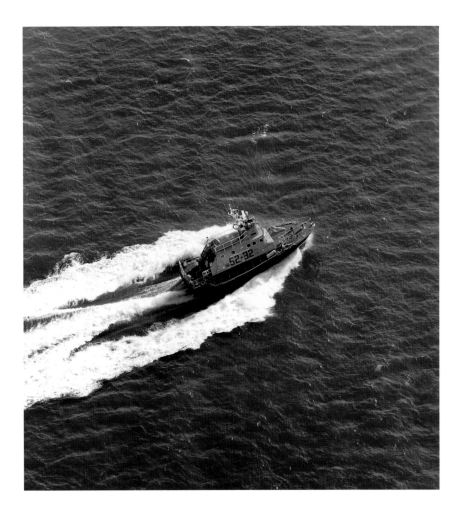

THE BRAVE VOLUNTEER LIFEBOAT CREWS of the Royal National Lifeboat Institution have been saving lives around the British coastline since 1824, going out in all weathers to rescue others in peril on the sea. Lifeboats have changed dramatically from the early days of manning the oars to today's high-tech self-righters, but the character of the crews remains as unchanged as the coastline. Today's lifeboatmen and women still demonstrate the same selfless spirit, the modest bravery and total willingness to risk their own lives to save others, for little or no financial reward.

So it is appropriate that the RNLI should lend its name to a book showing the many faces of the beautiful, varied and sometimes treacherous coast of Britain. While studying these wonderful aerial shots of the coastline, often taken on warm, sunny summer days, consider how dramatically different the same stretch of coast would look on a freezing, cold dark night, with a Force 10 howling and 40-foot waves lashing the rocks. That's when an RNLI crew faces being woken from their slumber by bleepers at their bedsides to get down to the boathouse and man the lifeboat.

W. M. Vernon

SIR MICHAEL VERNON
CHAIRMAN, ROYAL NATIONAL LIFEBOAT INSTITUTION

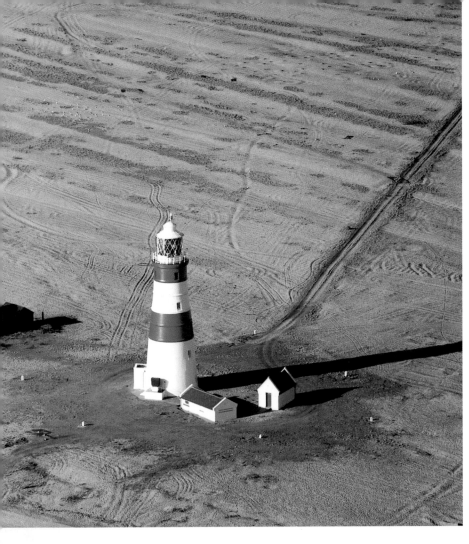
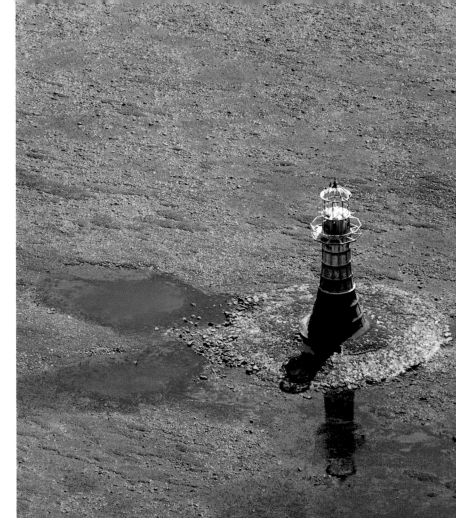
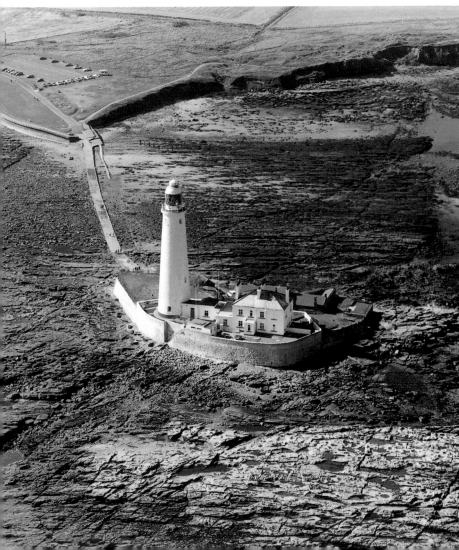
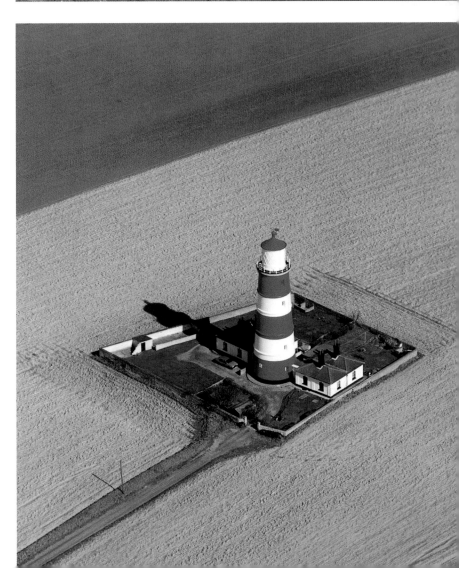

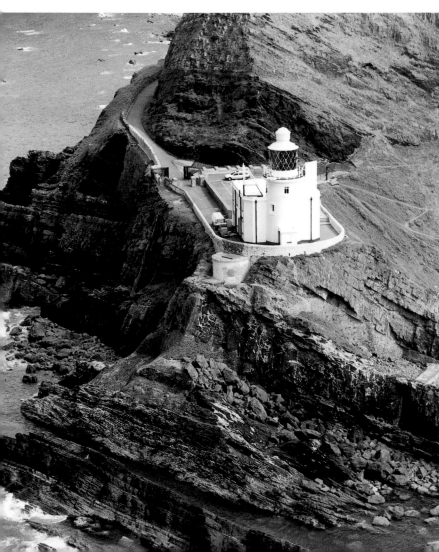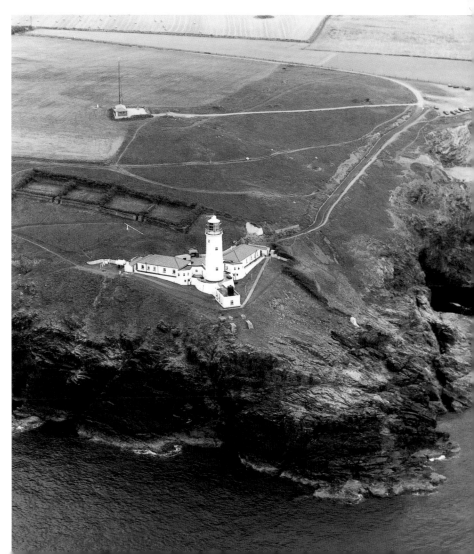

INTRODUCTION

THE ROYAL NATIONAL LIFEBOAT INSTITUTION exists to save life at sea. It is a modern, efficient emergency service, but different from the other emergency services, and quite unique, because the RNLI is manned by volunteers and financed entirely by voluntary contributions – exactly as it was when it was first established in 1824. Since then, the crews of the RNLI have saved more than 127000 people who would otherwise have lost their lives at sea.

The RNLI provides, on call, the 24-hour service necessary to cover search and rescue requirements up to 50 miles off the coasts of the United Kingdom and Republic of Ireland, playing a key role in both governments' search and rescue operations. RNLI lifeboats launch more than 6000 times and save more than 1600 lives each year. This means an average of 17 launches and 4 lives saved every day of the year.

Today there are 215 lifeboat stations strategically positioned around the coast. Some 4000 men and women crew the lifeboats. They come from all walks of life and today the image of the lifeboatman as a fisherman is rapidly becoming out of date. In a changing world, fishermen are working further from home and are not always readily available to crew the lifeboat at a moment's notice. Today's lifeboat could well be crewed by a dentist, a solicitor, a housewife, a publican, a computer analyst and a ladies' hairdresser. What they all have in common is their willingness to risk their lives to save others.

The majority of crew members are volunteers, although each station with an all-weather lifeboat has a paid mechanic to ensure that the lifeboat is constantly in tip-top condition and ready to launch. As well as the hours spent at sea, the crews give up their holidays and many hours of their spare time to train either at the RNLI's Training Centre at Poole in Dorset, the Inshore Lifeboat Centre at Cowes on the Isle of Wight or to attend courses and exercises at their own lifeboat stations.

By the turn of the century, the RNLI plans to be able to reach virtually any point 50 miles off the coast within two-and-a-half hours. This will be achieved by the introduction of high-tech lifeboats capable of 25 knots, which are fitted with the most up-to-the-minute equipment available. But even the most sophisticated lifeboat would be nothing without the brave and selfless individuals who form the crew – and would not exist at all without the thousands of fund-raising volunteers who give up their time to raise the money needed to keep the RNLI afloat.

It costs more than £60 million a year to run the lifeboat service. Hardly surprising when each new all-weather lifeboat costs between £1 million and £1.4 million. For every £1 spent by the RNLI, just over 12 pence is spent on fund-raising and less than 5 pence on administration. The rest is spent on maintaining and replacing the existing fleet, building new lifeboats and purchasing new equipment or shore facilities.

Those are the facts and figures. But what makes the RNLI so special are the brave men and women who are willing to run down to the lifeboat station and put to sea on a dark and stormy night while other mortals are safely tucked up in their beds. In September 1838 the steamship *Forfarshire* sailed from Hull to Dundee. She carried about 60 passengers and crew. On the night of 6 September a fierce storm blew around the Longstone lighthouse, with huge waves battering the walls. At around four in the morning, the *Forfarshire*

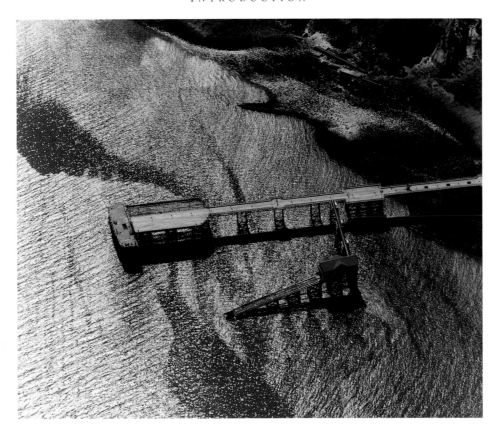

struck the rocks and broke in two. Grace Darling, the lighthouse-keeper's 22-year-old daughter, rowed out with her father in an open boat to rescue people she did not know and whom she was unlikely to see again, but she felt that someone ought to try to save them. She felt it was impossible to watch from the warmth and safety of her room and do nothing while people were being battered by the sea and frozen from its cold.

Grace and her father showed the same qualities as lifeboat crews today. They risked their own lives to save others in the face of great danger. Grace Darling died just four years after her courageous journey, but to this day she is remembered as a great heroine.

Despite Grace's exploits more than 150 years ago, many people are still surprised to learn that the RNLI has more than 120 women serving on lifeboat crews all round the coast. The first woman enrolled in the late 1960s to crew an inshore lifeboat. Now female crew members serve on both inshore and all-weather lifeboats and are accepted and well-respected for their skills.

Grace and her father were both awarded Silver Medals by the RNLI (or the Royal National Institution for the Preservation of Life from Shipwreck, as it was then known). A more modern Silver Medal rescue occurred on 30 December 1994.

An off-duty police officer was walking along the seafront at Porthcawl in South Wales when he saw a young surfer waving for help. By good fortune, Stuart Roberts was not only a policeman but a helmsman of the Porthcawl lifeboat. The wind was blowing south-westerly Force 9 – well beyond the official operational limits for the D-class inshore lifeboat, but with fifteen years' experience, Helmsman Roberts believed he could achieve a successful rescue.

The 16-foot inflatable lifeboat was launched into 12-foot high breaking waves to search for the surfer who was frequently out of sight in the wave troughs. The first three rescue attempts had to be aborted as huge waves hurtled towards the lifeboat. But at the fourth attempt the surfer was dragged aboard the lifeboat. His surfboard, still attached by a cord, shot into the lifeboat before it could be cut free and struck Helmsman Roberts on the head. For his great courage, superb boat-handling in extreme weather, his seamanship and command skills, Stuart Roberts was awarded the RNLI's Silver Medal for Gallantry.

So, 158 years after the Grace Darling rescue, with the latest high-technology available, lifeboat crews are still putting to sea in open boats and risking their own lives to save others.

During the production of this book, Hunting Aerofilms Limited has photographed every lifeboat station from the air. This has provided the RNLI with an important photographic record for operational and archival purposes, as well as providing a useful fund-raising tool. A proportion of royalties will also be donated to the RNLI.

If you want to know more about the Royal National Lifeboat Institution, please write to RNLI Headquarters, West Quay Road, Poole, Dorset, BH15 1HZ.

Sue Denny

SUE DENNY

PRESS AND PUBLIC INFORMATION OFFICER, ROYAL NATIONAL LIFEBOAT INSTITUTION

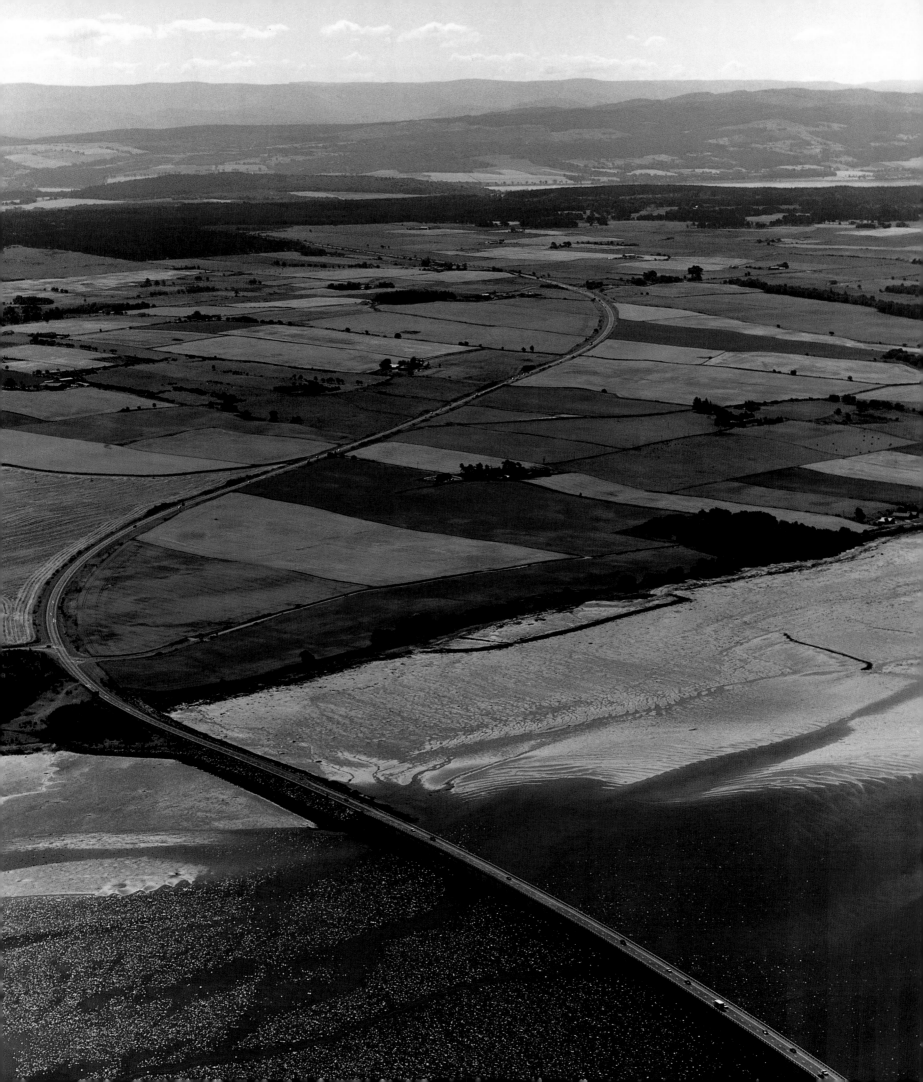

CROMARTY

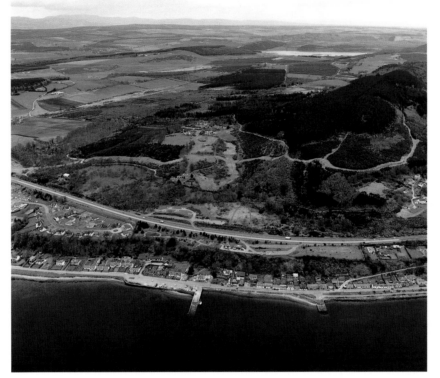

THE NORTH-EAST COAST OF SCOTLAND, from north of Wick in the Highland region to north of Stonehaven in Grampian, belongs to the sea area of Cromarty. This takes its name from the huge natural harbour of the Cromarty Firth. Travellers northbound on the A9 from Inverness have the privilege of driving along the coast all the way to Wick, which gives them fantastic, almost dizzying views from high cliffs and frequent glimpses of charming fishing villages. Further south, the coastline offers a mixture of steep cliffs and sandy bays, notably the 10 miles of golden sands that lie to the north of Aberdeen. Cromarty includes the holiday resorts of Cullen and Nairn, and the cities of Inverness and Aberdeen. There are several RNLI stations along this stretch of coast – travelling south from Wick there are lifeboats at Wick itself, Invergordon, North Kessock, Buckie, Macduff, Fraserburgh, Peterhead and Aberdeen, which has two lifeboats. Some parts of this coastline are particularly perilous to shipping, such as the reef known as Rattray Briggs north of Peterhead. Huge areas of land are now uninhabited, the result of the punitive Highland Clearances when thousands of Scots residents were forcibly evicted to make room for profitable sheep-farming.

CROMARTY FIRTH

The Vikings called it Sykkersand, or 'safe sand', because of the peaceful waters of this curved estuary. There are various stretches of sand, including the Sands of Nigg nature reserve, the nature reserve at Udale Bay and the sands in Alness Bay. The area around Invergordon was used as a deep-water anchorage by the Home Fleet during the First and Second World Wars. The Cromarty Firth borders the northern bank of the Black Isle, an evocatively titled peninsula that gets its name from the fact that its climate is so mild that snow rarely falls here, so when surrounding areas are white with snow, the soil of the Black Isle remains black.

NORTH KESSOCK

The Moray Firth and the Beauly Firth lie on the southern bank of the Black Isle. Beauly comes from the Norman name, *beau lieu*, meaning beautiful place, which it certainly is with its tree-fringed shoreline and distant mountain peaks on the horizon. North Kessock, with its little cottages lining its shore, stands at the point where the Beauly Firth flows into the Moray Firth. The local rigid inflatable inshore lifeboat is stationed here and is responsible for rescues in both Firths. To the west is Inverness and the breathtaking Kessock Bridge which spans the Moray Firth.

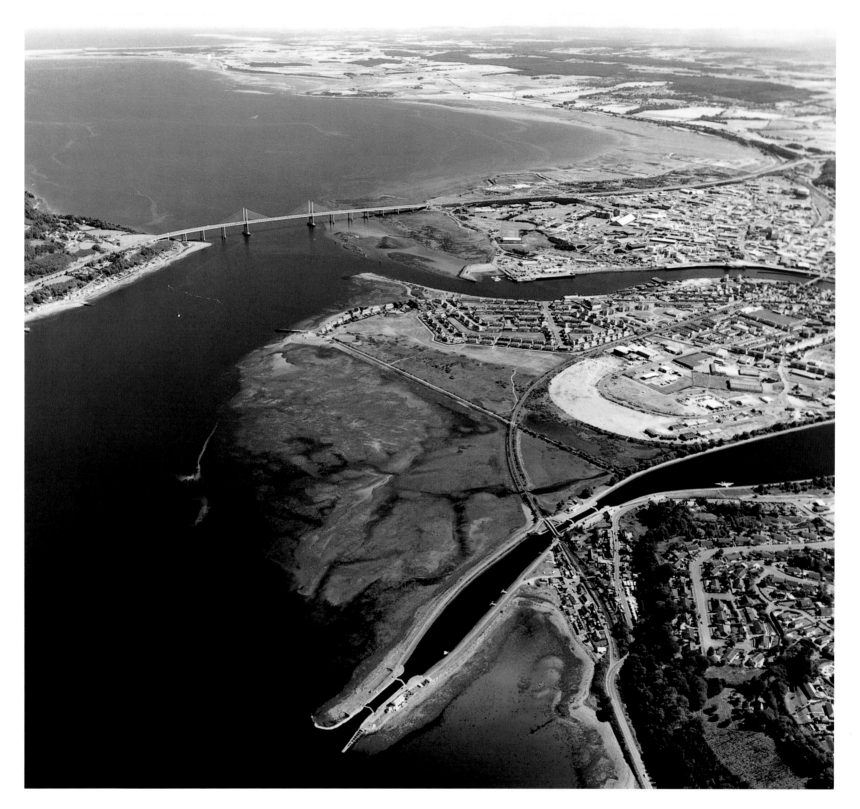

INVERNESS

From the air, the western section of Inverness looks like the head of a dolphin. The lips are formed by the entrance of the Caledonian Canal which reaches out into the Beauly Firth. This is its north-east terminus – the canal runs south-west down to Loch Eil near Fort William, and therefore forms a link between the North Sea and the Irish Sea, cutting out many miles of what would otherwise be a trip around Scotland's north coast. On the way, the canal passes through Lochs Ness, Oich and Lochy. The canal is the achievement of the Scottish engineer Thomas Telford, and it took twenty years to build. It was completed in 1823.

INVERNESS

In this photograph (*facing page*), the snaking River Ness and the Caledonian Canal are clearly visible. Also clearly visible is the beautiful Kessock Bridge, which joins North Kessock and Inverness across the Moray Firth. A couple of miles to the south-west lies Loch Ness, believed by many to be the home of the Loch Ness monster or Nessie, as he (or she) is affectionately known. The jury is still out on whether or not the monster exists, thanks in part to the loch's incredible depth (it is estimated to be 755 feet deep in some places) and in part to its very murky, peaty waters.

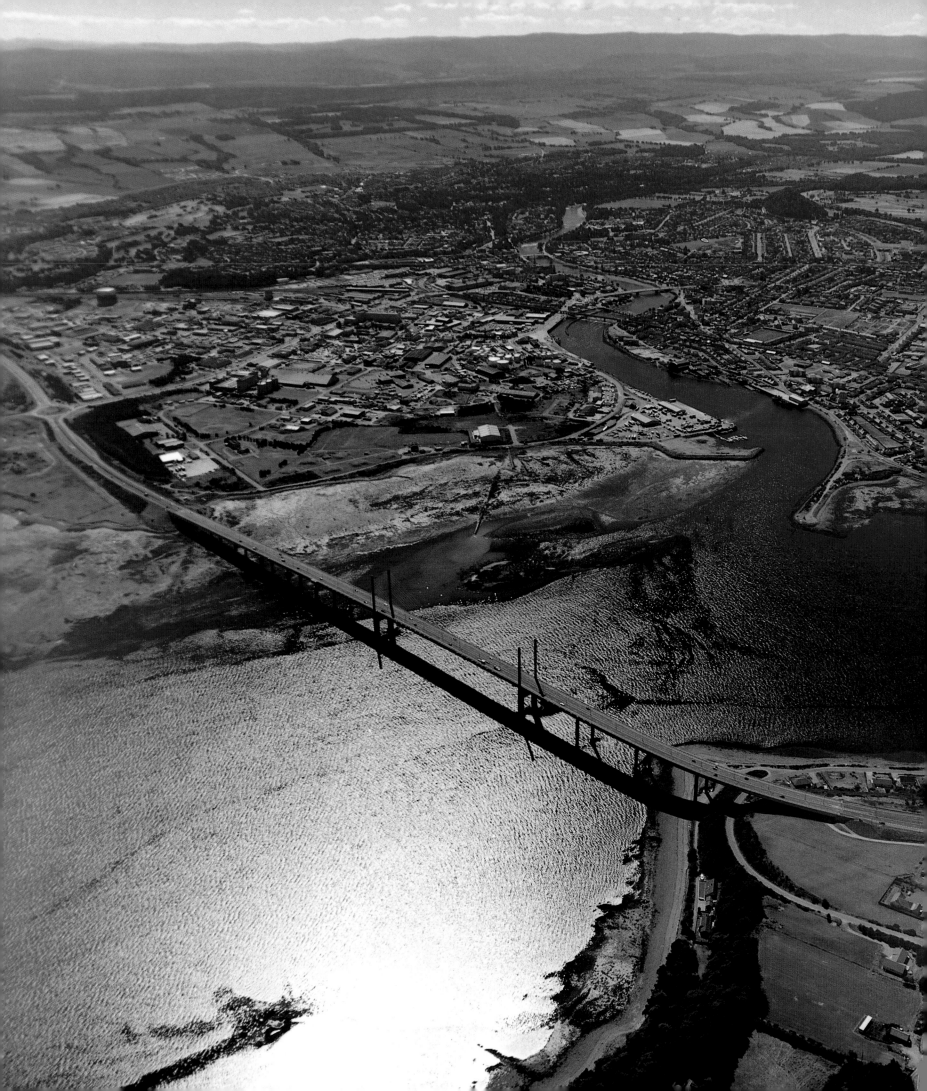

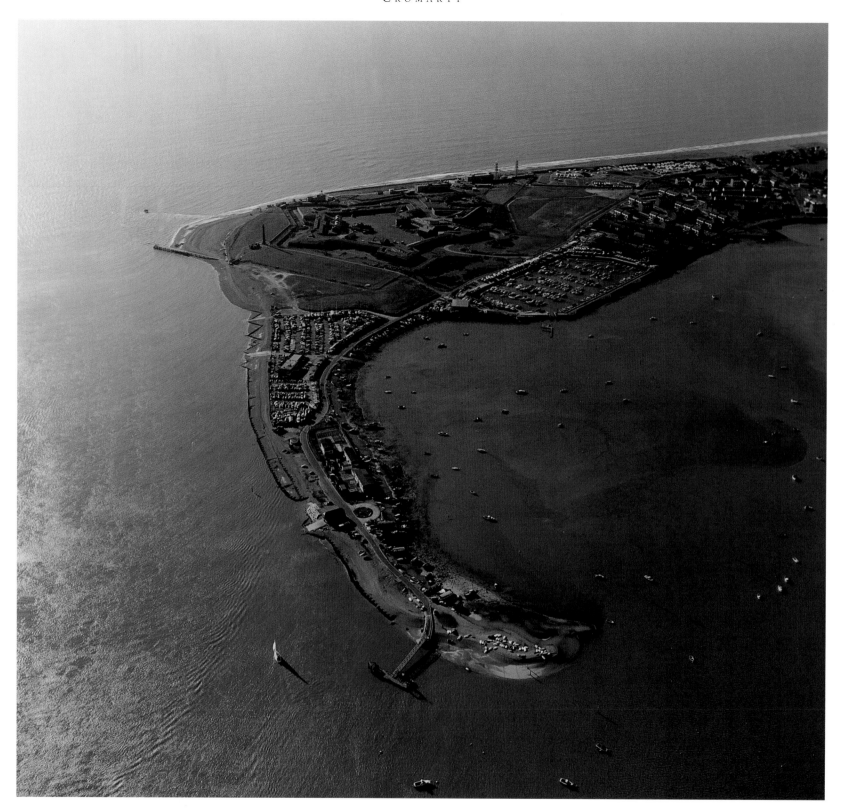

PETERHEAD

Even though the construction of the huge harbour at Peterhead (*above*) began in 1886, it was not finished until the late 1950s, with the help of the inmates of Peterhead Prison. Before that, during a weekend in January 1942, residents of Peterhead were given just cause to be proud of the crew of their local lifeboat when she rescued three ships that had taken refuge in Peterhead Bay during appalling weather conditions. In a blinding snowstorm, which later grew into a hurricane, the lifeboat went to the aid of each ship in turn. This act of bravery won the coxswain an RNLI Gold Medal.

FRASERBURGH

The busy fishing port of Fraserburgh (*facing page*) looks out on to the North Sea. The coastline here offers quite a contrast – rocky crags lie to the west of Fraserburgh while Fraserburgh Bay, with its long sandy beach, is directly to the east. One of the oldest lighthouses in Scotland can be found here, at Kinnairds Head. It began life as a castle in 1570 and was converted into a lighthouse in 1786. A very curious building, known as the Wine Tower, stands nearby. Although it has three storeys there are no stairs between the floors, and its purpose is a complete mystery.

14

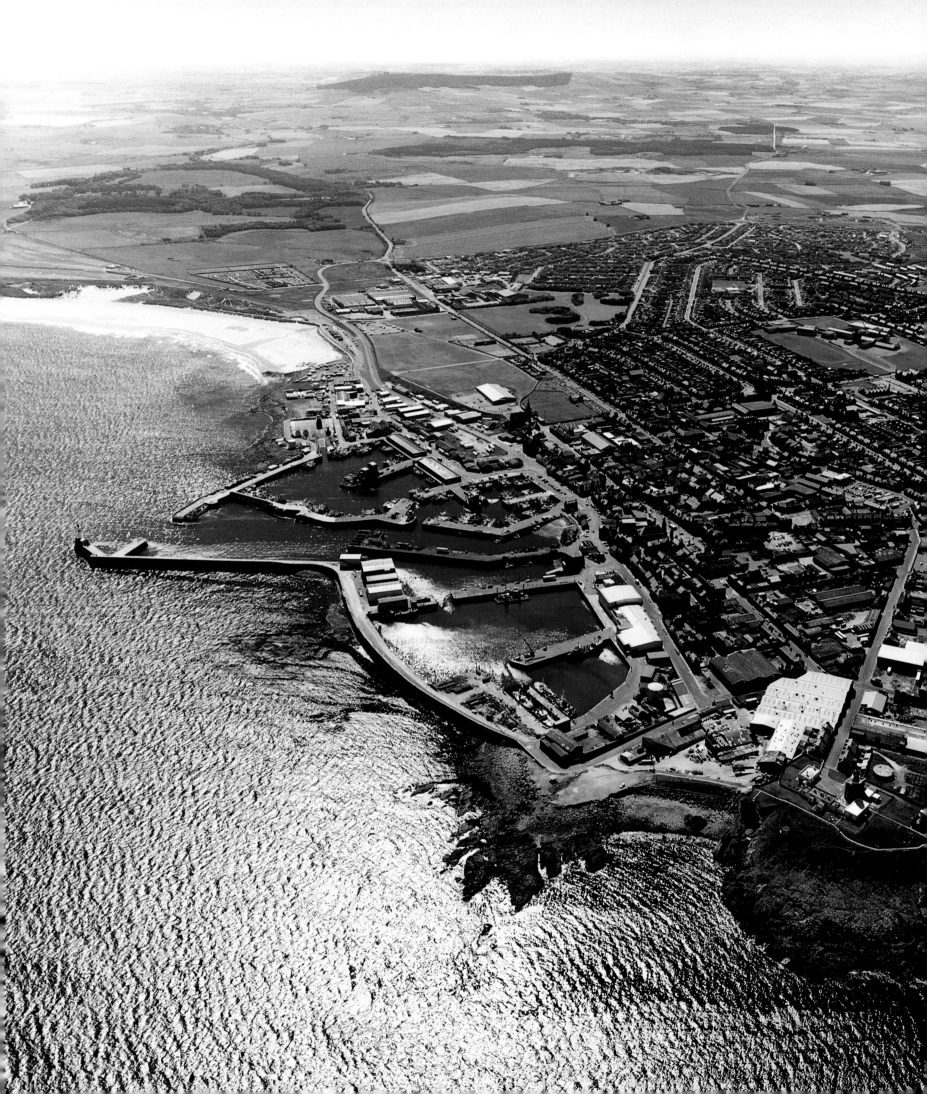

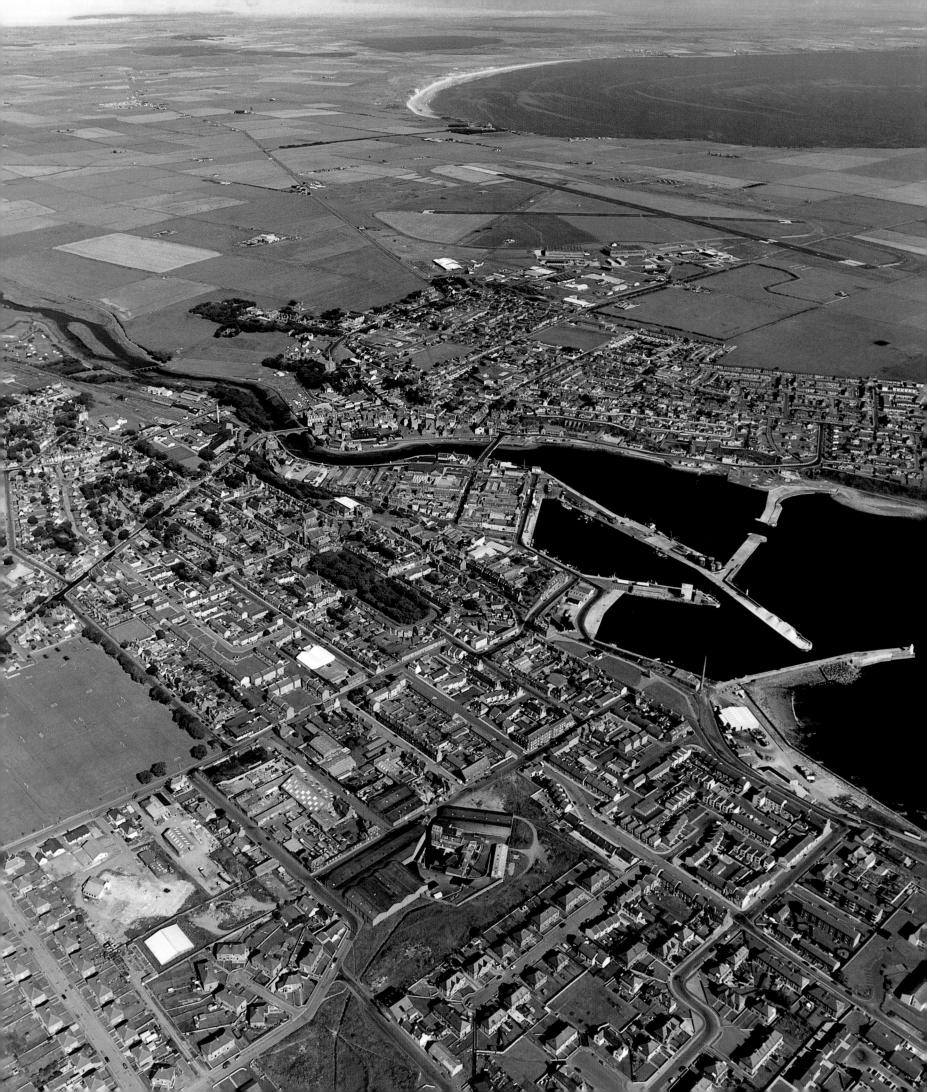

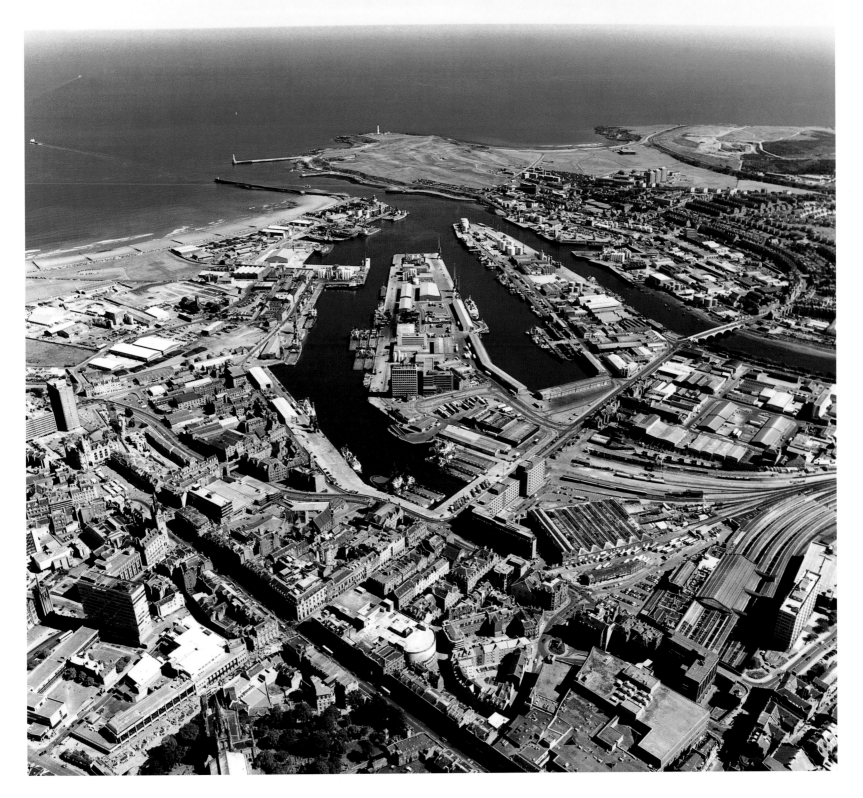

WICK AND ABERDEEN

Both these places have long been busy ports. Wick (*facing page*) was once a Viking settlement. It stands at the head of the River Wick and earned its name from the Norse word *vik*, which means 'creek'. Wick has a Tyne lifeboat, stationed to the south of Wick Bay. The pretty, curving bay pictured towards the back of the photograph is Sinclair's Bay, which has the remains of no less than four castles lining its sandy shores – Bucholie Castle, Keiss Castle, Castle Girnigoe and Castle Sinclair. Aberdeen (*above*), is now synonymous with the drilling of North Sea oil for this is the centre of mainland operations, but it was a busy city and docks long before that. The area of the city shown in the photograph fairly hums with activity, including the thick ribbon of railway lines and the rusty orange container ships waiting in the docks for another load of cargo. Aberdeen became a royal burgh in 1179 and the university (among the oldest in Britain) was founded in 1494. One of Aberdeen's exports is granite, for which it became known, unsurprisingly, as the 'granite city'. Aberdeen has two lifeboats stationed at Victoria Dock, one suitable for the high seas and the other, a rigid inflatable, used for inshore rescue work. A lifeboat was first established here in 1802.

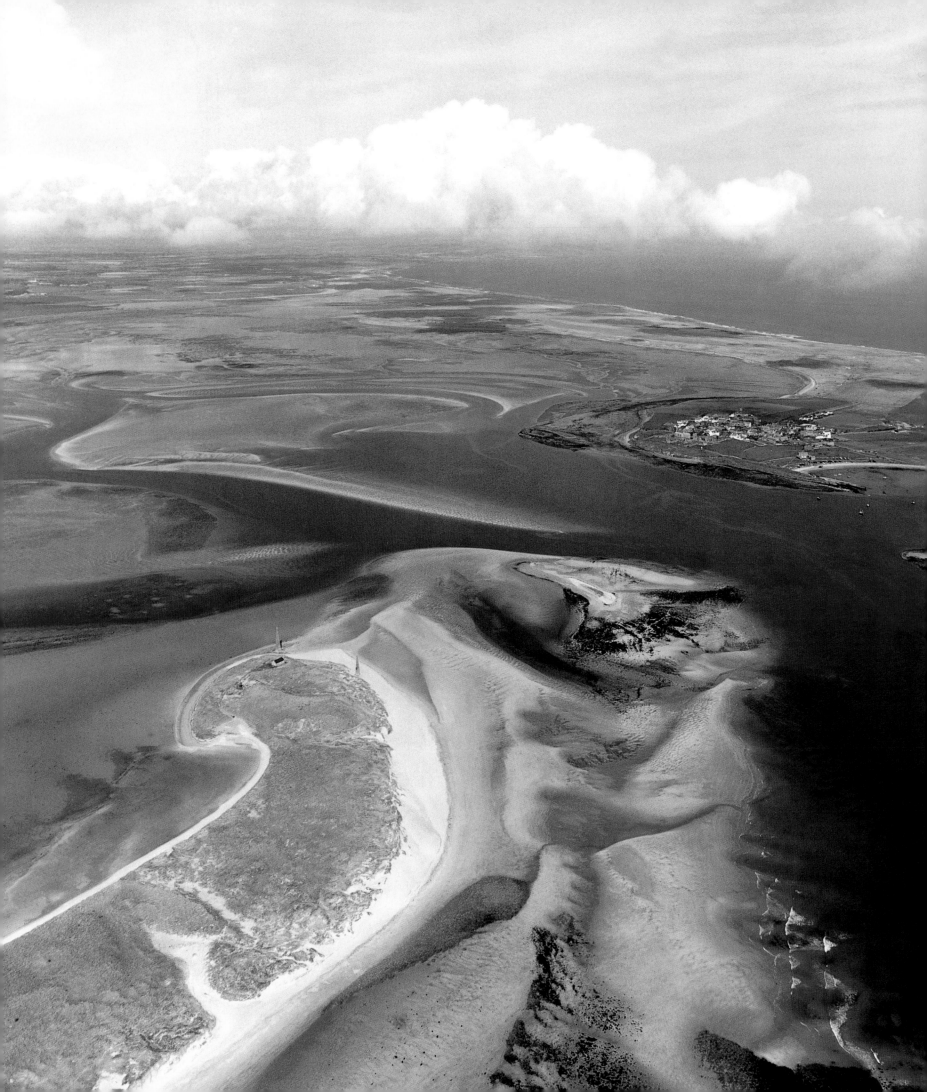

FORTH

THE SEA AREA OF FORTH stretches from north of Stonehaven in Grampian to south of Holy Island in Northumberland, and between those two locations it runs along the coasts of Fife, Tayside, Central, Lothian and the Borders. This is a part of the British coastline that can be buffeted by strong winds and dramatic seas all year round, and contains two of Scotland's great estuaries – the Firth of Forth and the Firth of Tay. The flourishing North Sea oil industry is a strong presence along this length of coastline, but so are the ghosts of the Border raiders and the Vikings who arrived long before them, eager to stake their claim on the land. The border between Scotland and England has altered fourteen times during a succession of wars and local skirmishes, but it finally settled in its present position north of Berwick upon Tweed in 1482. There are many RNLI stations in Forth, several of which are equipped with an inshore rigid inflatable lifeboat as well as an all-weather one – Montrose, Arbroath and Broughty Ferry, all three of which have two lifeboats each, Anstruther, Kinghorn, Queensferry, North Berwick, Dunbar (which has two lifeboats), St Abbs, Eyemouth and Berwick upon Tweed (which has two lifeboats).

LINDISFARNE

The stretches of sand that make up the nature reserve that lies between the island of Lindisfarne and the Northumbrian mainland is a haven for flocks of geese, swans, waders and wildfowl. At low tide the island is reached by a meandering causeway, once the rough thoroughfare of dog-carts and pony traps and now the metalled road for the many cars full of visitors who are drawn to the magic of Lindisfarne.

Lindisfarne is also known as Holy Island, a name which refers to its time as a religious settlement. In AD 635, King Oswald of Northumbria commanded a monk called Aidan to travel here from Iona in order to found a monastery. The Danes destroyed this settlement in the ninth century but a Benedictine monastery was built here in 1082 and parts of the priory still stand. To the south of Lindisfarne lie the Farne Islands, a collection of more than thirty islands of varying size, all of dolerite rock. They are owned by the National Trust, and the two largest, Inner Farne and Staple Island, are open to visitors at certain times of the year. However, these islands are home to so many birds that visitors are advised to wear hats.

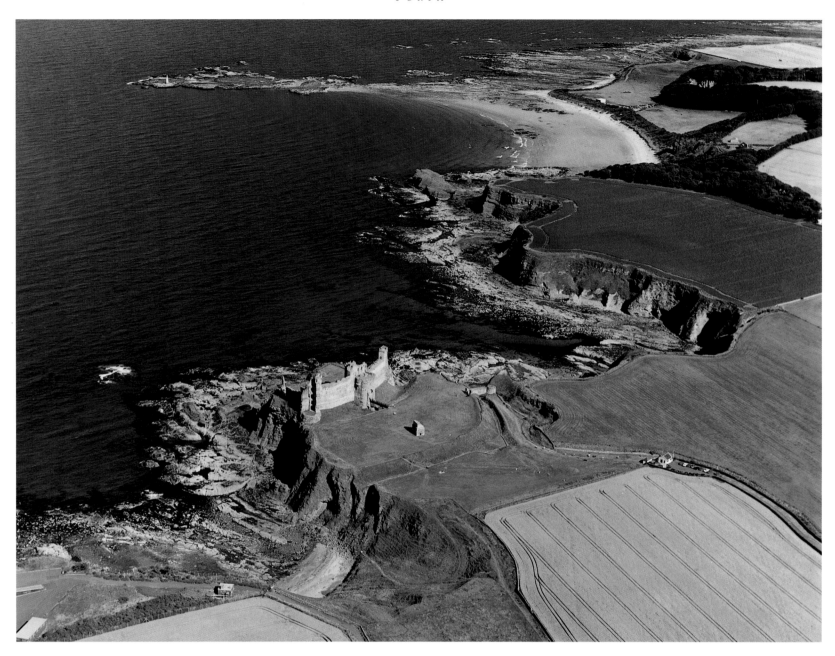

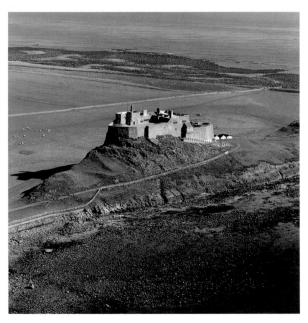

TANTALLON, LINDISFARNE AND DUNNOTTAR CASTLES

Sir Walter Scott, in his poem 'Marmion', described the ruined Tantallon Castle (*above*) as 'broad, massive, high and stretching far', and you can see exactly what he meant. This curiously shaped castle was built in the fourteenth century by the notorious Douglas clan, who chose it for its defensive position which affords excellent views of the coast to east and west. The romantic Lindisfarne Castle (*left*) was built on Beblowe Crag as a harbour defence in the sixteenth century. In 1902, the architect Edwin Lutyens was commissioned to rebuild the castle, and his sympathetic and inspired work can still be appreciated today. The impressive sight of Dunnottar Castle (*facing page*), standing on its promontory of sheer rock and towering 160 feet above the North Sea, truly stirs the imagination. There has been a fortress here since the ninth century, although it was considerably altered and added to over the centuries. Originally the rocks on which the castle stands were joined to the mainland by a narrow strip of stone, but this link was severed for defensive purposes. During the Civil War the Scottish Crown Jewels were hidden here for safe-keeping, a secret that was not lost on the Roundheads who tried to snatch the treasures. However, while the soldiers were battering the outer ramparts of the castle, the jewels were spirited away to nearby Kinneff Church.

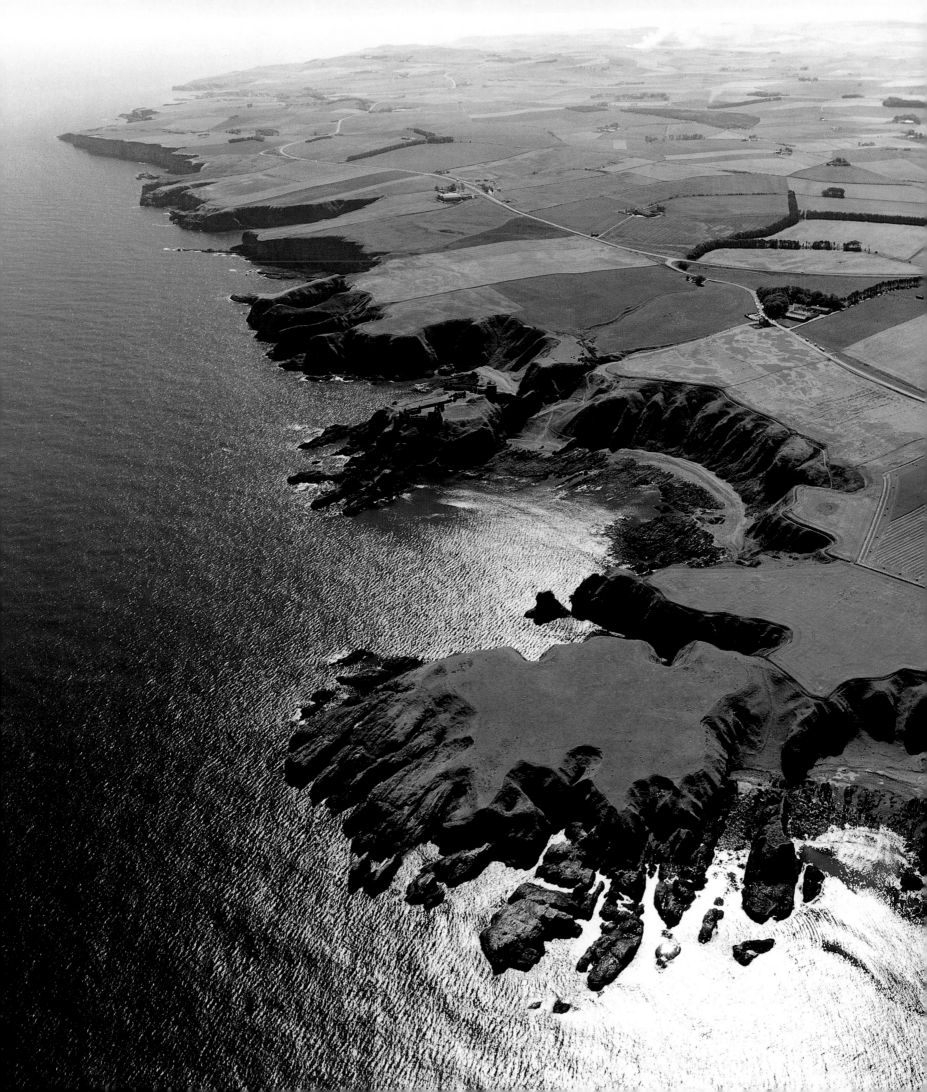

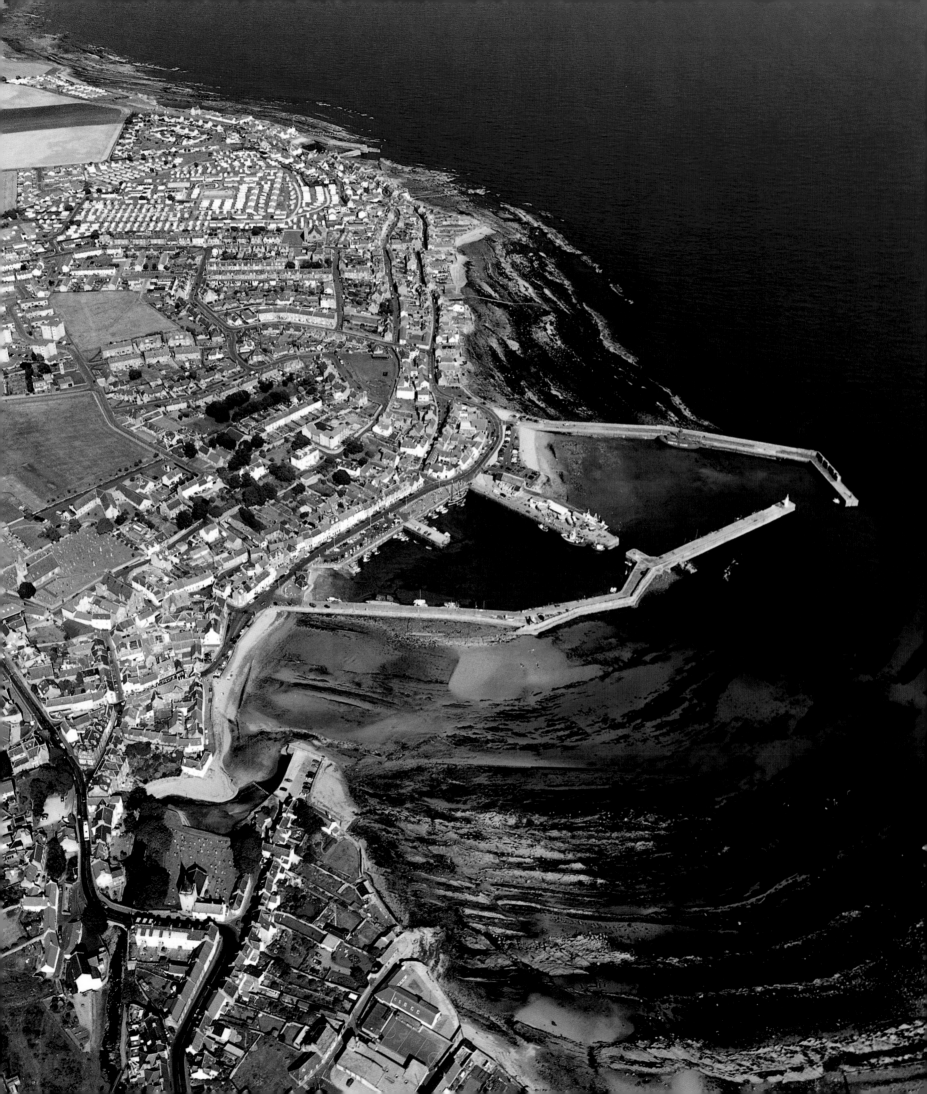

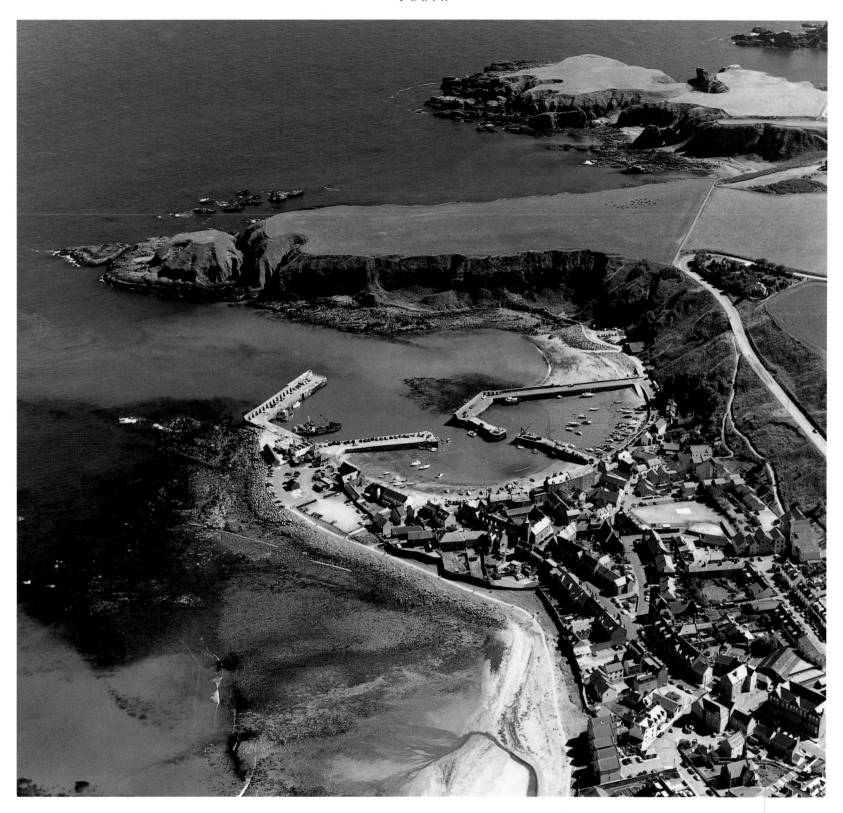

ANSTRUTHER

The town of Anstruther (*facing page*), or Anster, as it is known to the locals, was once an important fishing port. Its history is celebrated in the town's Scottish Fisheries Museum. Clearly visible in the photograph and secure within the enclosing arms of the harbour is the North Carr light vessel, which was retired from its station on Carr Briggs at Fife Ness in 1976. Light vessels are part of the impressive fleet of coastal stations ranged around the coast of Britain which monitor the weather for the Met. Office. The North Carr light vessel is now a maritime museum.

STONEHAVEN

Set in a wide curve of the Grampian coast, Stonehaven (*above*) combines a busy existence as a holiday town with its traditional life as a fishing village. The quayside around the twin-basined harbour is a bustle of activity, with fishing boats sitting alongside larger neighbours. The Tolbooth Museum at North Pier is the town's oldest building and contains many reminders of the bad old days of the seventeenth and eighteenth centuries when punishments were harsh and it was not unknown for thieves to be hanged. Originally, the building was a storehouse for cargoes before they travelled a couple of miles south to Dunnottar Castle.

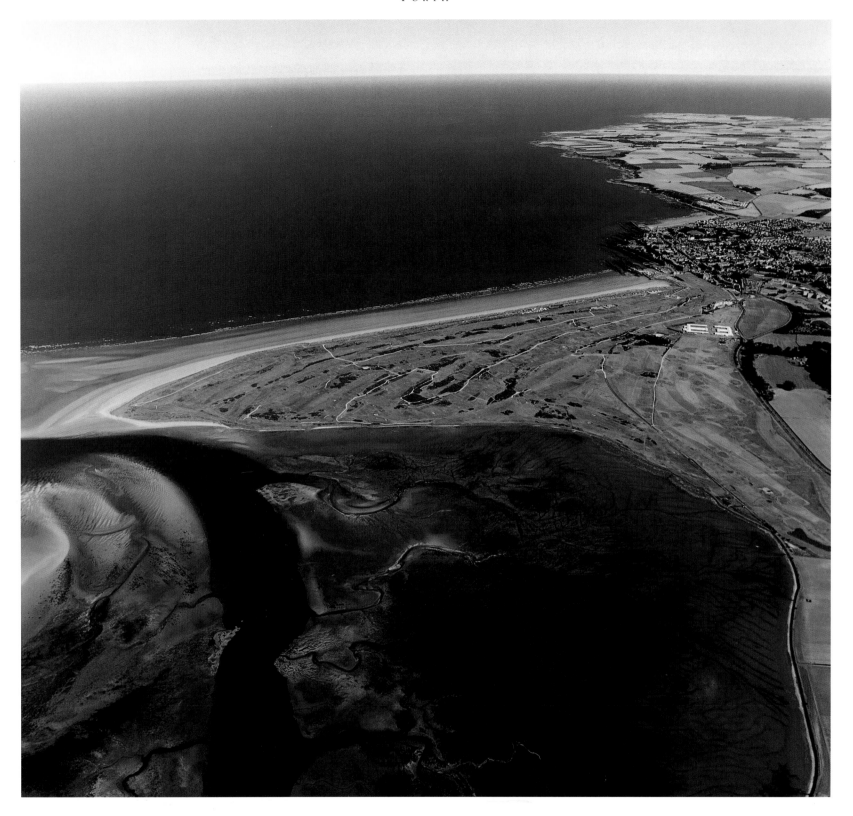

ST ANDREWS

St Andrews (*above*) means different things to different people. If you are a scholar of Christianity or a Scottish patriot, it was here that the bones of the long-dead St Andrew were shipwrecked. A Greek monk called St Regulus had brought the relics from his homeland and he founded a Christian settlement here. Several hundred years later, a cathedral was built and the town grew around it. St Andrew, who was crucified on a X-shaped cross, is the patron saint of Scotland. If you are a keen golfer, you associate St Andrews with golf – the Royal and Ancient Golf Club is the world headquarters of the sport.

MONTROSE

Montrose Basin, shown at the bottom of the photograph (*facing page*), is a large, virtually circular, nature reserve formed by a shallow tidal inlet at the head of the South Esk river. At low tide it drains completely and becomes an expanse of mud that is the hunting ground of countless thousands of birds. To the east lies the port of Montrose, which grew up around this superb coastal position. New docks have been built to accommodate the shipping involved in drilling for oil in the North Sea. Montrose has two lifeboats – an all-weather lifeboat and an inshore rigid inflatable.

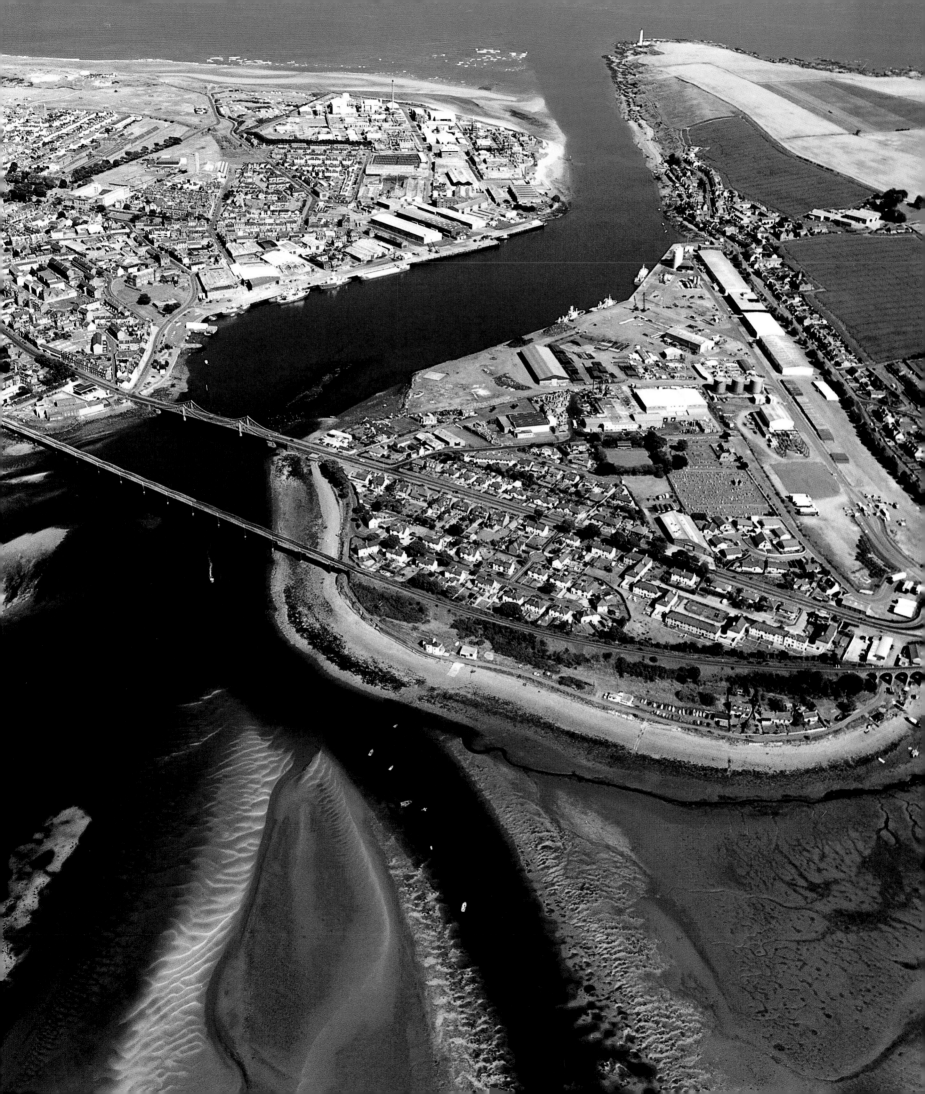

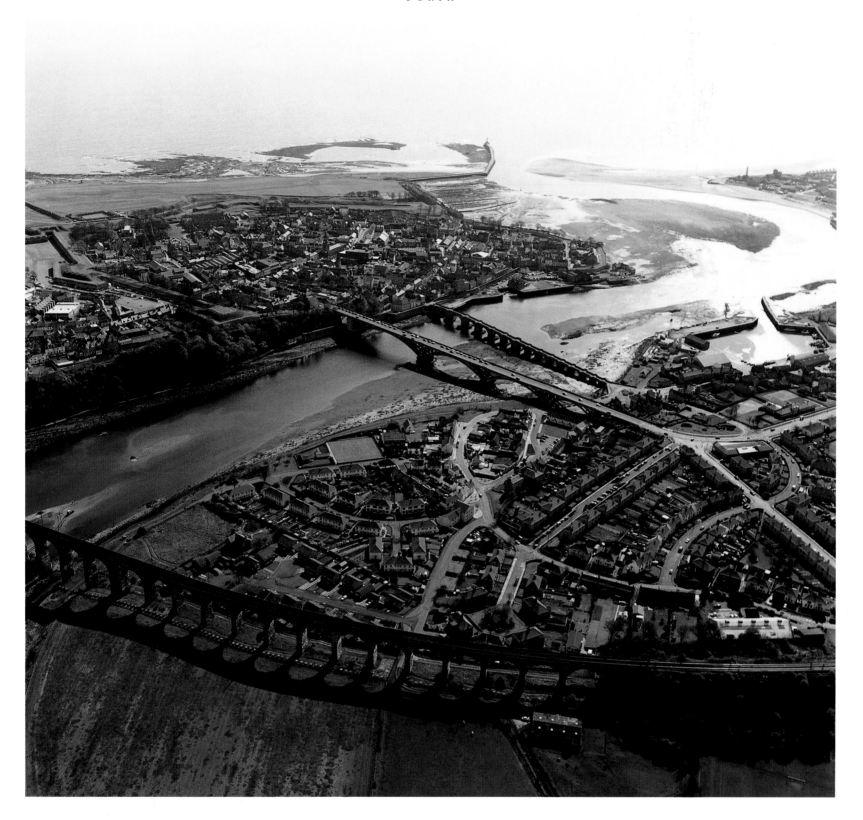

BERWICK UPON TWEED

Berwick upon Tweed must hold a record as the town that has switched nationality fourteen times (often in most violent fashion) before finally becoming English in 1482. If it ever wants to change its name, it might consider something that mentions its three splendid bridges. The one nearest the camera and looking like a long stretch of vertebrae, is the Royal Border Bridge built by Robert Stephenson to carry the burgeoning railway in 1847. The next bridge is the Royal Tweed Bridge, built in the 1920s to carry the A1, and the furthest one is Berwick's original Jacobean Bridge, built in the early seventeenth century.

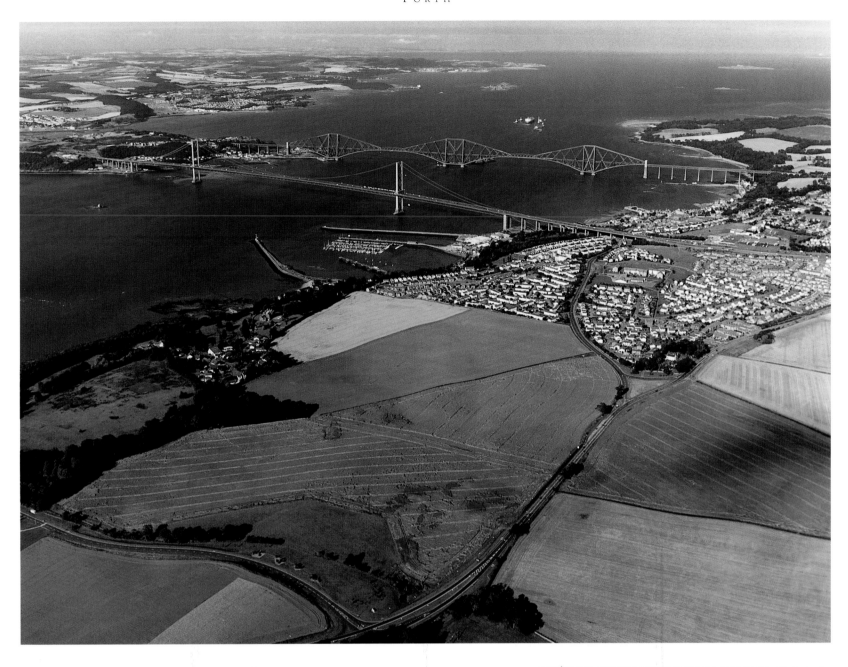

QUEENSFERRY AND NORTH QUEENSFERRY

The long tongue of the Firth of Forth narrows near the two towns of Queensferry and North Queensferry (*above*) and provides the perfect crossing point between the two halves of the estuary. Queen Margaret of Scotland used to cross here by ferry when she made the journey between her palaces at Dunfermline to the north and Holyrood in Edinburgh to the south, and it is from her that the two towns of Queensferry and North Queensferry get their name. Today, this crossing point is spanned by two of the most famous bridges in the world – the Forth Rail Bridge and the Forth Road Bridge.

FORTH RAIL BRIDGE

When this bridge was opened in 1890, it was one of the wonders of the Victorian industrial age and the world's first cantilever bridge. It is nearly 1¾ miles long and consists of two main spans which join together on the tiny island of Inch Garvie in the middle of the estuary. It is no hyperbole that the bridge is always being painted – it takes three years to finish the painting and when it is completed the painters start again. Its sister bridge is the Forth Road Bridge, completed in 1964 and one of the world's longest suspension bridges at 8244 feet.

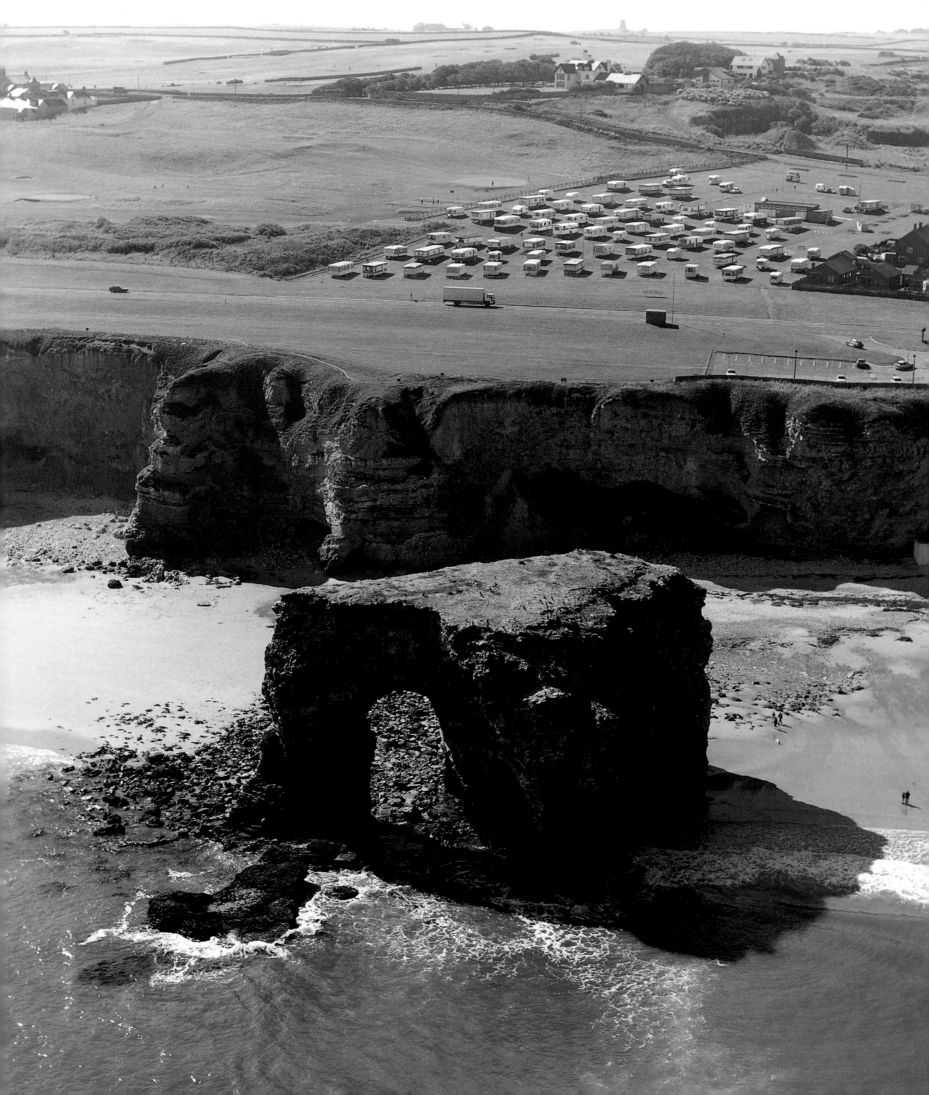

TYNE

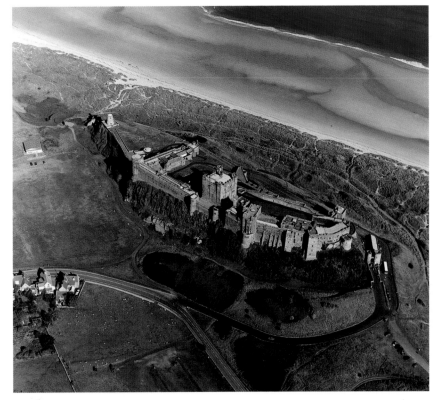

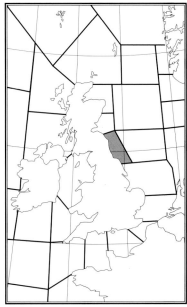

TYNE IS THE SEA AREA that runs from south of Holy Island in Northumberland to south of Scarborough in North Yorkshire. It takes its name from the Tyneside area and the River Tyne which flows out to sea at Tynemouth, passing on its way the great northern port of Newcastle upon Tyne. For centuries, the export of coal mined locally provided a thriving income for this area and many of the harbours were built solely for the transportation of coal. Tyne also encompasses the beautiful North Yorkshire coast, which includes the picture postcard delights of Robin Hood's Bay, the extremely pretty town of Staithes and beautiful Whitby which enjoys associations with Captain Cook and Dracula. The unspoilt Farne Islands, with their flocks of seabirds, are also included in this area. They pose a hazard for shipping, as the many stories of shipwrecks demonstrate. The RNLI lifeboat stations are found here at North Sunderland (two lifeboats), Craster, Amble (two lifeboats), Newbiggin, Blyth (two lifeboats), Cullercoats, Tynemouth, Sunderland and Hartlepool (all three of which have two lifeboats each), Teesmouth, Redcar (two lifeboats), Staithes and Runswick, Whitby and Scarborough (both of which have two lifeboats each).

MARSDEN ROCK

Over the centuries, the sea and wind have worked steadily to erode the limestone cliffs that line Marsden Bay (*facing page*) just south of South Shields. The result is the perfect arch carved out of Marsden Rock, which stands sentinel in the middle of the sandy bay. You can reach the rock by a steep flight of steps on the headland, although it is dangerous to walk along these cliffs because they crumble so easily. Another local attraction is the pub called the Grotto which is tucked snugly into the caves at the foot of the cliffs. It was originally the home of an eighteenth-century miner and his family.

BAMBURGH CASTLE

A fortified building has stood on this site for centuries, from the time of the Romans onwards, but the present castle dates from the twelfth century although its well may be several hundred years older. Some of the castle's walls are 11 feet thick, enhancing its strong defensive position – it stands on an outcrop of sheer rock 150 feet high overlooking the North Sea. The local churchyard contains the tomb of Grace Darling, the daughter of the keeper of the Longstone lighthouse in the Farne Islands. Together, in an open rowing boat, they rescued the survivors of the steamer *Forfarshire* during a ferocious storm in 1838.

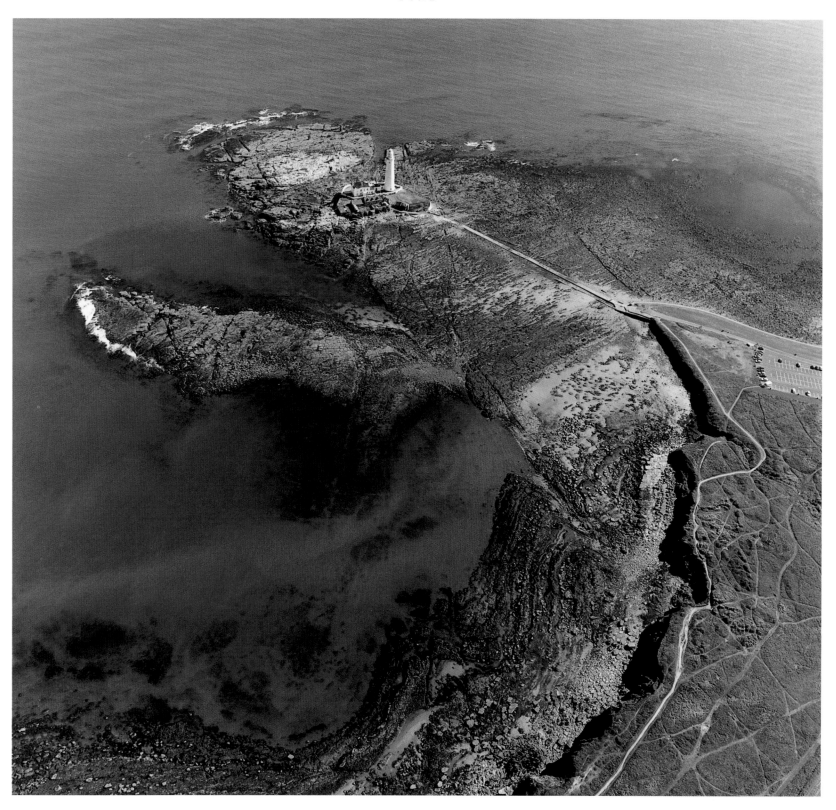

ST MARY'S ISLAND

Just to the north of Whitley Bay, on the border between Tyne and Wear and Northumberland, stands the minute piece of rock called St Mary's Island (*above*). It is joined to the mainland at low tide by a long causeway and is home to a lighthouse and a small cluster of houses. The harbour of nearby Seaton Sluice was once used to export local coal and salt but it silted up so much that a sluice gate, long since vanished, was erected (hence the name of the village). To the south, positioned at either side of the Tyne estuary, lie the towns of Tynemouth and South Shields.

FARNE ISLANDS

If you ever decide to count the Farne Islands (*facing page*), do so at low tide when they are all revealed – at high tide over half of them are submerged beneath the waves. This makes them treacherous to shipping, especially at night. The largest island of the group is Farne Island or Inner Farne, which has special links with St Cuthbert, who became the Prior of Lindisfarne in the seventh century. After he retired from the monastery St Cuthbert lived on Farne Island in a secluded stone cell, and apparently spent much of his time reproving the many seabirds for their voracious appetites.

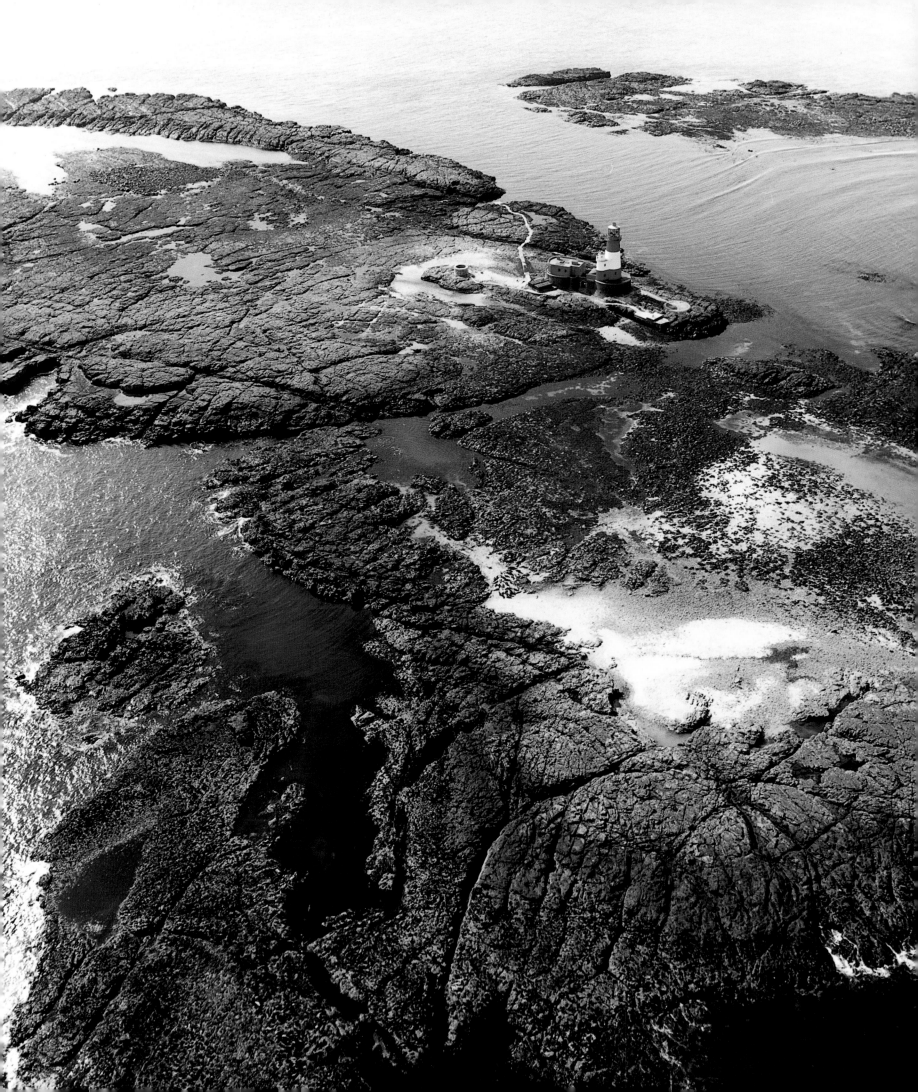

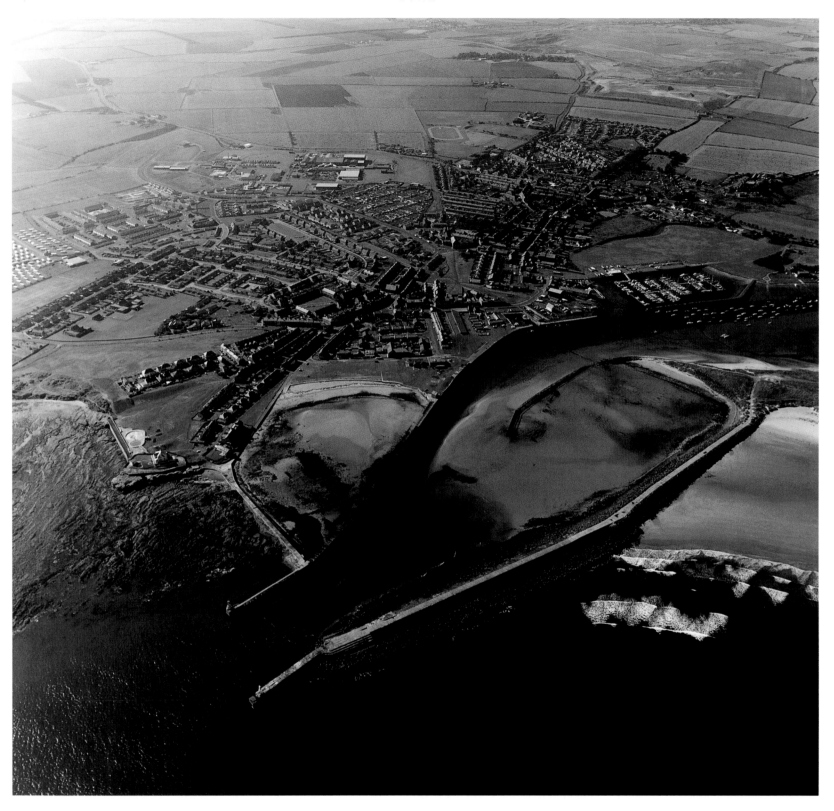

WHITBY AND AMBLE

High on the cliffs above Whitby harbour (*facing page*) stand the broken remains of the medieval Whitby Abbey, successor to the one founded here by St Hilda in 657. The Danes destroyed it three centuries later. Nearby is the parish church of St Mary, which is reached from the town below by 199 steps. It was while watching some pall-bearers carry a coffin up these steps for a funeral that the nineteenth-century author, Bram Stoker, was inspired to write his novel *Dracula*. Whitby is the setting for some of the scenes in the book, including the arrival of Dracula's coffin by sea. On a less creepy note, a statue of Captain Cook stands on the western clifftop, looking out over the harbour where he was once apprenticed to a Whitby shipowner. The three ships in which he sailed around the world – *Endeavour*, *Adventure* and *Revolution* – were all built here. The harbour at Amble (*above*) was once as busy as Whitby, when local coal was being exported by ship. Those days have long since gone and Amble is now known for its fishing and manufacturing industries. There are two lifeboats stationed here, both of which can be visited by arrangement. The tiny Coquet Island lies 1 mile away in the sea, and was once the home of an ascetic monk called Henry the Hermit.

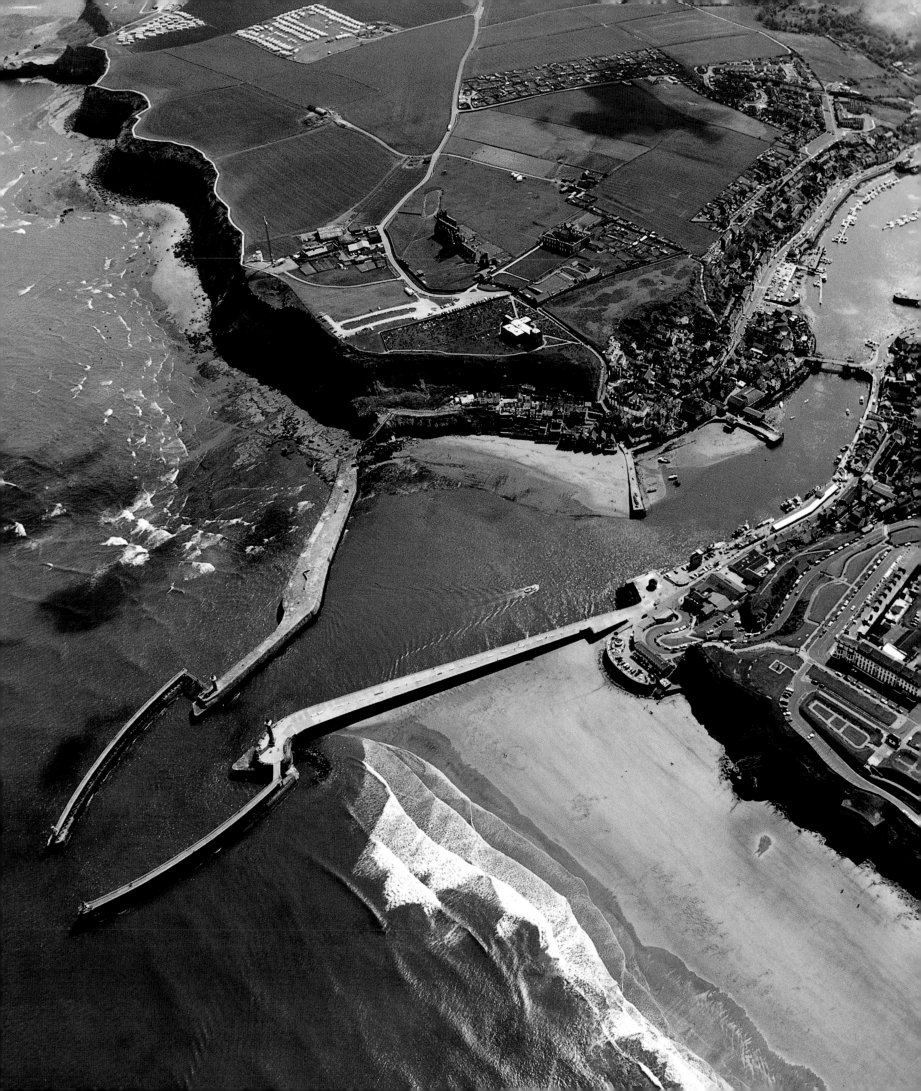

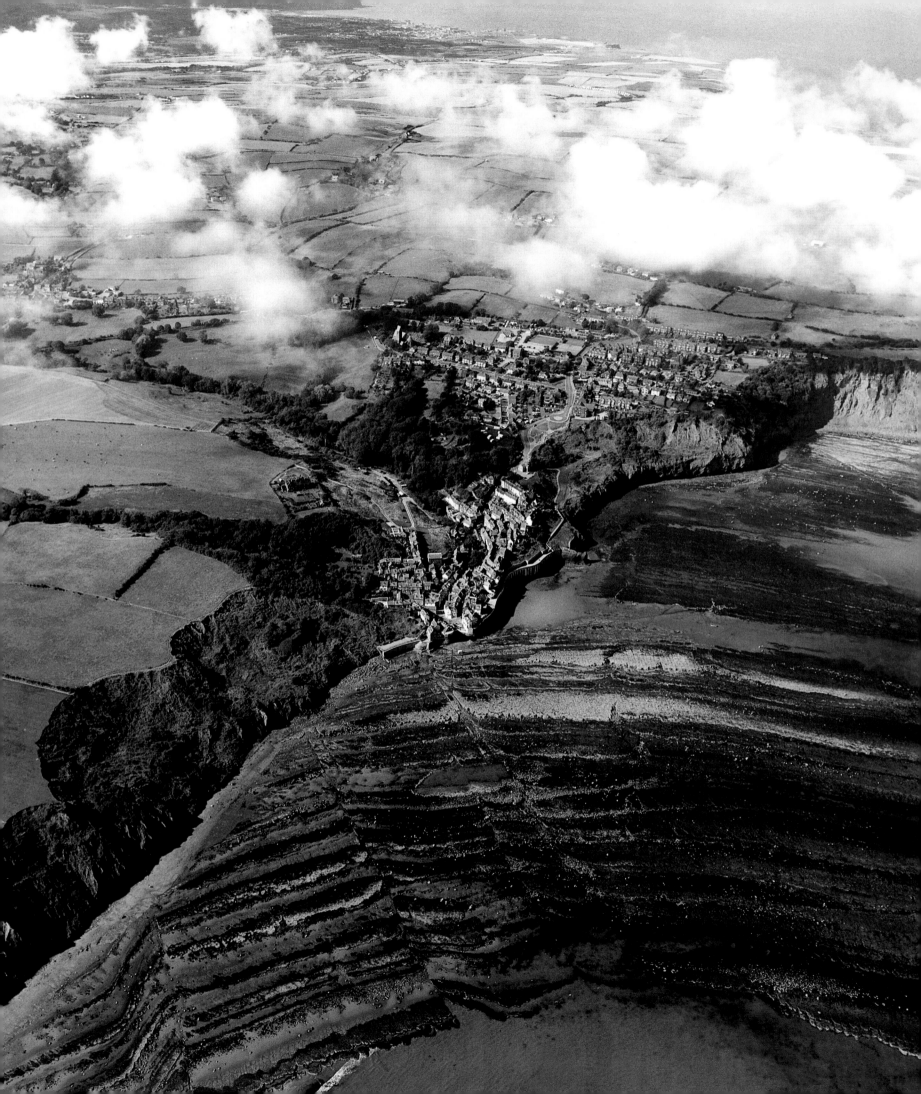

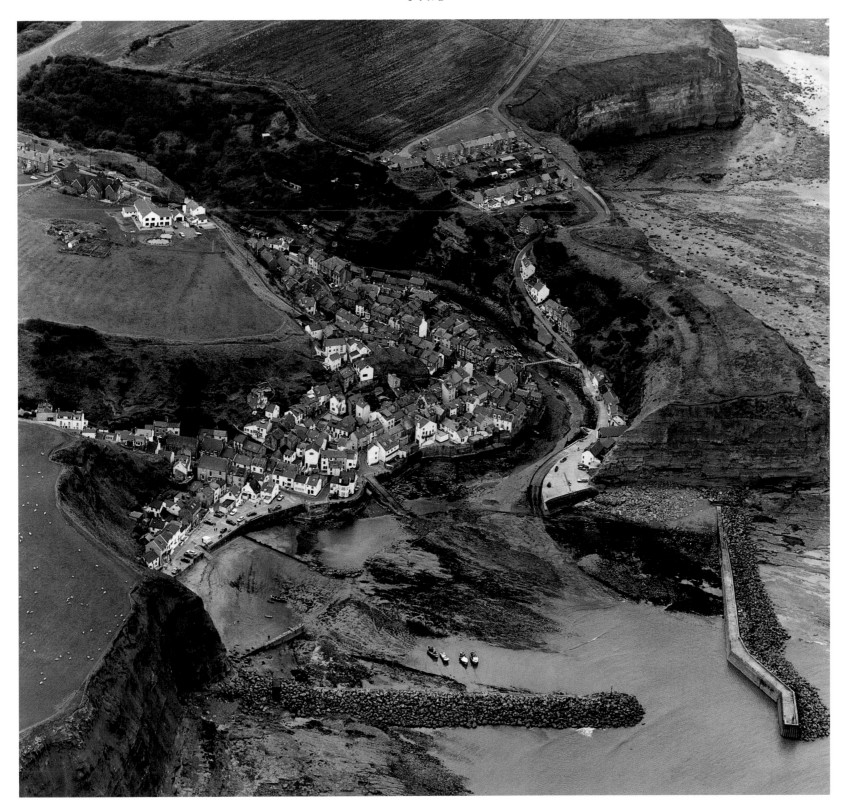

ROBIN HOOD'S BAY

The history of Robin Hood's Bay (*facing page*) matches its picturesque and photogenic qualities. The town's connection with the famous and eponymous outlaw is tenuous – some stories say that Robin Hood used to holiday here while others say he came to help the monks of Whitby in their fight against the Danes. What is certain is that the town became the haunt of smugglers in the eighteenth century, who brought in cargoes from Holland. A network of tunnels ensured that contraband goods could pass from one end of the town to the other without seeing the light of day – or meeting the inquisitive glances of the Excise men.

STAITHES

This pretty, working harbour lies on the southern side of the border between North Yorkshire and Cleveland. With its cobbled streets, jumble of red-roofed cottages, little footbridge over Roxby Beck and meandering headlands, Staithes (*above*) attracts artists and tourists in droves each year. Yet all its many attractions – including the lovely coastline along here – were not enough to keep the sixteen-year-old James Cook satisfied as an apprentice to a local grocer. After eighteen months he had had enough and went to sea as a cabin boy on a Whitby ship. The rest, as they say, is history.

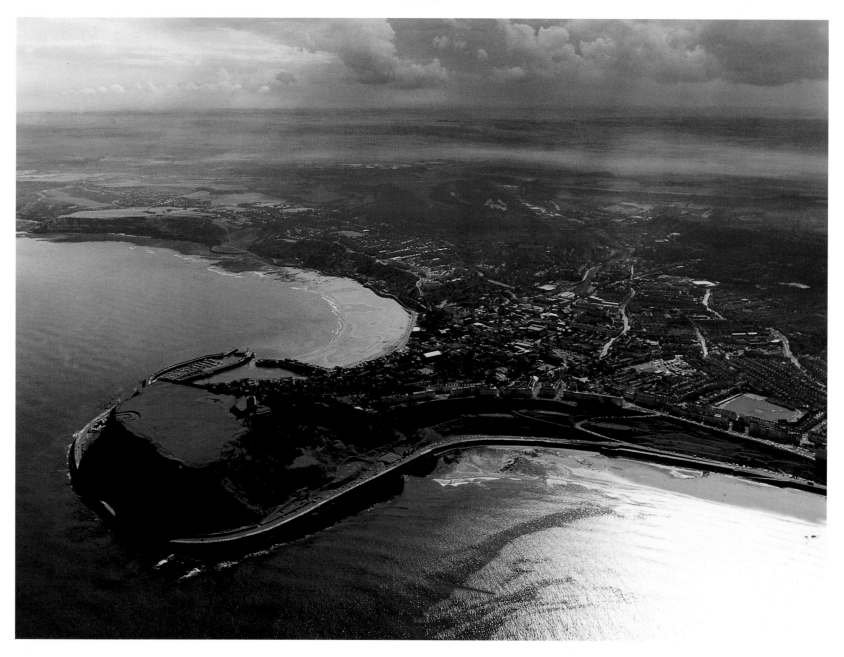

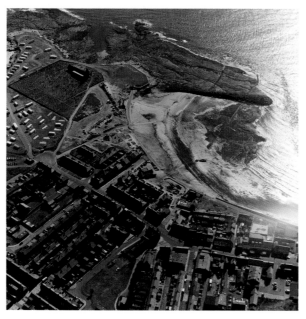

SCARBOROUGH AND NEWBIGGIN

During Roman times, sea-raiders were a real menace on the north-eastern coast of England, which is why five signal stations were erected along this stretch of coastline. One of them was built on the headland at Scarborough (*above and facing page*) in about 370 and the semi-circular outlines of the foundations are clearly visible in these photographs. In the twelfth century, the Normans built a castle on the headland, the battlements of which still stand. The castle was shelled from the sea during the First World War. In the seventeenth century, Scarborough became the first seaside resort in the country, thanks to the discovery of its healing spring waters by Elizabeth Farrer, a local resident. The town became a spa and, in due course, a Mecca for the growing fashion of sea-bathing. Local people claim that the first bathing machine in the country was invented at Scarborough. The town has several links with fame – the actor Charles Laughton was born in the Victoria Hotel in 1899, and the Sitwell family spent their summers here. Newbiggin (*left*) is a much more modest town, although in the Middle Ages it was a big grain port. Today, the harbour is used by fishing cobles and pleasure craft instead.

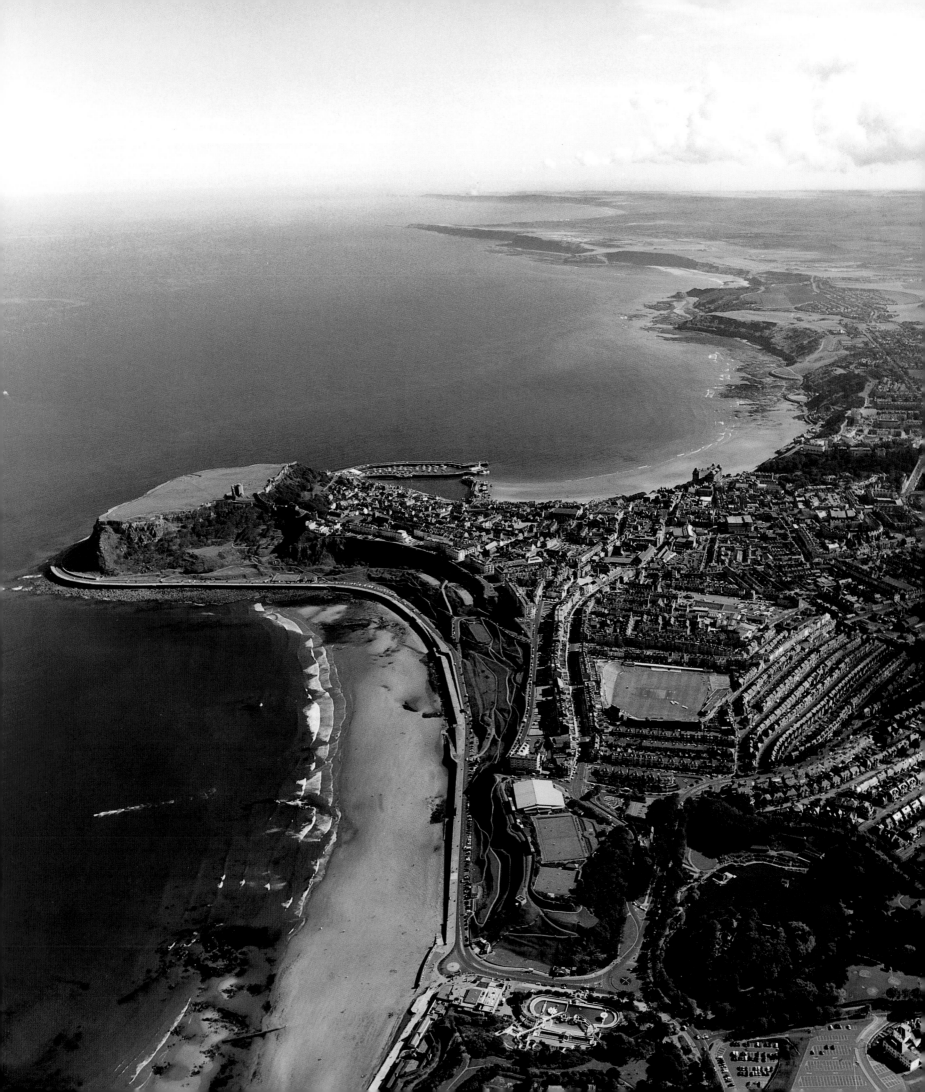

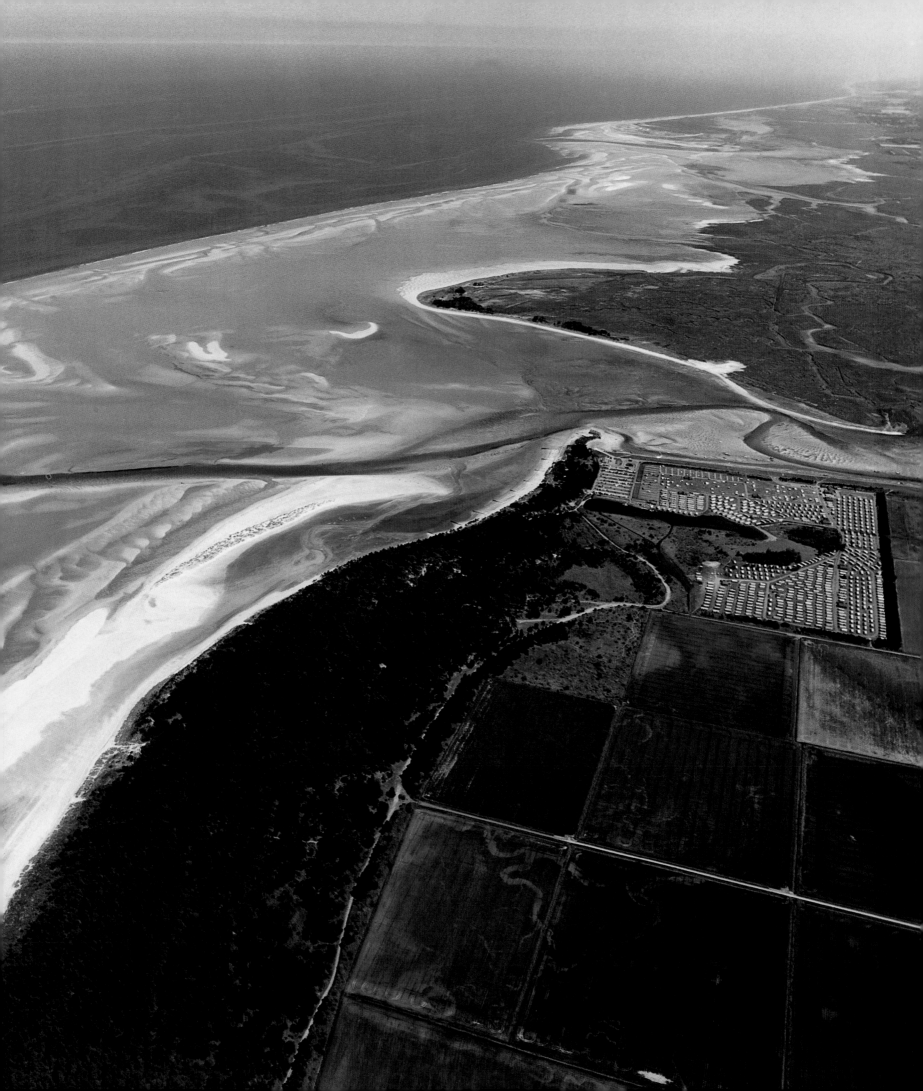

HUMBER

THE HUGE HUMBER ESTUARY cuts a deep gash in the centre of the coastline along the Humber sea area, to remind us of the seafaring and fishing traditions of this section of the east coast of Britain. Humber runs from south of Scarborough in North Yorkshire to north of Great Yarmouth in Norfolk, and travels through the counties of Humberside and Lincolnshire along the way. It includes the huge ports of Hull and Grimsby on Humberside, and the lovely medieval port of Boston which nestles amid the marsh, saltings, sandbanks and mudflats of The Wash in Lincolnshire. In the thirteenth century, Boston was the most important port in England, but its fortunes declined as its waters silted up, a common problem along this coast. The RNLI stations on this section of coastline are found at Scarborough (which has two lifeboats), Filey (two lifeboats), Flamborough, Bridlington (two lifeboats), Withernsea, Humber, Cleethorpes, Mablethorpe, Skegness (two lifeboats), Hunstanton, Wells-next-the-Sea (two lifeboats), Sheringham, Cromer (two lifeboats) and Happisburgh. The number of lifeboat stations with both an inshore rigid inflatable lifeboat and an all-weather one is a reminder of how busy this coastline is both for shipping and tourists.

HOLKHAM NATIONAL NATURE RESERVE

A strip of coastline, 12 miles long and running between Burnham Overy Staithe and Blakeney, comprises England's largest coastal nature reserve. Holkham is bordered by two others – Scolt Head Island Nature Reserve to the west and Cley Nature Reserve to the east. The sand formations are extraordinary here at the Holkham National Nature Reserve (*facing page*), as the photograph so clearly shows. The blue ribbon of water is known as The Run, and is suitable for sailing as well as water-skiing. It is here that the two local Wells-next-the-Sea lifeboats are stationed – one for inshore rescue work and one for rescues out in the open sea.

HUMBER BRIDGE

The single span of the beautiful Humber Bridge (*above*), which crosses the Humber Estuary, is the longest in the world at 4626 feet. It is a feat of engineering skills and simple, elegant design, and links the two villages of Hessle and Barton upon Humber on either side of the River Humber. Hull, as it is more commonly known, is Britain's third largest seaport after London and Liverpool. The oldest part of the city is the medieval area around the Rivers Hull and Humber, and it was from here that wool produced in the nearby Meaux Abbey was shipped to Europe.

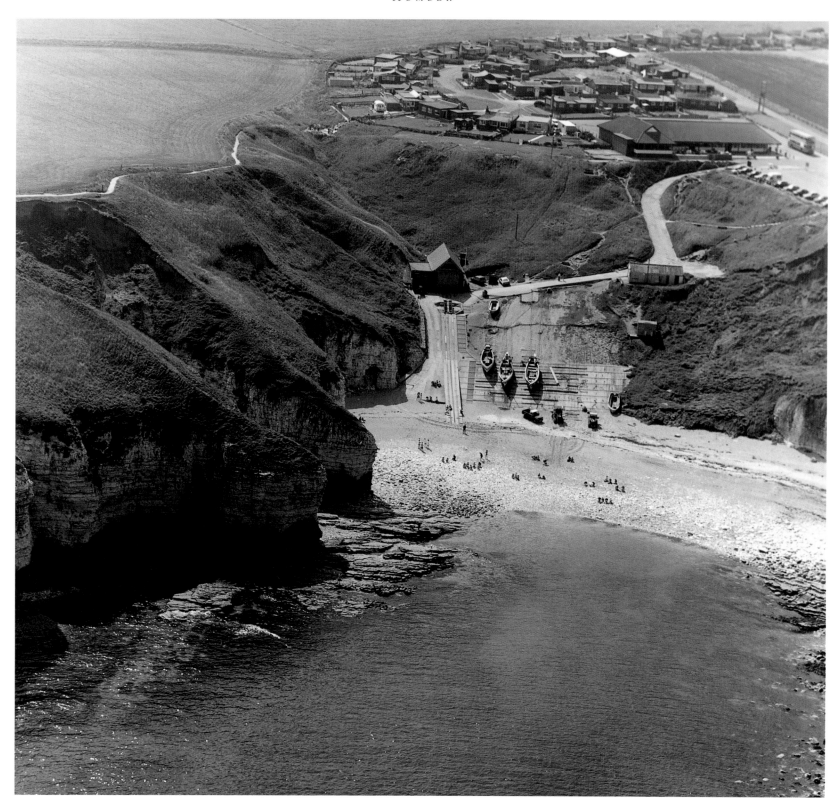

FLAMBOROUGH HEAD

Do not be deceived by the tranquil seas shown in these photographs of one of the most dramatic places along England's north-eastern coast. Looking rather like a nose, Flamborough Head juts out into the North Sea above the long, pointed chin of Spurn Head. The seas are not always so calm here, hence the benevolent presence of the 85-foot tall lighthouse which was built in 1806 to warn ships of the treacherous currents that are found in these waters. Studying the coves and crags that have been gouged out of the chalk cliffs through the centuries will also tell you a great deal about the sometimes violent nature of the sea. Although the cliffs look magnificent from the top of the headland, they can also be explored at sea level at Selwicks Bay, just to the north of Flamborough Head. Slightly further west is the tiny cove called North Landing (*above*), where fishing cobles are moored on a large ramp. Flamborough's rigid inflatable RNLI lifeboat is stationed at South Landing. Countless thousands of shrieking seabirds have made their home in the intricately carved cliffs at Bempton Cliffs, now a RSPB bird reserve, including puffins, razorbills, fulmars, gannets and guillemots. You may wish for earplugs if visiting the cliffs during the birds' mating season.

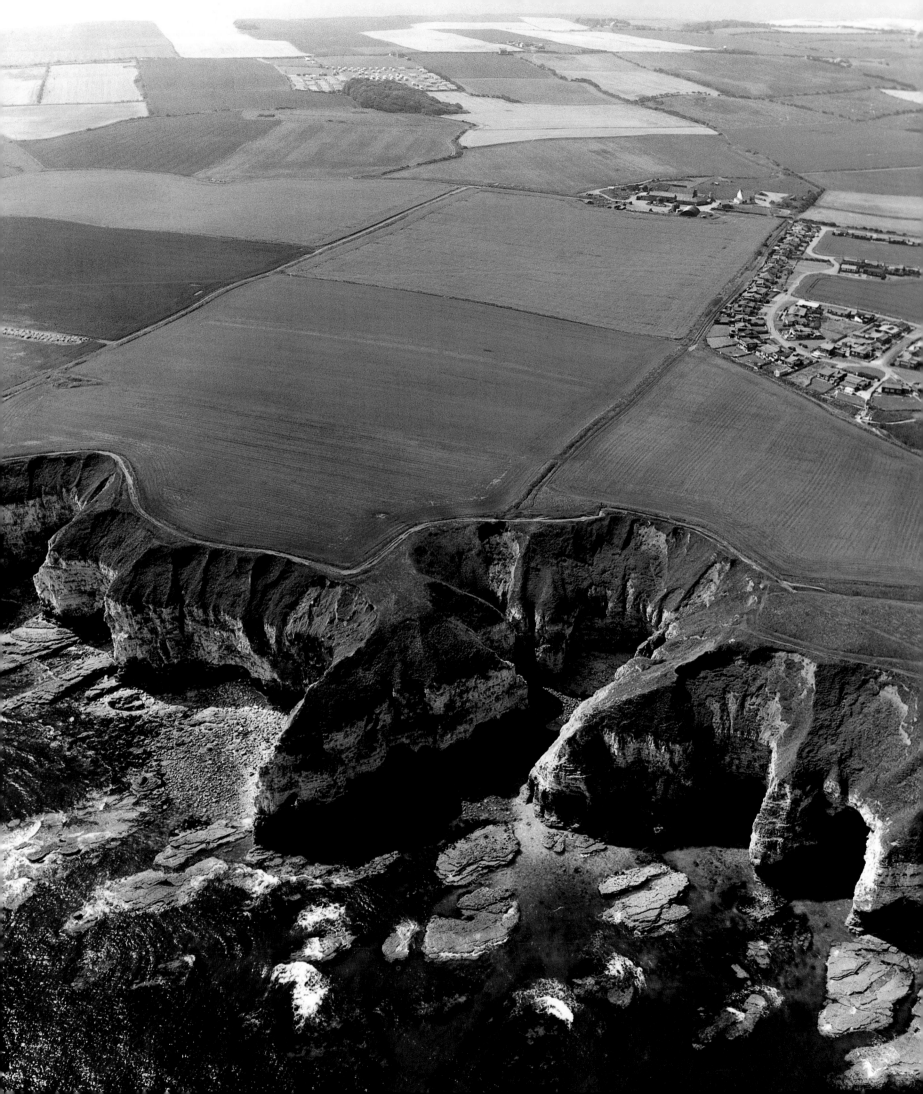

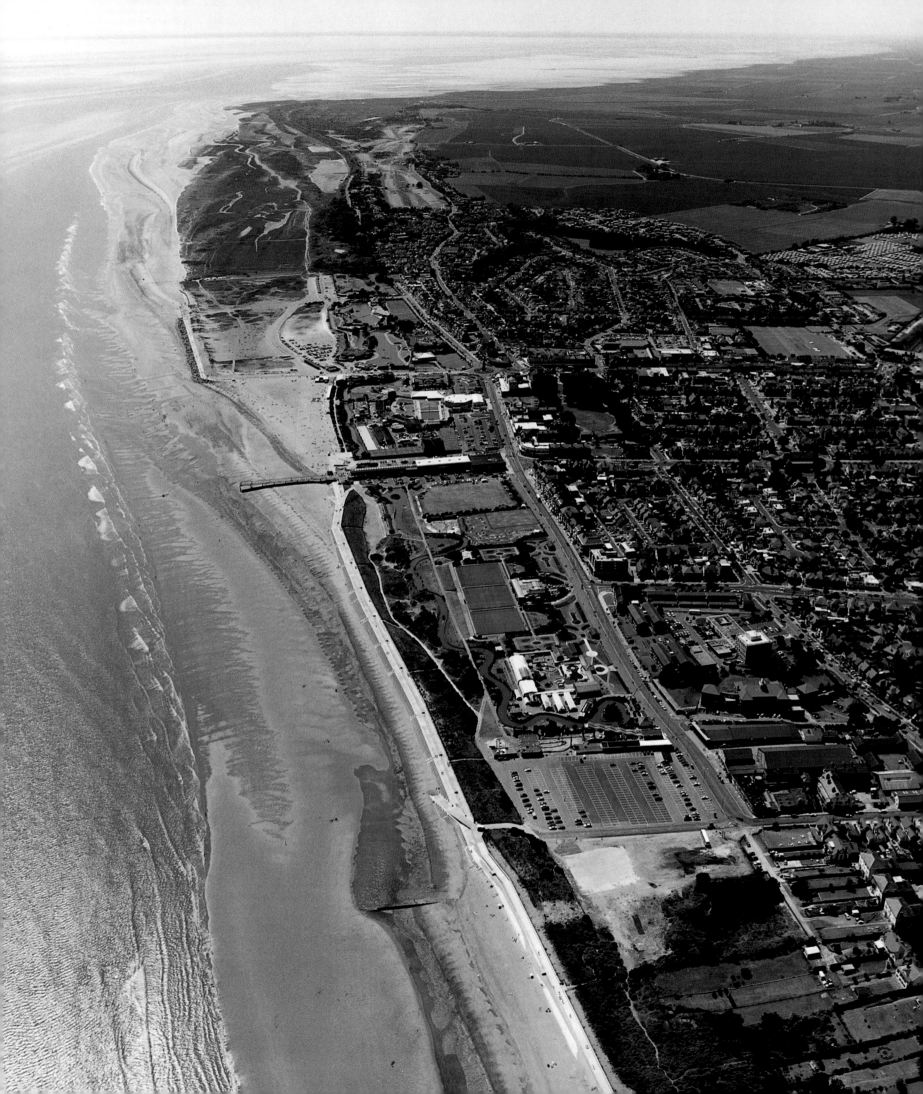

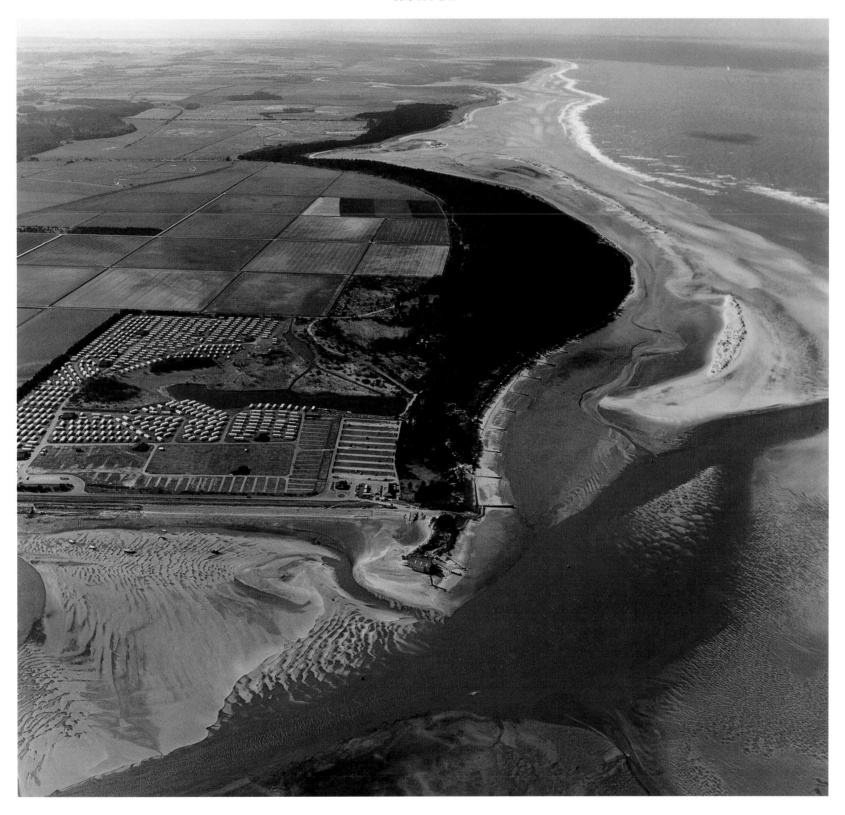

SKEGNESS

One of the great holiday resorts on the north-eastern coast of Britain, Skegness (*facing page*) was once famously described as being '*so bracing*'. It began its life as a holiday town in the nineteenth century when the local squire, the 9th Earl of Scarborough, began to draw up plans that would convert a small fishing village into a big seaside resort. In order to ensure that visitors would be able to reach Skegness easily, he persuaded the owners of the Great Northern Railway to extend its line from Wainfleet to the coast, and the railway duly arrived in 1875. In 1881, it was joined by the pier which was destroyed by gales in 1978.

WELLS-NEXT-THE-SEA

Despite its name, Wells (*above*) is not quite next to the sea – a long stretch of sand dunes and grass separates it from the vast sandy stretches of beach. You can reach the beach by foot or, charmingly, by miniature railway and, once there, you can either go swimming (but make sure you check the signs saying which areas are safe for bathing first) or go sailing in the large lagoon, called Abraham's Bosom, next to the car park. The sea comes in extremely rapidly in this part of Norfolk, and a klaxon sounds whenever the tide turns, warning beachcombers to hurry ashore before they are cut off by the sea.

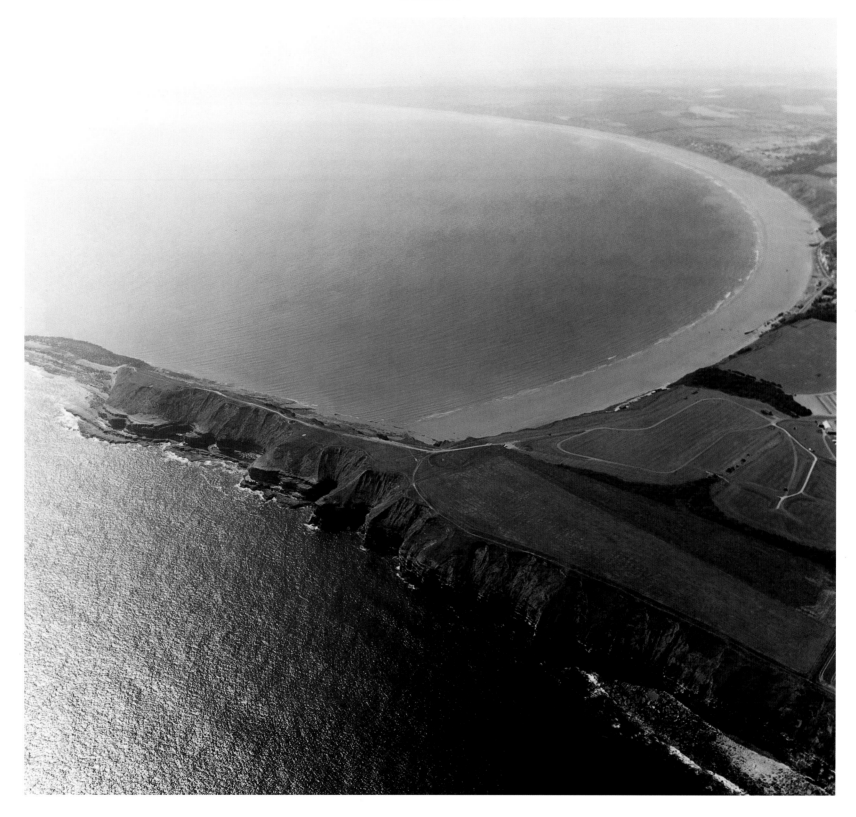

FILEY

The spit of land that extends 1 mile into the sea just north-east of the town of Filey is Filey Brigg (*above*). Although it is safe to explore these rocks at low tide when the weather is calm, it is not a place to visit when the wind is blowing and the sea is hurling itself over the rocks. Over the centuries, many ships have come to grief in this stretch of water. Beyond Filey Brigg lies Filey Bay, a 6-mile long, curving band of sand that runs down to Flamborough Head. It was thanks to this bay, and the coming of the railway in the 1840s, that Filey became a popular seaside resort.

SPURN HEAD

Like a protective arm curled around the mouth of the Humber Estuary, the narrow spit of Spurn Head (*facing page*) stretches for over 3 miles into the sea, enclosing a vast area of muddy sandbanks. It is the accumulation of centuries of sand and silt that have been washed here by the tide. The section of Spurn Head shown in the photograph is a nature reserve, and the lighthouse is no longer in operation, having been superseded by electronic warning devices. Spurn Head also has a lifeboat station, the only one in the country to be staffed by a full-time crew because of its remote position.

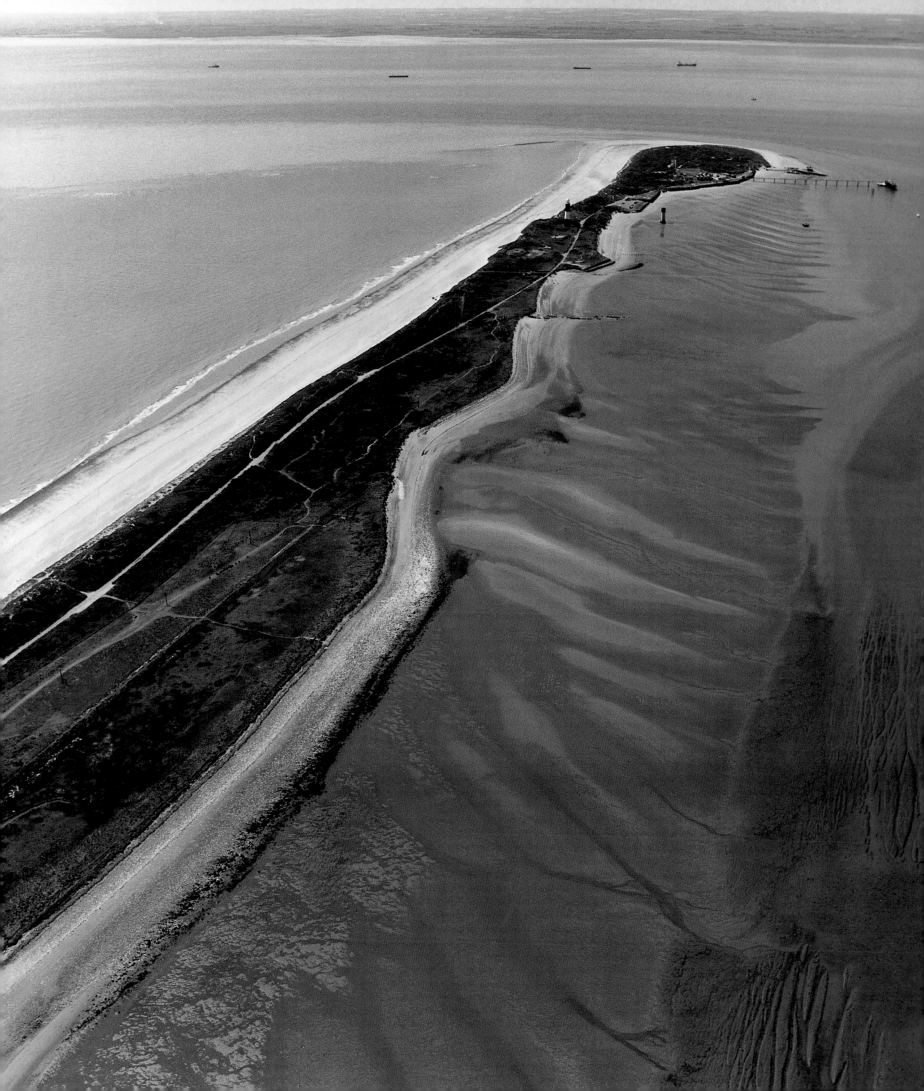

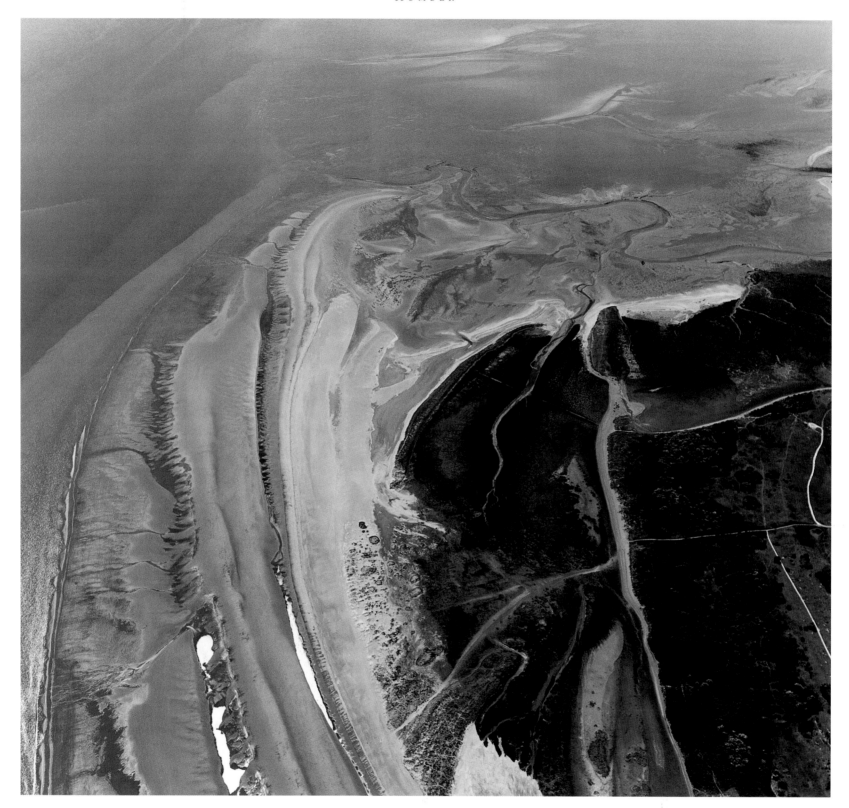

GIBRALTAR POINT

Like so many other coastal areas in this part of England, the salt marshes of Gibraltar
Point are a nature reserve and provide a vital sanctuary for the wide variety of seabirds
and wading birds that live here. Gibraltar Point lies south of Skegness and forms the
northern border of The Wash, a huge area of sea and sandbanks in which King John
famously lost all his baggage. Just beyond Gibraltar Point is the RAF's bombing range
on the mudflats of Friskney Flats. This whole stretch of coastline tells the story of how,
over the centuries, the unforgiving sea has gradually silted up what were once thriving
harbours, docks and quays.

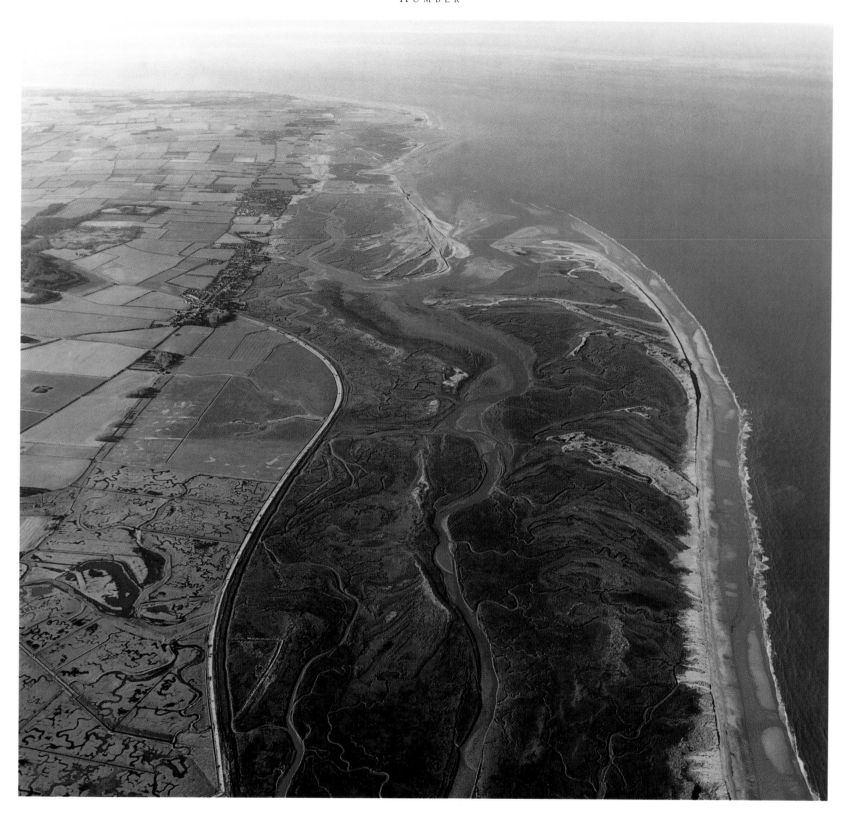

SCOLT HEAD ISLAND NATURE RESERVE

North of the village of Burnham Market lies the sprawling mass of Scolt Head Island, which has been a nature reserve since 1923. It is jointly owned by the National Trust and the Norfolk Naturalists' Trust, and is best known for the colonies of terns that nest here. They are protected during their breeding season, which lasts from May to July, when the area is closed to visitors. Although this is a wonderful place to walk, it is often dangerous to do so because of the marshy ground, and should only be attempted in the company of someone who knows the area well. The RSPB Titchwell Marsh Reserve lies to the west of Scolt Head.

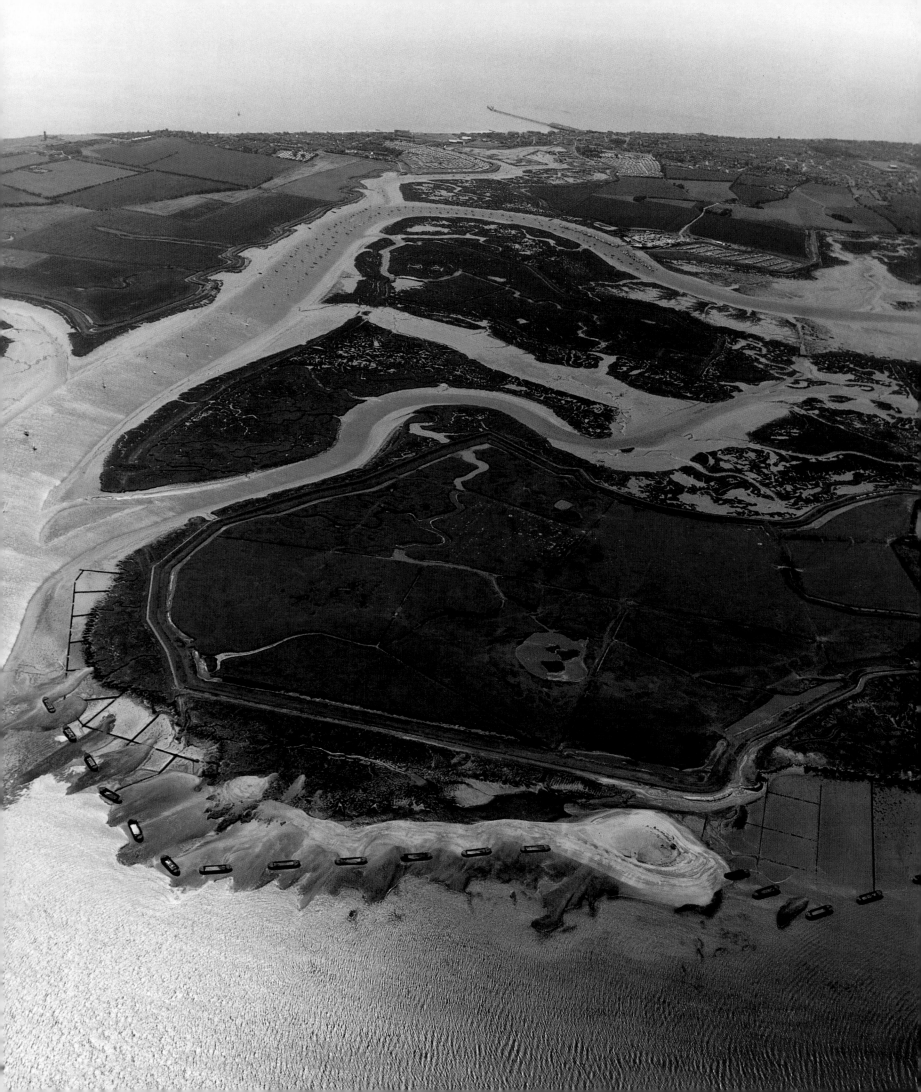

THAMES

NAMED FOR THE MIGHTY RIVER THAMES, the sea area of Thames runs from north of Great Yarmouth in Norfolk to south of Sandwich in Kent, passing through the counties of Norfolk, Suffolk, Essex and Kent. The RNLI stations in Thames are Great Yarmouth and Gorleston (which has two lifeboats), Lowestoft, Southwold, Aldeburgh (two lifeboats), Harwich (two lifeboats), Walton and Frinton, West Mersea, Clacton-on-Sea (two lifeboats), Burnham-on-Crouch, Southend-on-Sea (no less than three lifeboats), Sheerness (two lifeboats), Whitstable, Margate (two lifeboats) and Ramsgate (two lifeboats). Many of these stations have two lifeboats, one of which is always an inflatable or rigid inflatable for inshore rescue work, because there is so much pleasure boating and other marine activity, such as water-skiing, along this stretch of coast. Two particularly popular areas for sailing are the Blackwater and the Crouch in Essex, which together enclose a large peninsula of land. There are many interesting creeks and saltings to explore around here because the area is littered with islands, from the tiny islands found in the Walton Backwaters to Mersea Island in the Blackwater. Many parts of the coastline are home to a rich variety of wildlife but especially birds.

WALTON BACKWATERS

Behind the seaside resort of Walton-on-the-Naze lies the collection of islands and creeks that make up the Walton Backwaters (*facing page*). This reedy, watery wilderness offers ideal conditions for the thousands of birds that nest here. Walton Backwaters run into other stretches of water – The Wade, Walton Channel and Hamford Water – and contain several islands including the large Horsey Island. Many of the place names are quaint – for example, Naze means 'nose' – and the inclusion of Le Soken in several village names comes from the days when they paid 'socage', or rent, to St Paul's Cathedral.

TENDRING PENINSULA

One of the many joys of aerial photographs is that they can provide entirely new perspectives of land and sea whether or not they are familiar to the viewer. This estuary on the Tendring peninsula – the small semi-circle of land that juts out into the North Sea between Brightlingsea and Harwich – is a classic example of the way the camera can record sights that have only previously been seen by birds and low-flying aircraft. One is able to study the beautifully intricate patterns made by small rivulets of water flowing out on to stretches of sand, so characteristic of this part of Essex.

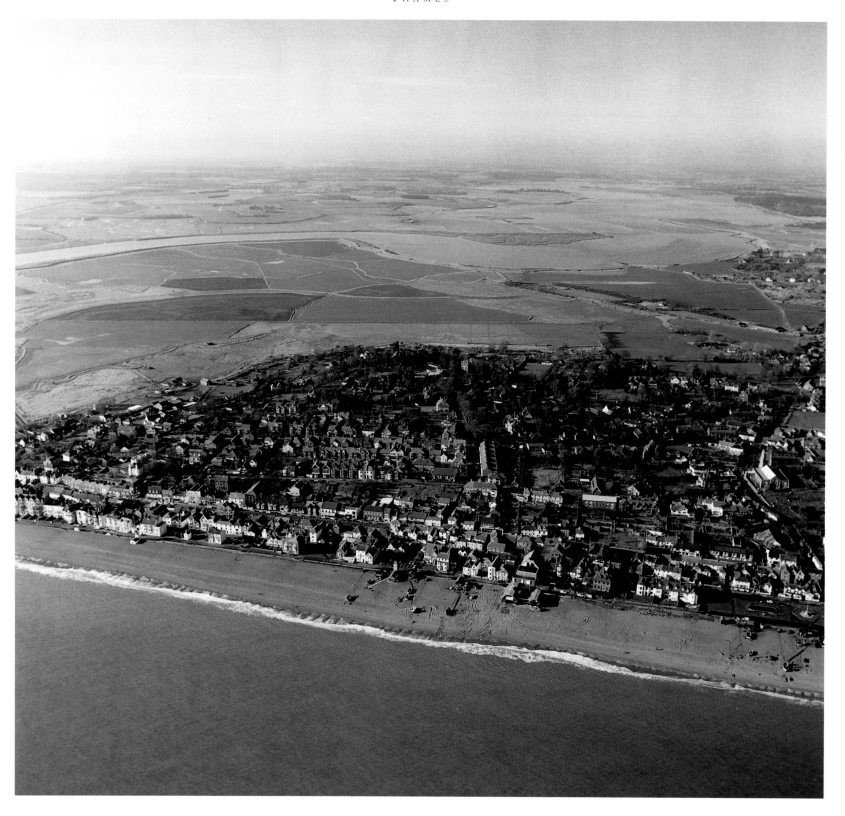

ALDEBURGH

Fans of Benjamin Britten's works equate Aldeburgh (*above*) with the music festival that has been held here each June since 1948. The concert hall is at Snape Maltings, the tiny village at the head of the Alde estuary, seen snaking its way out to sea in the photograph. Some parts of Aldeburgh have long been lost to the relentless sea which continues to erode the shoreline around here. Aldeburgh still has a Martello tower to the south of the town, relic of Britain's coastal defences during the Napoleonic Wars, while to the north lies Sizewell village, best known for its nuclear power station.

SOUTHWOLD

Lighthouses usually sit alone on rocks or headlands, far away from the bustle of everyday life, but at Southwold the white-painted lighthouse dwells happily among cottages and houses dating from Georgian times. It arrived in the 1880s and has been here ever since, providing a landmark for the townsfolk as well as a warning beacon for shipping. In the past, Southwold has had more than its fair share of trouble. By the end of the sixteenth century the encroaching tides were gradually choking the harbour mouth with shingle, which had to be cut away, and sixty years later most of the town was destroyed in a fire.

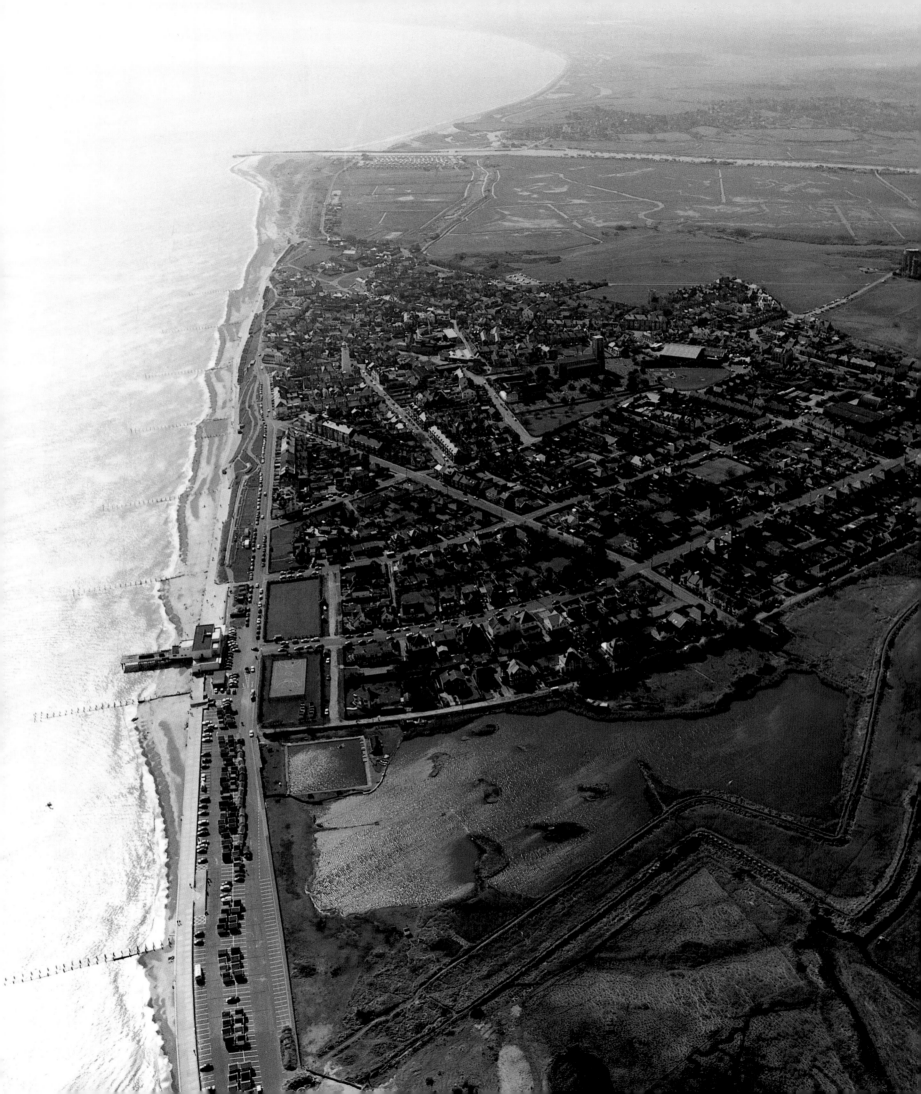

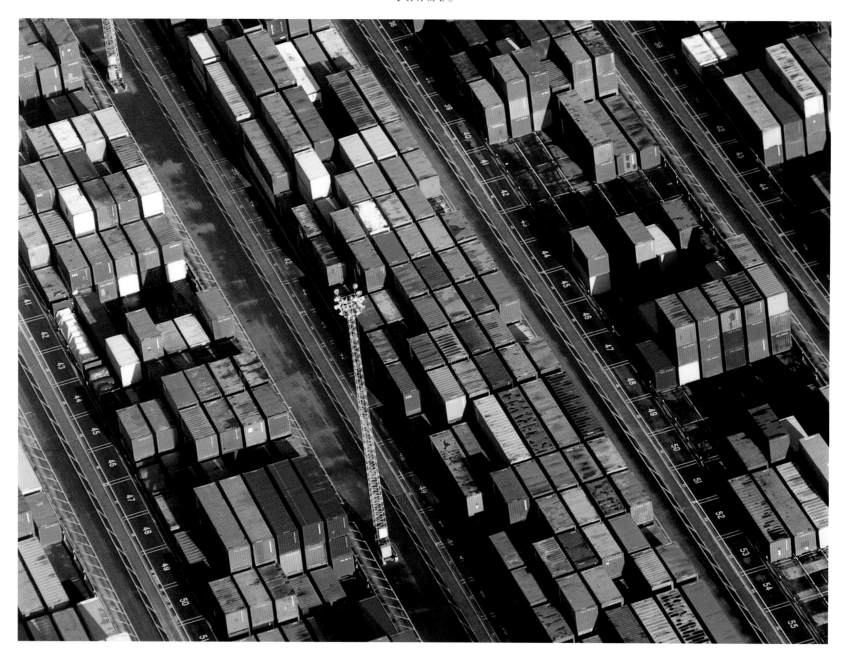

WEST MERSEA AND FELIXSTOWE

When viewed from the air, what looks like a jumble on the ground becomes a fascinating arrangement of colour and texture. At West Mersea (*left*), fishing and sailing boats are lined up waiting for the tide, their masts forming a delicate tracery against the bronze sand. There is also a line of beach huts at West Mersea which face the part of the Blackwater known as Virley Channel. The container docks at Felixstowe (*above*) have a very different atmosphere. Felixstowe is now one of Europe's busiest container ports, and it lies to the west of the main town. Ferries leave here bound for Harwich, Belgium and Norway.

THE ISLE OF GRAIN

More patterns are revealed in this car park on the Isle of Grain. It is interesting to realize how sights that appear ugly on the ground become almost beautiful when viewed from the air – one gains an entirely new perspective of what can be extremely familiar scenes. Despite its name, the Isle of Grain has nothing to do with the export of wheat or other crops. Instead, it gets its name from the old English word *greon*, which means gravel or sand. The land here has been quarried for centuries, and several villages contain old workings. Today, the south part of the Isle of Grain overlooking the Medway is host to an oil refinery and a power station.

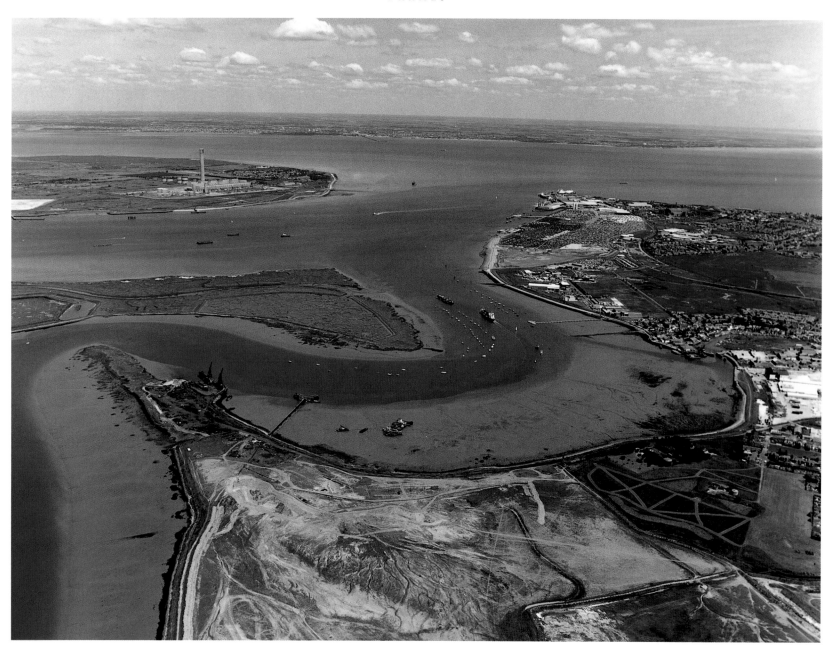

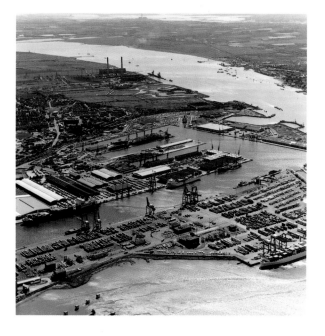

TILBURY, HARWICH AND THE MEDWAY

If Elizabeth I were to visit Tilbury (*left*) today, she would not believe her eyes. Although there was a fortress built by her father Henry VIII, it was a much quieter place when Elizabeth rallied her troops here in 1588, readying them for war in case the navy failed to repel the invading Spanish Armada. Today, Tilbury is a major container port supplying London, which lies several miles upstream along the Thames. Harwich (*facing page*) also has historic seafaring traditions and was once a walled town. Many of England's great sailors have set out on voyages from Harwich, and the town was the home of Christopher Jones, the master of the *Mayflower*, in which the Pilgrim Fathers sailed to America in 1620. Now, Harwich offers shelter to a rich variety of ships, from the biggest ferries to the smallest pleasure craft, including lightships and the local lifeboats. The Medway estuary (*above*) is a mixture of creeks, islands and huge areas of silt and sand. It is enclosed by the Isle of Grain to the north-west and Sheerness to the north-east, with the Roman town of Rochester sited at the head of the river to the west.

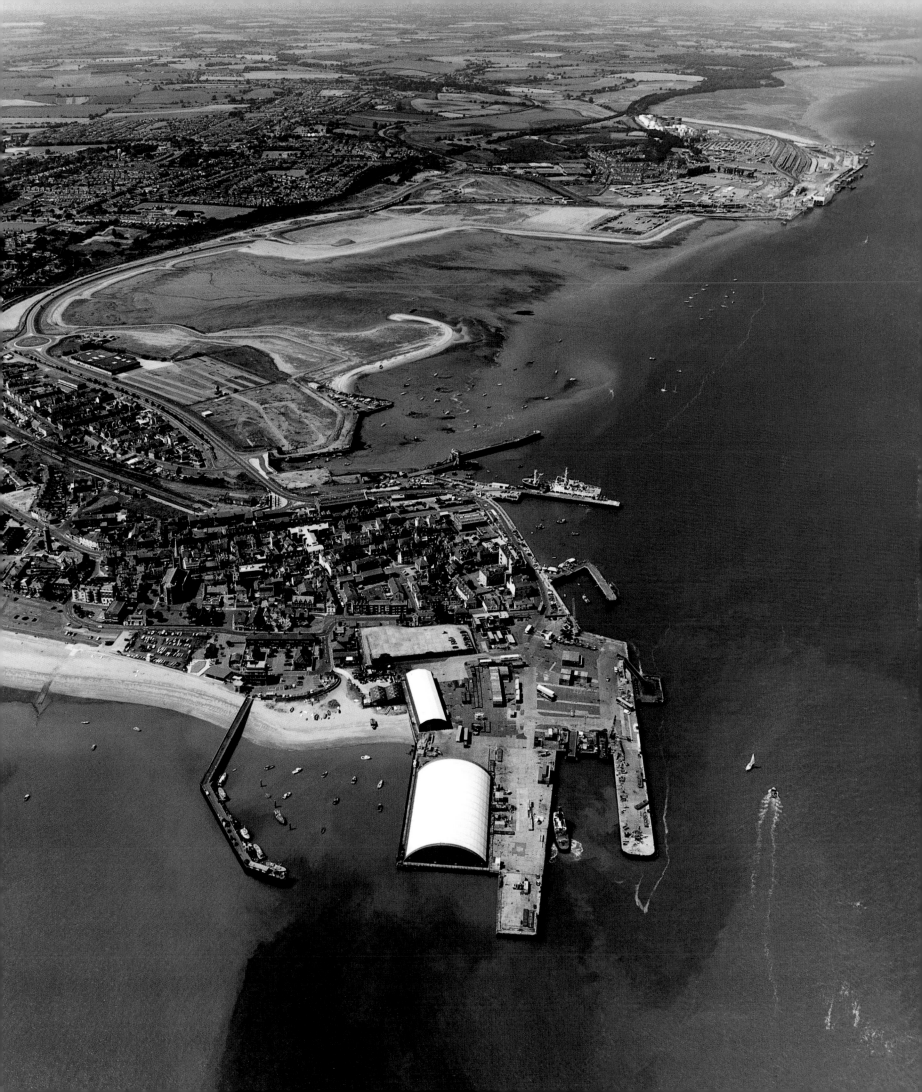

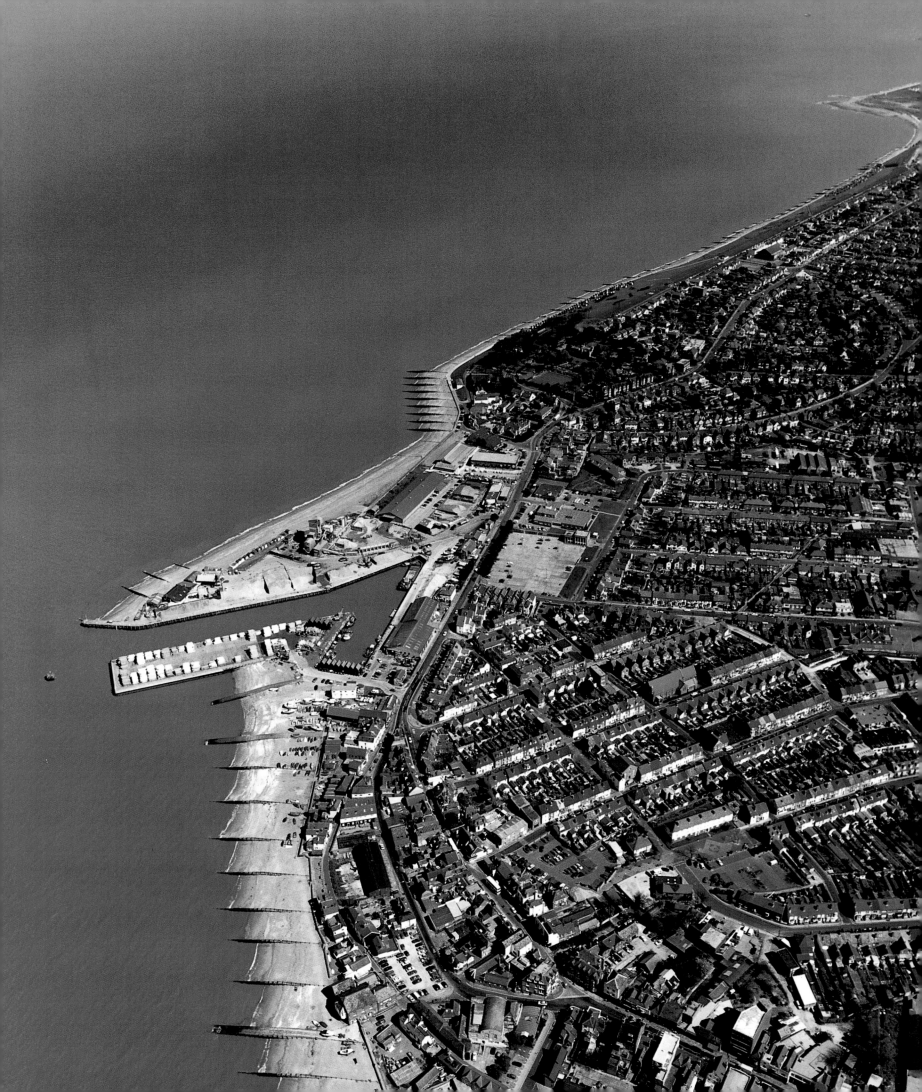

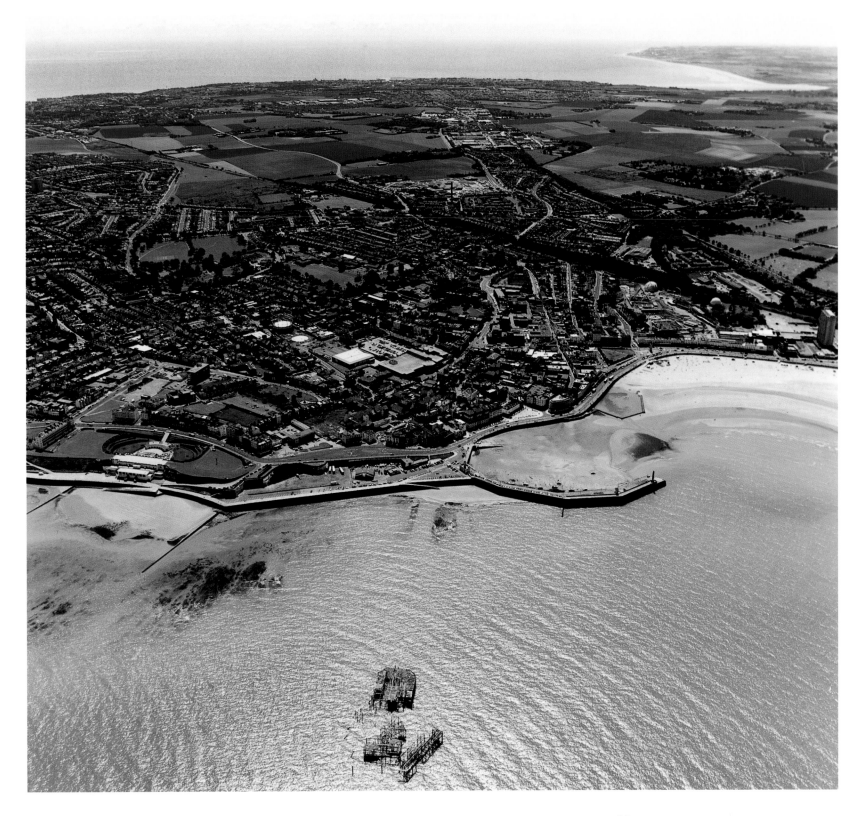

WHITSTABLE

Even in Roman times, Whitstable (*facing page*) was famous for its oysters. Although the combined effects of sea pollution and the terrible storms of 1953 put paid to the industry for a while, the production of Whitstable oysters is now thriving once more. So much so that the harbour houses Europe's largest oyster hatchery. The harbour also has the distinction of being the first one in the world to be served by a steam railway. It was built in 1830 and linked Whitstable with Canterbury, which lies a few miles inland. To the east of Whitstable is the quiet seaside resort of Herne Bay.

MARGATE

Londoners in search of sea and sand have flocked in their droves to Margate (*above*) during the past 200 years. By 1775 Margate could boast 30 bathing machines which stood, ready and waiting, on the beach. The trippers arrived from London in special boats, called Margate Hoys, and disembarked at the curved jetty, known as Margate Pier, shown in the photograph. Later, they arrived by steamer and then, from the 1840s onwards, by railway. These Georgian and Victorian day-trippers would be agog at the attractions that Margate's sea front offers today – a colossal funfair, joke shops, amusement arcades and bingo halls.

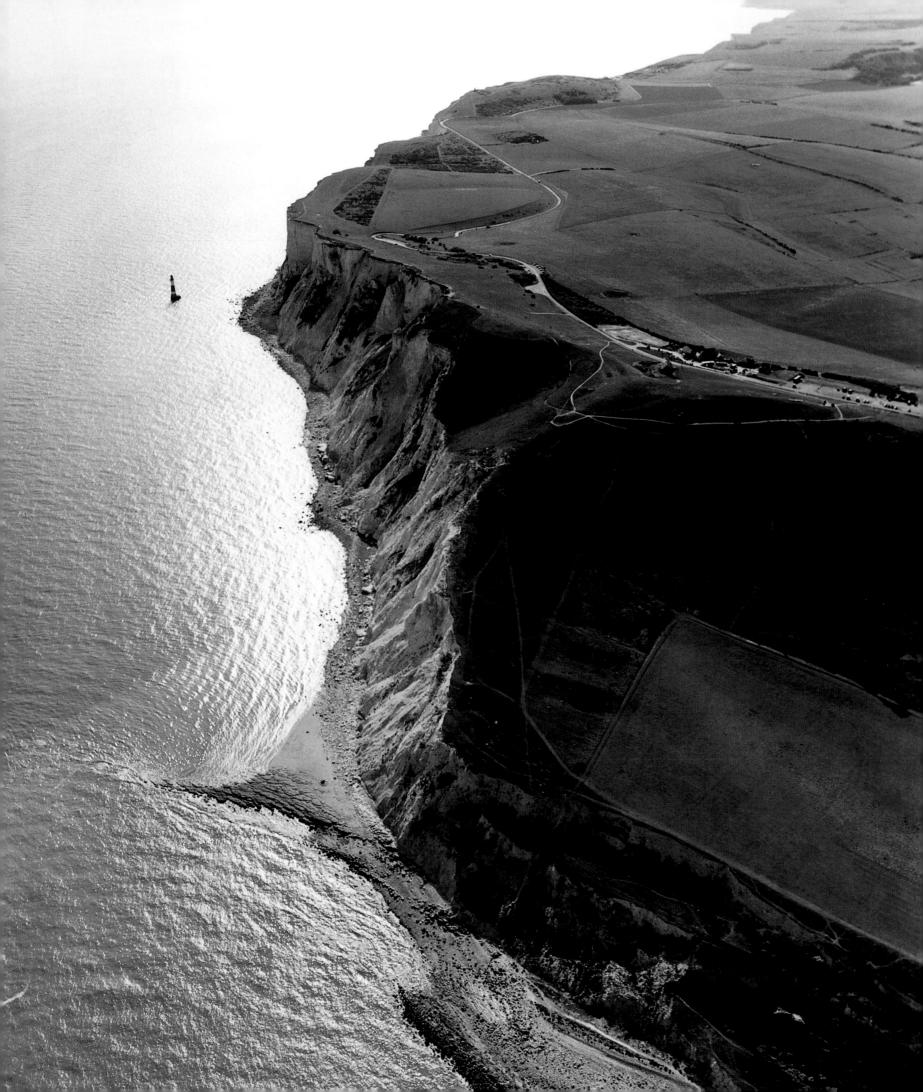

DOVER

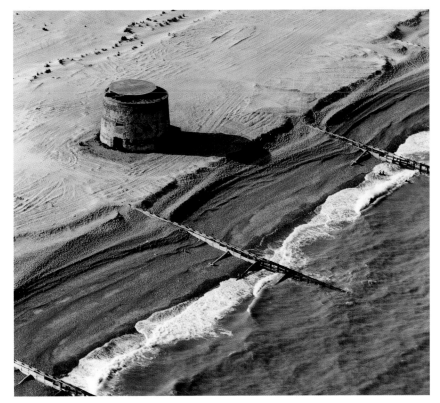

AS ONE MIGHT EXPECT, the world-famous white cliffs of Dover are included in this sea area, which extends from south of Sandwich in Kent to west of Beachy Head in East Sussex. It encompasses the counties of Kent and East Sussex and, along the way, a wealth of history. This was the home of the Cinque Ports, the name given to the five ports of Sandwich, Dover, Hythe, Romney and Hastings which Edward the Confessor authorized to provide a coastal defence. The towns of Rye and Winchelsea were added later. However, even they were unable to prevent the invasion of England which took place in 1066 when a party of French troops, led by the man we now call William the Conqueror, landed at Pevensey. The sea area of Dover contains several seaside resorts, including Folkestone, Hastings (notable for its tall, black sheds used by fishermen to dry their nets), Bexhill, Pevensey Bay and Eastbourne. The RNLI stations in Dover are Walmer (which has two lifeboats), Dover, Littlestone-on-Sea, Dungeness, Rye Harbour, Hastings (two lifeboats) and Eastbourne (which also has two lifeboats). Smugglers were once active along this coast, and are particularly associated with Rye, Hastings and Eastbourne.

BEACHY HEAD

The steep, sheer cliffs at Beachy Head (*facing page*) rise to the dizzying height of 534 feet and are not the ideal location for anyone suffering from vertigo. The wind can be merciless at the summit of the cliffs and the chalky ground is sometimes slippery underfoot, especially near the edge. Nevertheless, this is one of the most beautiful and mesmerizing places on the south coast, with views on a clear day that really do stretch for miles, from Hastings in the east to Brighton in the west. Beachy Head lighthouse, with its cheerful red and white stripes, is one of the most easily recognized lighthouses in the country.

PEVENSEY BAY

The Martello tower standing in dignified, sandy isolation at Pevensey Bay (*above*) was built in the first years of the nineteenth century as a defence against the threatened invasion of the French during the Napoleonic Wars. It was one of 103 towers rapidly erected along the south-east and east coasts of England. 'Boney' and his troops never arrived but if they had it would have been history repeating itself if they had landed at Pevensey – it was somewhere near here that William the Conqueror and his French troops waded ashore on 28 September 1066, ready to seize the English throne and dramatically alter the course of history.

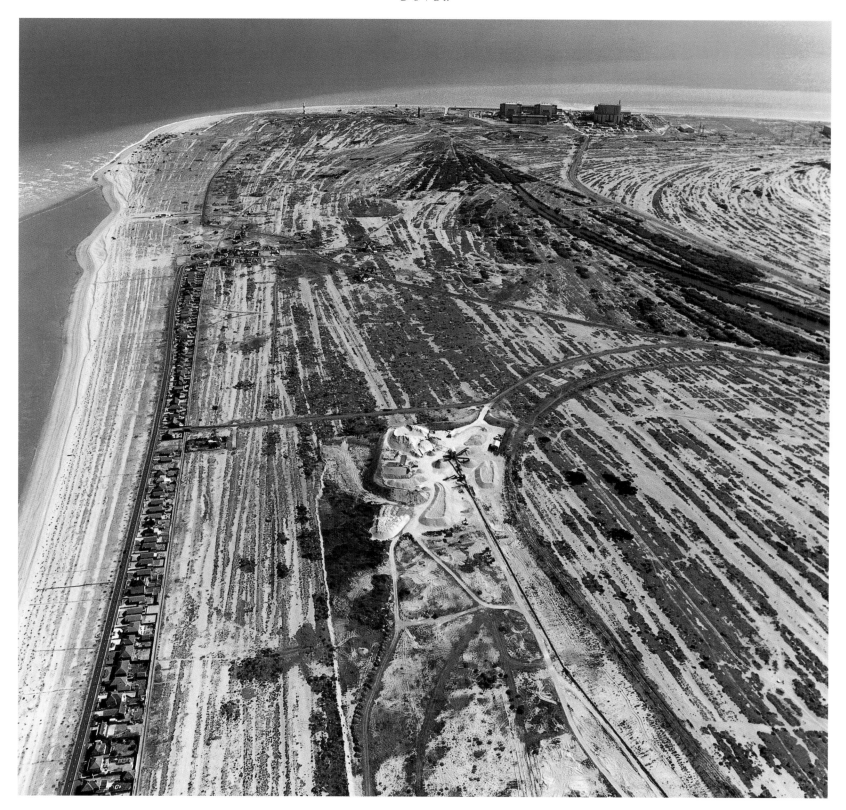

DUNGENESS

The ground here at Dungeness looks as if it has been viciously combed by a giant hand, and in a way that is exactly what has happened. It is the fierce winds that whip around this promontory that create the curious striped effect and ensure that only the hardiest of plants can survive such an inhospitable climate. Yet sharp-eyed observers have been known to see dolphins sporting in the sea, drawn here by the warm currents of water spewed out daily by the Dungeness 'A' and 'B' power stations. The beaches are not safe for human bathers, however, because the currents are so strong and swift.

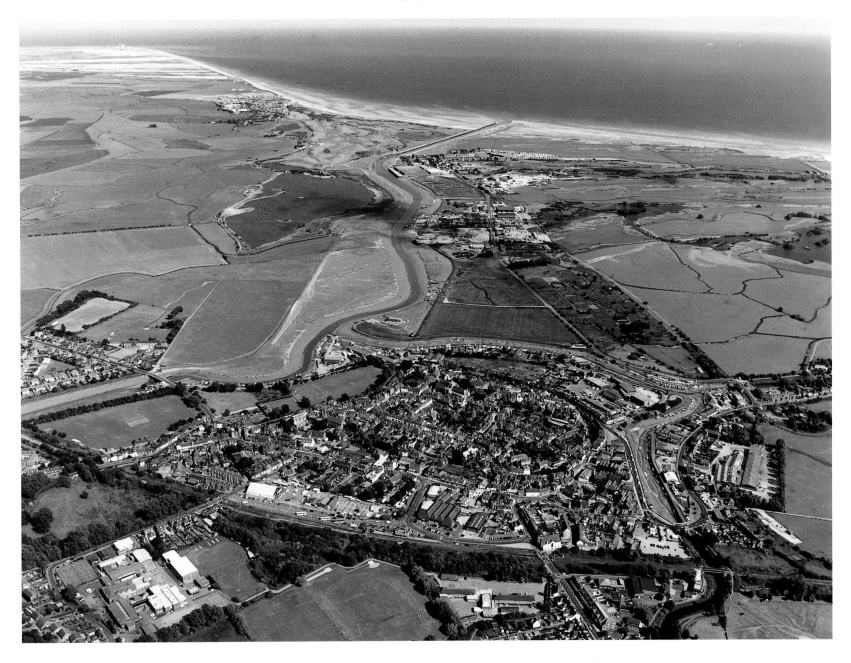

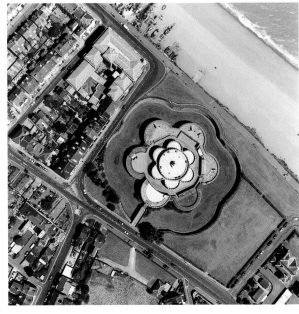

RYE

Although it is now more than 2 miles away from the coast, the delightful, medieval town of Rye (*above*) was once lapped by the sea. The waters have now retreated, but in its time Rye was one of the leading ports of the south coast and had the honour of supplying fish for the royal table. Less honourable were the notorious Hawkhurst gang. These eighteenth-century smugglers enjoyed the comforts of the famous Mermaid Inn, and would sit with their pistols loaded and left in full view of other customers to deter any impertinent enquiries.

DEAL CASTLE

Shaped like a Tudor rose, Deal Castle (*right*) was built of Caen stone by Henry VIII in 1540 as a defence against the Catholic threat of France and the Holy Roman Empire (caused by Henry's conversion to Protestantism and the introduction of the Church of England). The castle had 145 cannons and the shape of the castle ensured that the weapons were given as much protective cover as possible. The castle was built here because it directly faces a safe anchorage, known as The Downs, where whole fleets could shelter from storms. Many ships anchored in The Downs, awaiting favourable weather before they moved on.

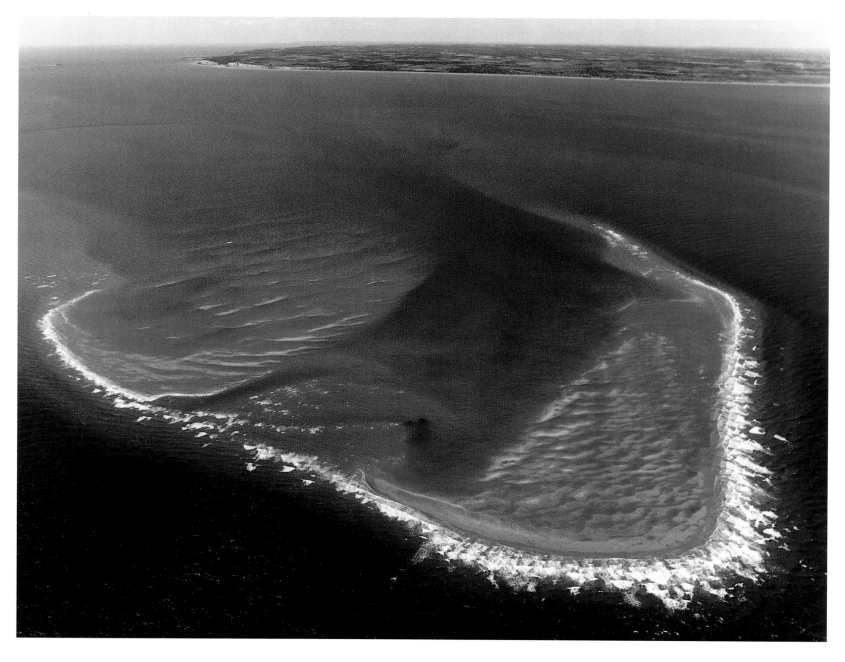

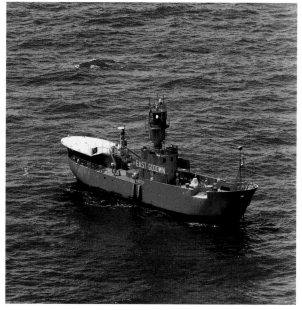

GOODWIN SANDS

They may look beautiful, but the Goodwin Sands (*above and facing page*) are among the most treacherous waters in the world. They consist of a 12-mile long sand-bar, part of which is always submerged. To make matters worse, the sands are never static – they are always being shifted by the tides and are slowly moving in a westerly direction towards the east coast of Britain. No wonder the RNLI maintains a strong presence along the coast here, with lifeboat stations at Margate, Ramsgate, Walmer and Dover. In fact, the Goodwin Sands were the scene of a Gold Medal rescue by the Ramsgate lifeboat, *Bradford*, in January 1881 when the *Indian Chief* merchant ship broke her back on Long Sands during a violent gale. Some of the crew lashed themselves to the masts while the seas raged and the ship disintegrated, killing 16 men in the process. After 26 hours at sea, in terrifying conditions, *Bradford* was able to rescue all the remaining survivors. Lifeboats from far up the coast at Harwich, Clacton and Aldeburgh had also been launched but were unable to help because the seas were so rough. The Goodwin Sands are monitored by three lightships, of which East Goodwin (*left*) is one. This is a dangerous business – in 1954 the South Goodwin lightship lost her moorings during a gale and was wrecked.

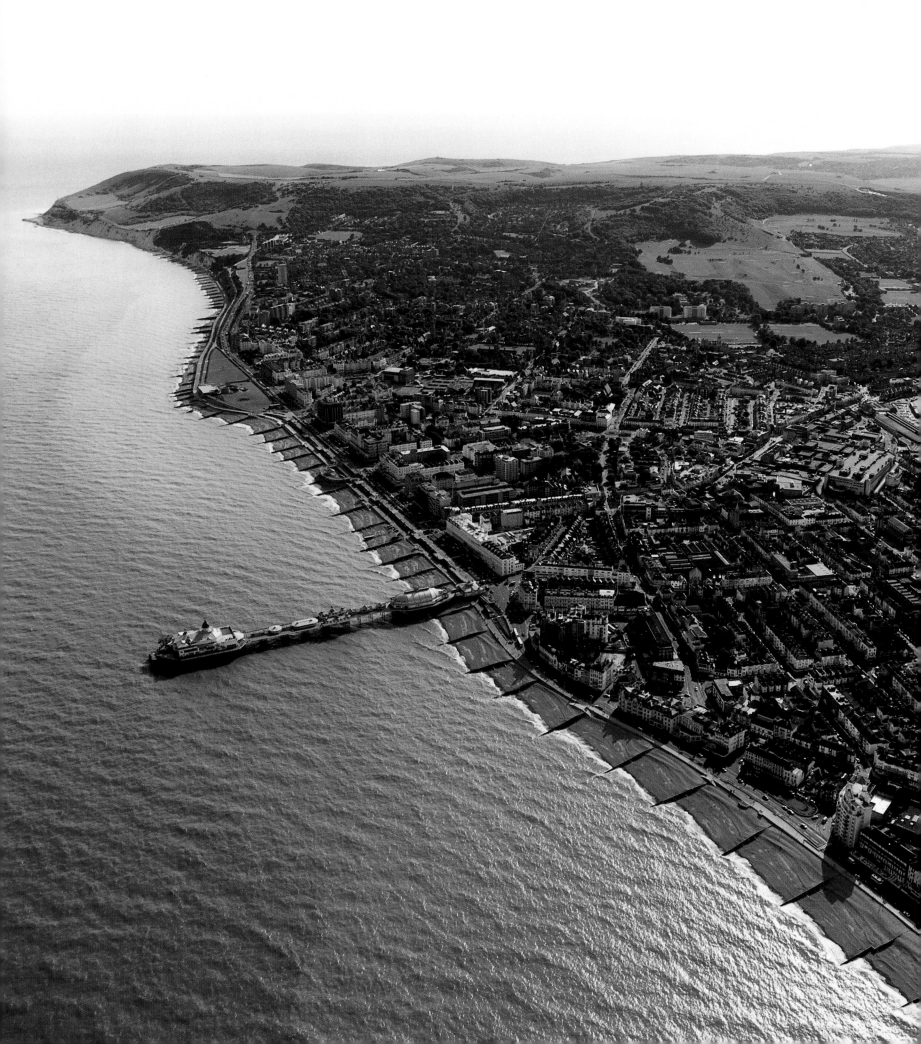

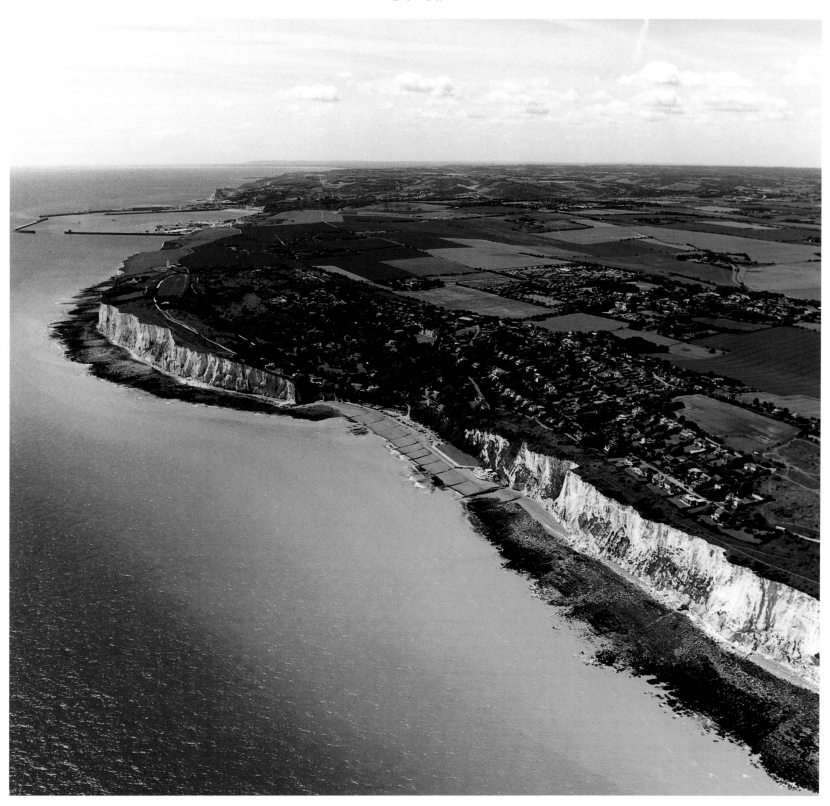

EASTBOURNE

From its humble beginnings as a little village in the part of the town known as Old Town, Eastbourne (*facing page*) has blossomed over the centuries to become one of Britain's most popular seaside resorts, rejoicing in the sobriquet of 'Suntrap of the South' while retaining its dignity. Nearby Brighton and Hastings may both be busy and bustling but Eastbourne has an elegant promenade unsullied by shops – only hotels and houses are allowed. There is plenty for visitors to do, from strolling along the pier and listening to concerts at the Bandstand to visiting the Lifeboat Museum, which was the first one to open in the country in 1937.

ST MARGARET'S BAY

While Eastbourne retains a sophisticated charm, St Margaret's Bay (*above*) was once home to Noel Coward, who for many people epitomized charm and sophistication. This small, sheltered cove, bordered on both sides by chalk cliffs, has the distinction of being the nearest point to France (which only lies 21 miles away) and therefore marks the beginning and end of many cross-Channel swims. The first Briton to swim the Channel from here was Captain Matthew Webb, in 1875. At the top of the cliffs is the village of St Margaret at Cliffe, whose church tower was once used by the local smugglers as storage space.

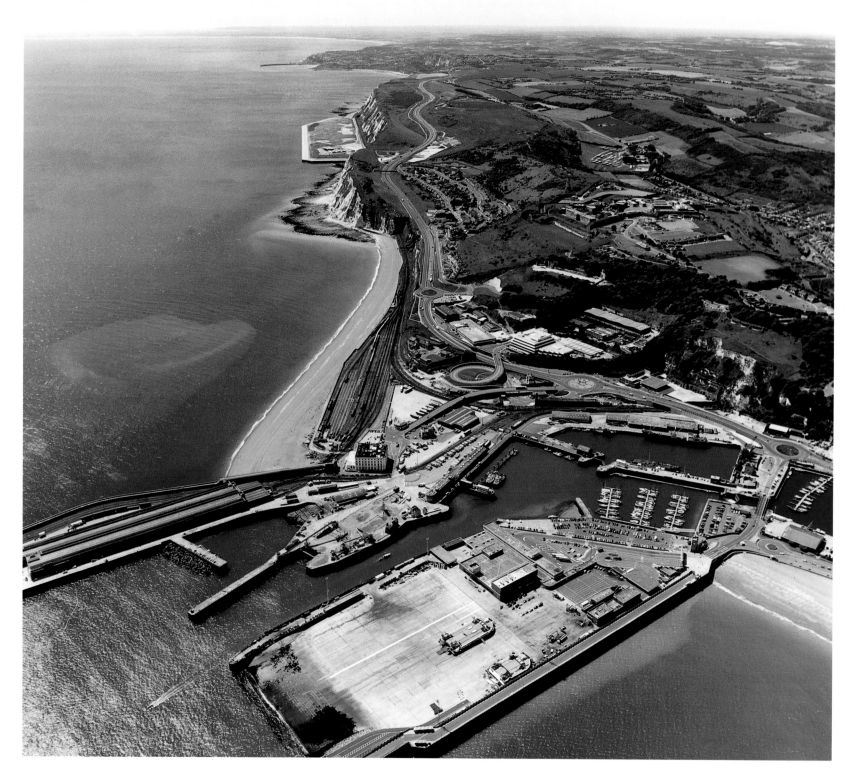

DOVER HARBOUR

This is one of the world's largest artificial harbours, at over 850 acres. It is divided into two areas – the Western Docks and the Eastern Docks – and although the harbour is impressively modern and busy, there are many reminders that Dover has been Britain's chief cross-Channel port for almost 2000 years. The Romans chose Dover for the headquarters of their northern fleet, the Classis Britannica, and their *pharos*, or lighthouse, still stands next to the Saxon church of St Mary-in-Castro. More recently, during the two World Wars, the town was the headquarters of the Dover Patrol, a fleet of fishing trawlers converted into minesweepers which patrolled the Channel.

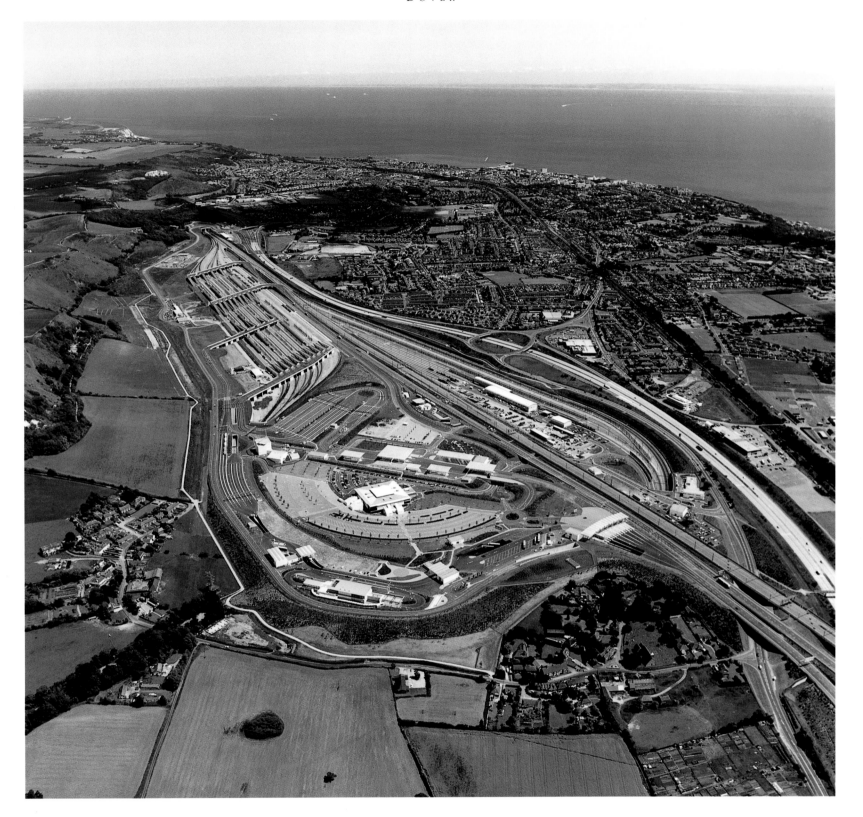

FOLKESTONE

The construction of the Channel Tunnel has cut livid scars in the form of new railway tracks through the landscape of south-east England, as well as stirred up national feeling on a massive scale. Is Britain still technically an island? Yet there is nothing new about the idea of a Channel Tunnel. Flush with the success of their great feats of engineering, the Victorians planned a tunnel and in 1880 began work at Shakespeare Cliff, between Folkestone and Dover, yet nothing came of it. One wonders what they would think of the complex network of railway lines that now enables people to cross the Channel in about 20 minutes.

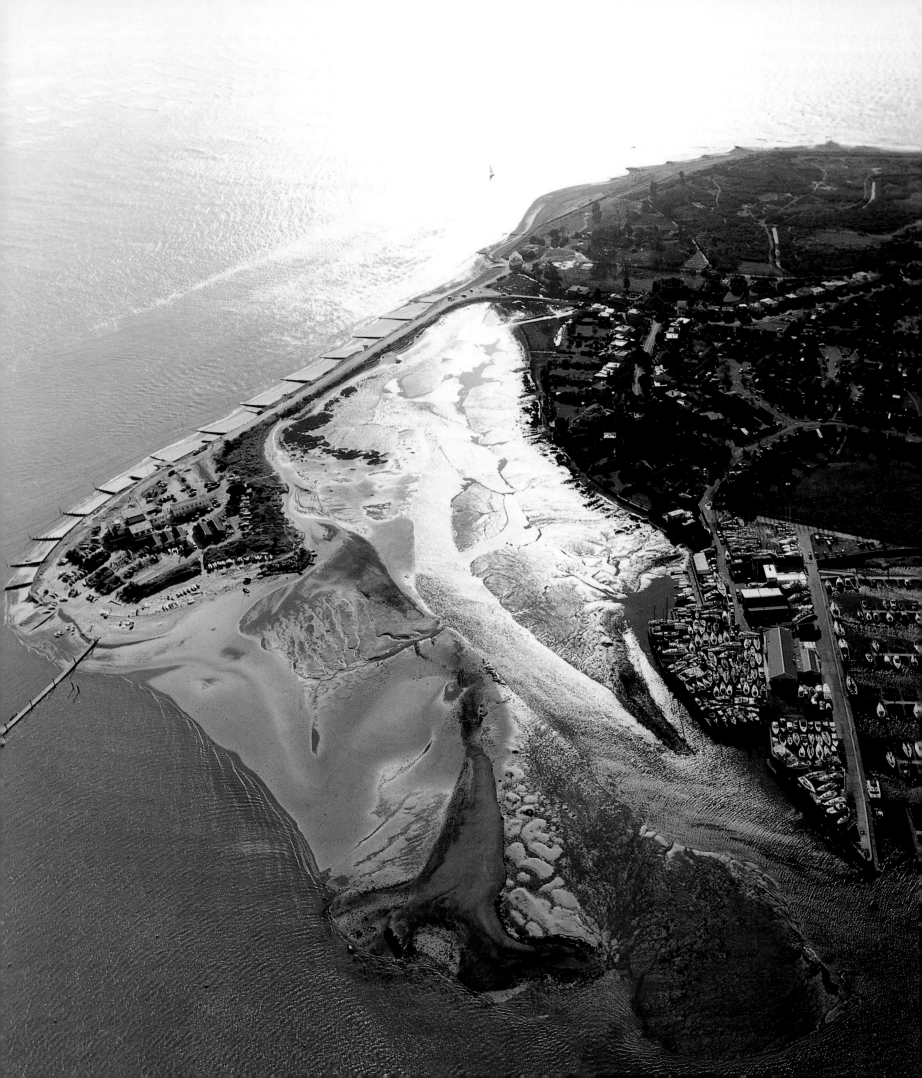

WIGHT

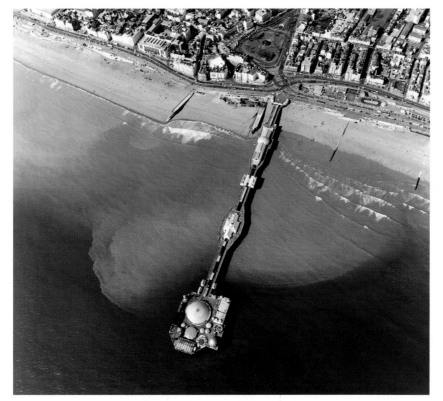

T HE SEA AREA OF WIGHT runs from west of Beachy Head in East Sussex to south of Swanage in Dorset. It covers one of Britain's best known stretches of coastline and several popular seaside resorts, including cheerful Brighton, sedate Worthing, regal Bognor Regis, busy Portsmouth, the various charms of the Isle of Wight and the Victorian splendours of Bournemouth. Although the coastline is famous for its white cliffs, which have often been carved into sharp jagged outlines by the sea, it also has areas of marshland, sand dunes and islets. There are huge, natural harbours at Portsmouth, Southampton and Poole, which is the headquarters of the Royal National Lifeboat Institution. For the RNLI, this is the busiest area of the whole British coastline. Indeed, the English Channel is one of the busiest shipping lanes in the world, in which massive tankers and huge ferries sail past small fishing boats and even more modest pleasure craft. The RNLI stations in the sea area of Wight are at Newhaven, Brighton, Shoreham Harbour (two lifeboats), Littlehampton, Hayling Island, Selsey, Portsmouth and Bembridge (all five of which have two lifeboats each), Yarmouth, Calshot, Lymington, Mudeford, Poole and Swanage (both of which have two lifeboats each).

HAYLING ISLAND

The stretch of coastline that runs between West Wittering in West Sussex and Gosport in Hampshire consists of creeks, islands (including Hayling Island, *facing page*) and peninsulas. The seas here can be treacherous, keeping the local lifeboat station very busy. One such occasion was in October 1992 during a severe gale, when the 28-foot rigid inflatable *Hayling Island* and the lifeboat *Aldershot* were called out to rescue a yacht in trouble in 20-foot high waves. The rescue was so dangerous and involved such a high level of skill and courage that two members of the crew were each awarded the extremely prestigious RNLI Silver Medal.

BRIGHTON

For many people, Brighton (*above*) is the classic seaside resort. It meets all the requirements – a good record for sunshine, a marina, a reputation for seediness and thrills which was enhanced by the novel and film *Brighton Rock*, interesting shops for those days when the weather refuses to co-operate, the fantasia that is Brighton Pavilion, and not one but two piers. Sadly, only one pier is still intact – the Palace Pier, shown here, which was opened in 1899. The West Pier, which was built in 1886, has fallen victim to neglect and some ferocious batterings from the sea.

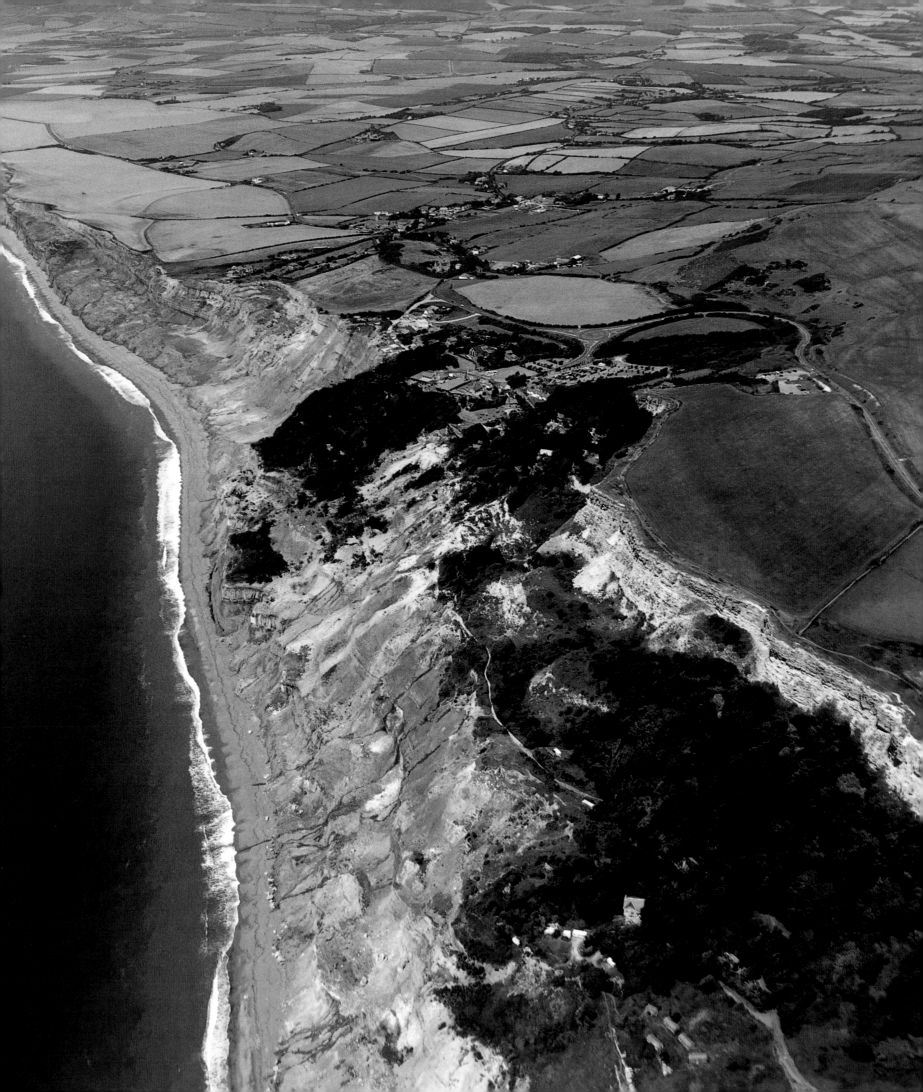

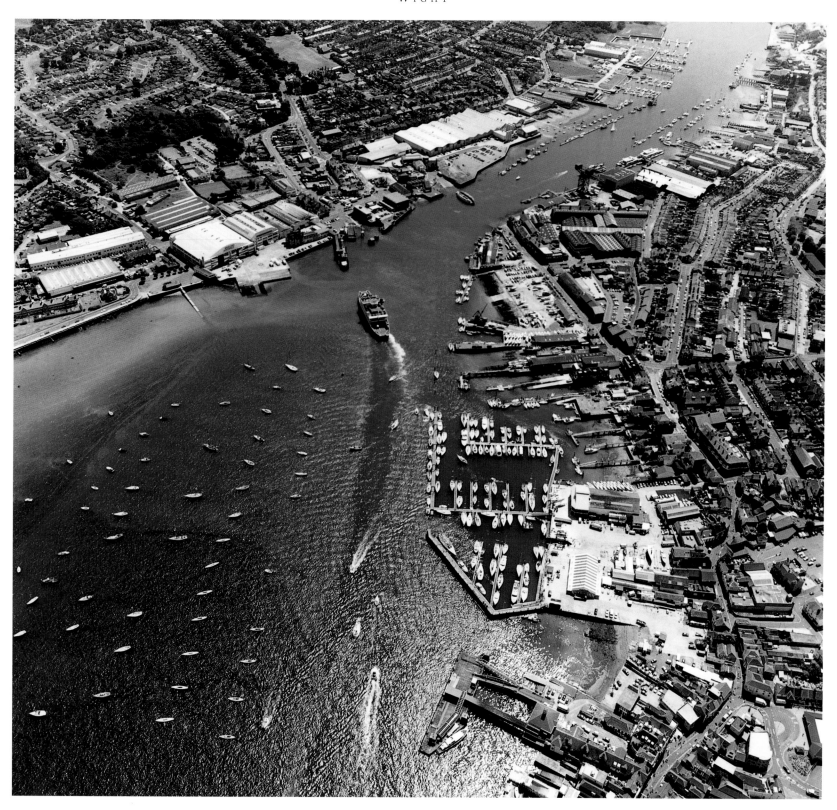

BLACKGANG CHINE

Once the haunt of a notorious gang of smugglers for whom the chine was named, Blackgang Chine ('chine' is a local word for a chasm) on the Isle of Wight (*facing page*) is now better known as the home of a Fantasy Theme Park and also of the Blackgang Sawmill. The clifftops along here offer breathtaking views of the north-west coast of the Isle of Wight, and visitors in a suitably contemplative mood can ponder the fate of the many houses that once stood here and have long since slipped into the sea. The sea has also taken its toll on shipping – since 1750, over 170 ships have come to grief on the rocks here.

COWES

For nine days each August, Cowes (*above*) is home to thousands of sailors and yachting enthusiasts who flock here for Cowes Week. But they do not only come here in August because Cowes is synonymous with yachting at any time of the year, and also with the world's most prestigious yacht club, the Royal Yacht Squadron, which sits proudly at the entrance to Cowes Harbour. The Squadron's building was built by Henry VIII as part of his defences for the Solent. Cowes is the main port of the Isle of Wight, and ferries and hydrofoils run between here and the mainland.

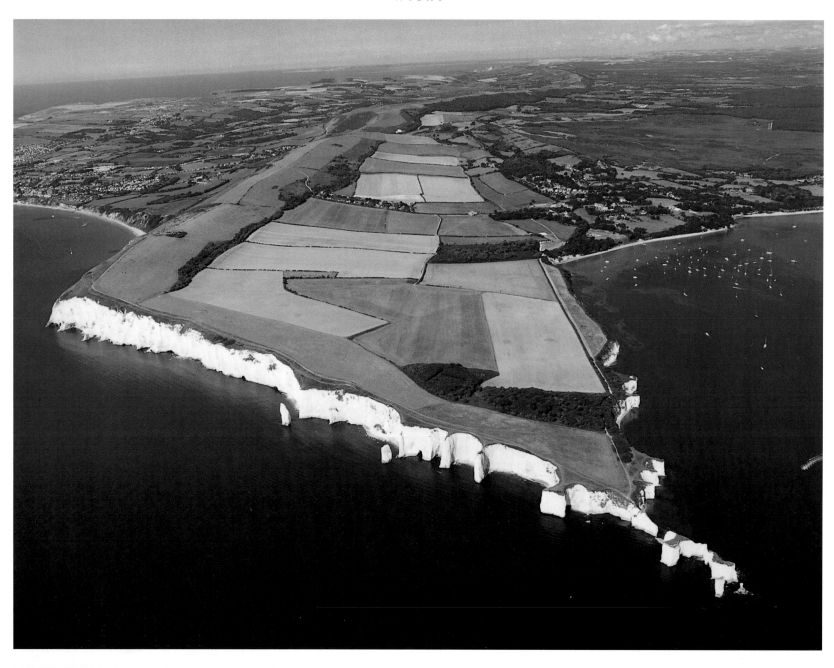

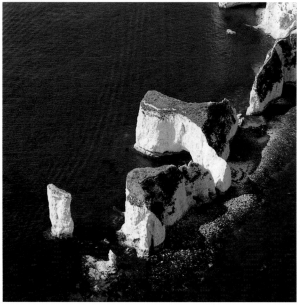

OLD HARRY ROCKS

It looks as if giant mice have nibbled their way through these chalk cliffs in Dorset, in which case they may have been demonic rodents since the rocks take their name from a synonym for the Devil. It is the final two rocks in the chain that are known as Old Harry and his much thinner wife – the rest are simply part of the headland called the Foreland which is shown in such a striking manner in the photograph above. The long sandy bay to the north of the Foreland (to the right in the photograph) is Studland Bay. The Foreland forms part of the busiest stretch of coastline in Britain, with approximately 15 per cent of the RNLI's rescue activities taking place in these waters every year. To the north of Studland Bay is Poole Harbour. Every shape and size of vessel has to squeeze through the narrow entrance to the harbour, and the bigger ones are escorted on their way by the Harbour Authority tugs. Perhaps it is just as well that Poole is the national headquarters of the RNLI. All the administration and back-up services needed to maintain the country's 215 lifeboat stations operate from here.

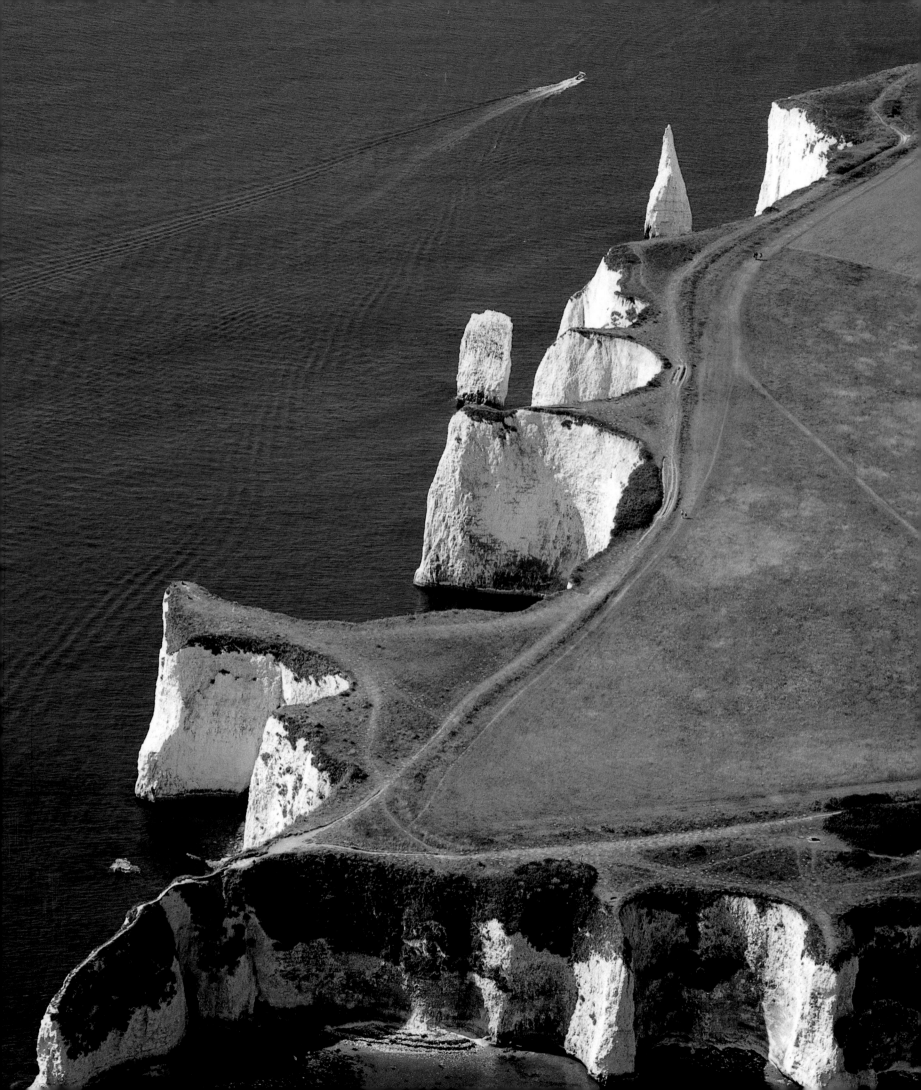

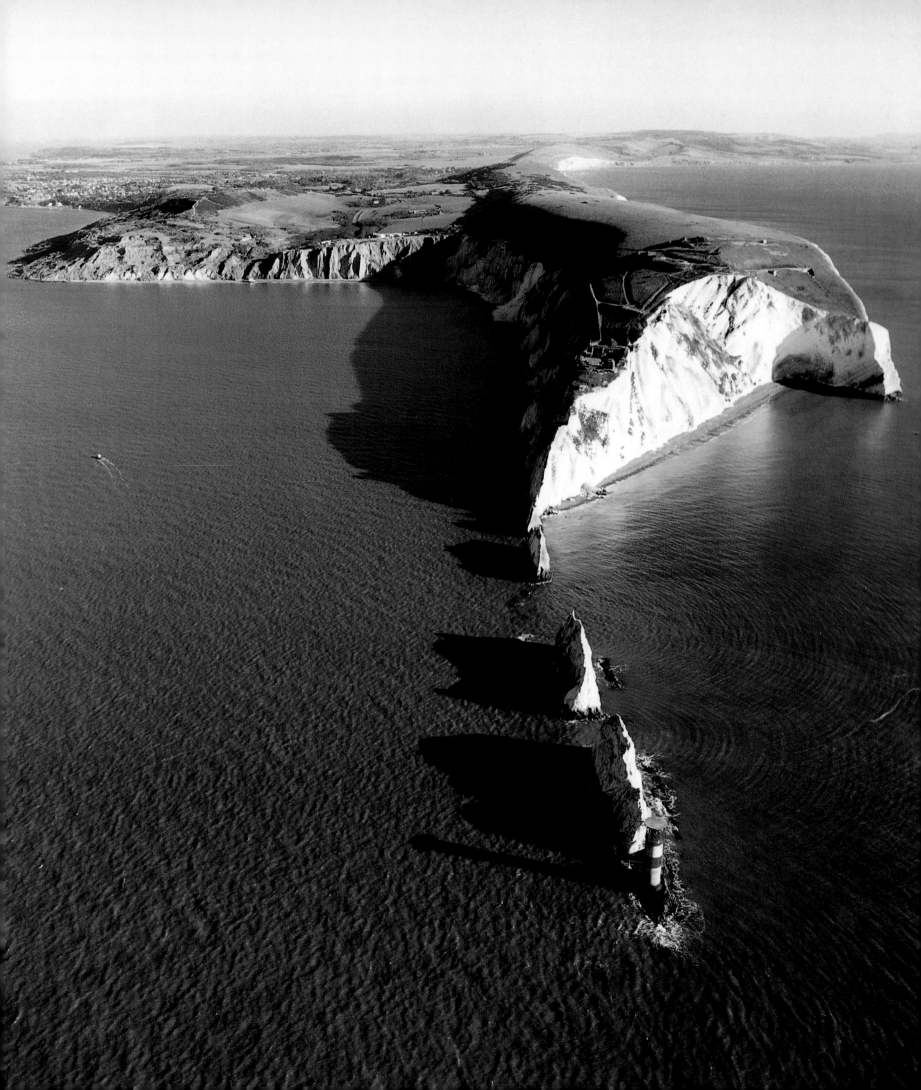

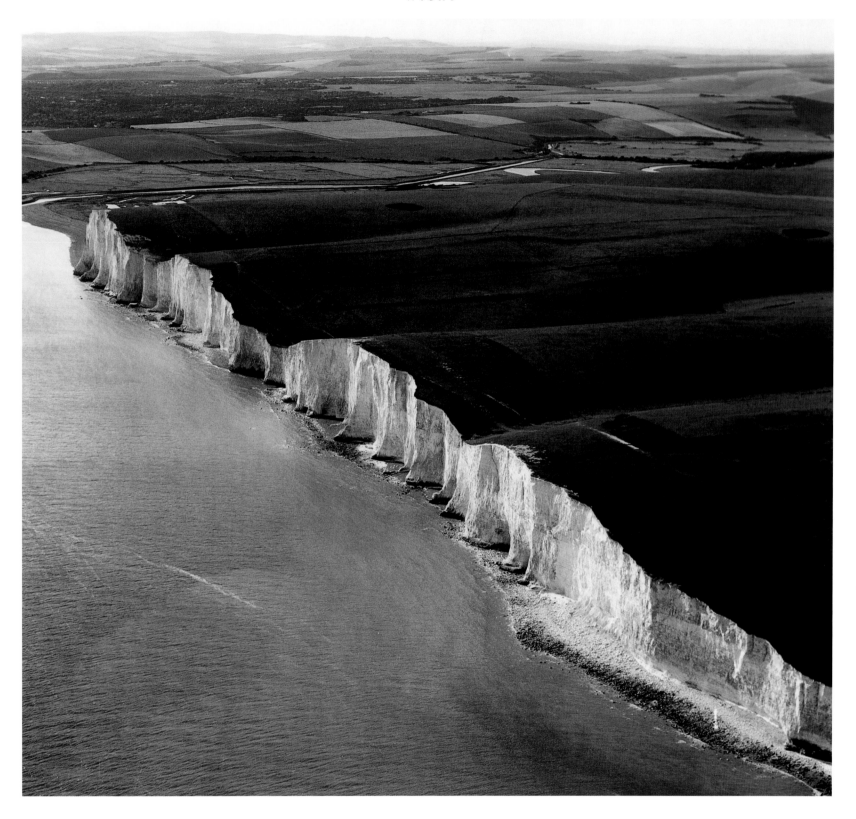

THE NEEDLES

The Needles (*facing page*), those three jagged lumps of chalk that rear out of the water at the westernmost point of the Isle of Wight, are one of the most famous geographical features of Britain's south coast. The lighthouse which stands sentinel in front of them was built in 1859 to replace the original lighthouse on the clifftop. The Needles are part of a thick ridge of chalk, clearly visible in this photograph, which once joined the Isle of Wight to the mainland. Alum Bay, which is shown in shadow in this photograph, is renowned for its multi-coloured cliffs and sands.

THE SEVEN SISTERS

Like the famous white cliffs of Dover further east, the Seven Sisters (*above*) are a sight that stirs the blood of every patriot. They run from Cuckmere Haven, once the haunt of smugglers and the point where the River Cuckmere meanders its way to the sea, to Birling Gap which lies to the west of Beachy Head. Strangely enough, there are eight sisters, not seven – from west to east they are Haven Brow, Short Brow, Rough Brow, Brass Point, Flagstaff Point, Flat Hill, Baily's Hill and Went Hill Brow. Walking along them requires quite a lot of puff in places but the staggering views are more than ample reward.

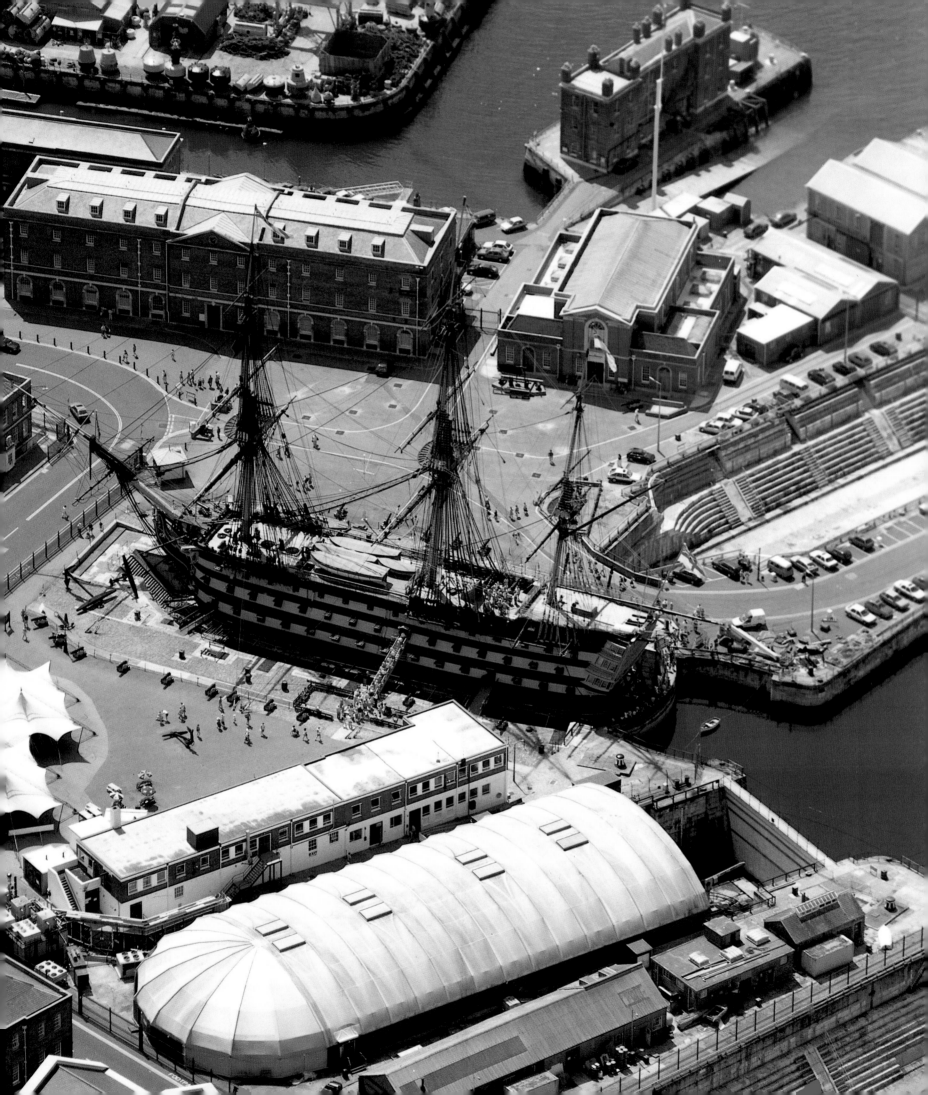

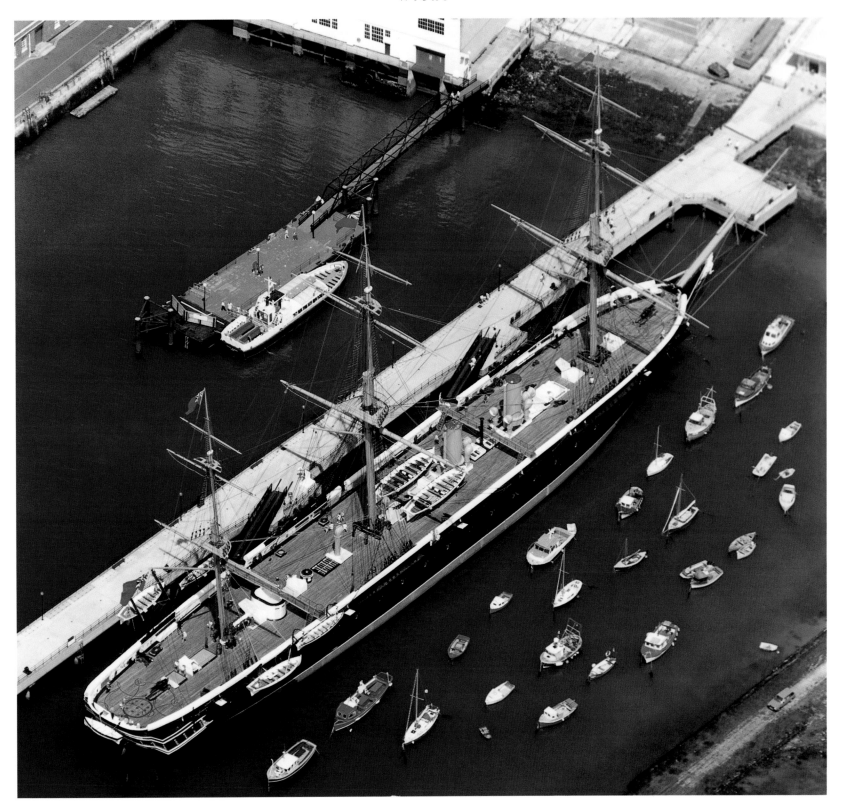

PORTSMOUTH

England's naval history is inextricably linked with Portsmouth. Not only is the town still a working port and harbour, it is also a fascinating naval museum. The most famous ship berthed here is HMS *Victory* (*facing page*), which was launched in 1765, became the flagship of the British fleet and remained afloat until 1921. There is only one event with which she is associated in most people's minds – the Battle of Trafalgar, and the death of her commander, Admiral Lord Nelson, on 21 October 1805. At the time, she was the most effective ship in the world, able to fire a broadside every 80 seconds. For fifty years, HMS *Warrior* (*above*) was a

floating oil jetty off Milford Haven, her upper deck covered in concrete. It was a far cry from her glory days in the 1860s when she had just been launched as the Royal Navy's first iron-hulled warship, and also the largest and fastest warship in the world. The French emperor, Napoleon III, excitingly described her as 'the black snake among the rabbits in the Channel'. Restoration on this splendid ship only began in 1979, much of it based upon a detailed log book kept by an early Midshipman, but today she has regained her dignity and is a magnificent museum of nineteenth-century naval life.

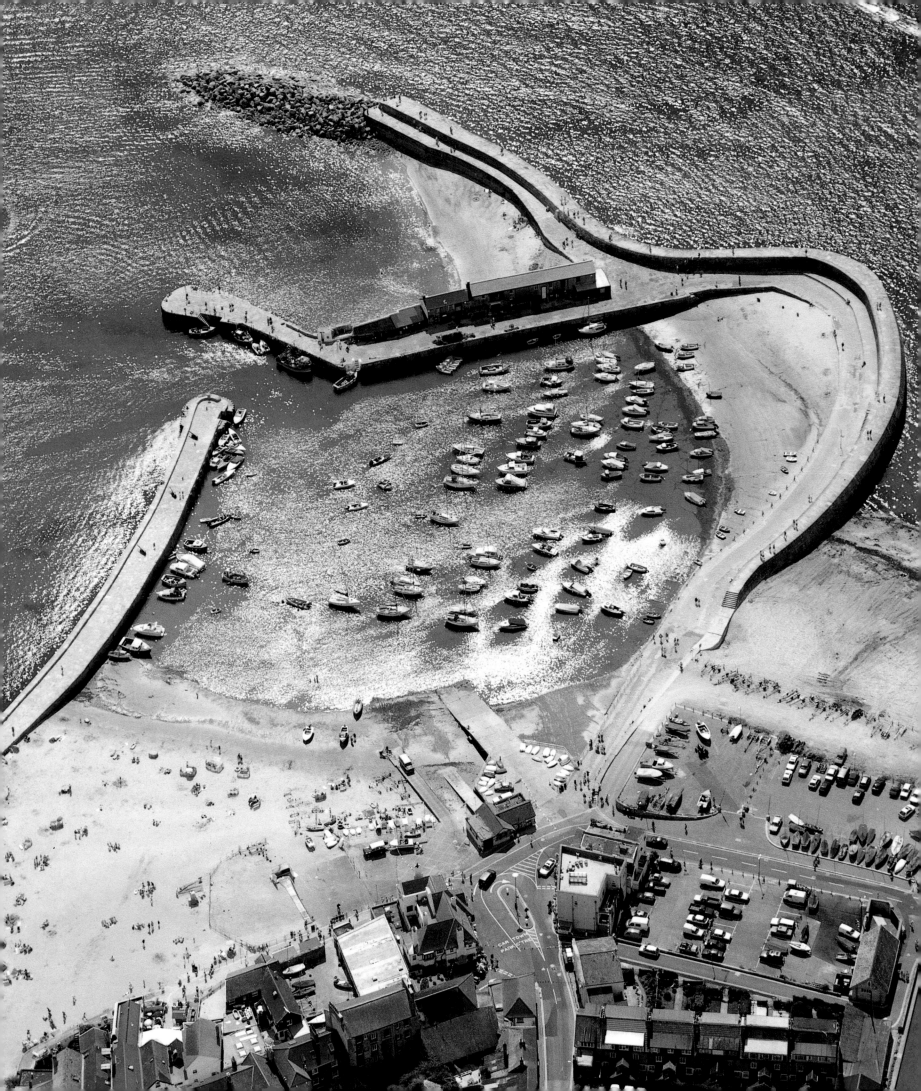

PORTLAND

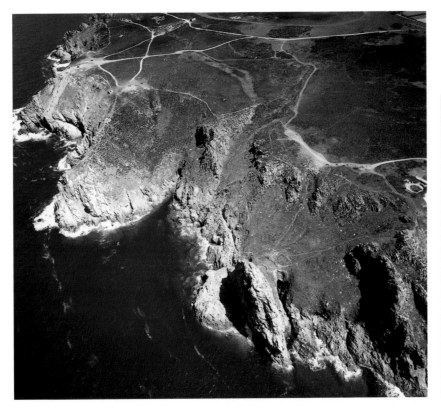

Portland covers the stretch of coastline from south of Swanage in Dorset to near Dawlish in Devon. It is an area rich in attractive and unusual coastal scenery, including the soft sandstone cliffs around Lyme Regis which have been eroded into sweeping bays and jagged promontories, and the extraordinary bank of shingle at Chesil Beach. Portland also has the highest cliff in southern England – Golden Cap, west of Bridport, is 626 feet high. In addition, this area contains two so-called islands – the Isle of Portland, which is a triangular-shaped peninsula joined to the mainland by a thin strip of land at the southern end of Chesil Beach, and the Isle of Purbeck which looks like a clenched fist jutting out below the huge harbour at Poole – as well as Jersey, Guernsey, Alderney, Herm and Sark, which together make up the Channel Islands. Like its neighbouring sea area of Wight, Portland keeps the RNLI busy all year round, and there are RNLI stations at Weymouth (two lifeboats), Lyme Regis and Exmouth. On the Channel Islands, there are lifeboat stations at Alderney, St Peter Port on Guernsey, and St Helier and St Catherine on Jersey.

Lyme Regis

Literary and historical connections abound in this busy harbour (*facing page*). The title of Regis was conferred on the town in 1284, when Edward I granted Lyme a charter and used the harbour as a base during his wars against the French. The ancient, curved arms of the harbour are known as the Cobb and in this photograph they look rather like a human ear. The Cobb provided a memorable part of the setting of John Fowles' novel *The French Lieutenant's Woman*, which was later filmed here. Jane Austen also took inspiration from the town, particularly the scene in *Persuasion* where Louisa Musgrove falls down the steps of the Cobb.

Grosnez

This north-western tip of Jersey, one of the Channel Islands, affords spectacular views of the surrounding headland and an almost panoramic seascape. The curious name of this headland, Grosnez ('big nose'), is a reminder of the very strong French influence that pervades all five of the Channel Islands. They have never been owned by France, despite the short distance of 14 miles that separates them from the French mainland. They are all popular tourist attractions, each with its own character. Jersey and Guernsey are the busiest, while the other three islands – Herm, Sark and Alderney – all seem to belong to a bygone, more sedate, age.

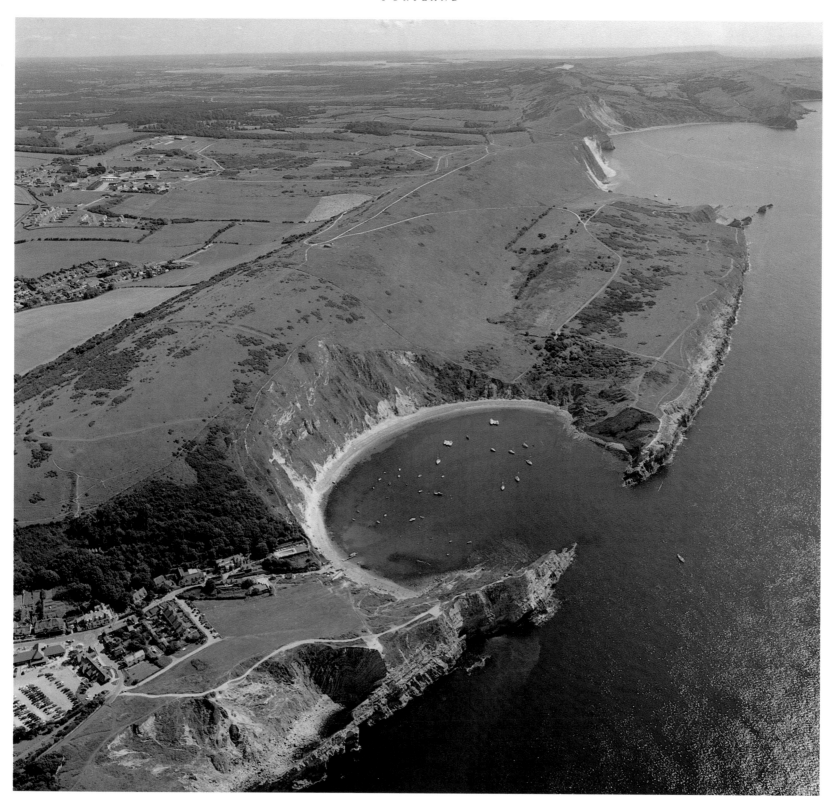

LULWORTH COVE

Like Durdle Door which is shown on the facing page, Lulworth Cove (*above*) is a classic example of how the sea can wear away the shore's defences until it eventually sculpts geographic features that are truly beautiful. On the clifftop to the east of the cove, however, is something far less attractive and welcoming – over 7000 acres of Lulworth Range, owned by the Royal Armoured Corps and used as a firing range. It includes the abandoned village of Tyneham, which became a ghost village in 1943 when its residents were forced to depart and make way for the army. They were never able to return.

DURDLE DOOR

Looking like the face of a hammerhead shark, Durdle Door (*facing page*) forms a craggy barrier between two perfectly curved sandy bays. The strange construction, with a rocky arch on the west side, has been carved out by the sea over centuries as it has slowly eroded the softer surrounding rocks until only a ridge of Portland stone was left. A winding set of steps, which are not for the faint-hearted, wind down to the west-facing bay from a pathway that runs along the top of the ridge and looks like the shark's spine. Durdle Door got its name from the Anglo-Saxon word *thirl*, which means 'to pierce'.

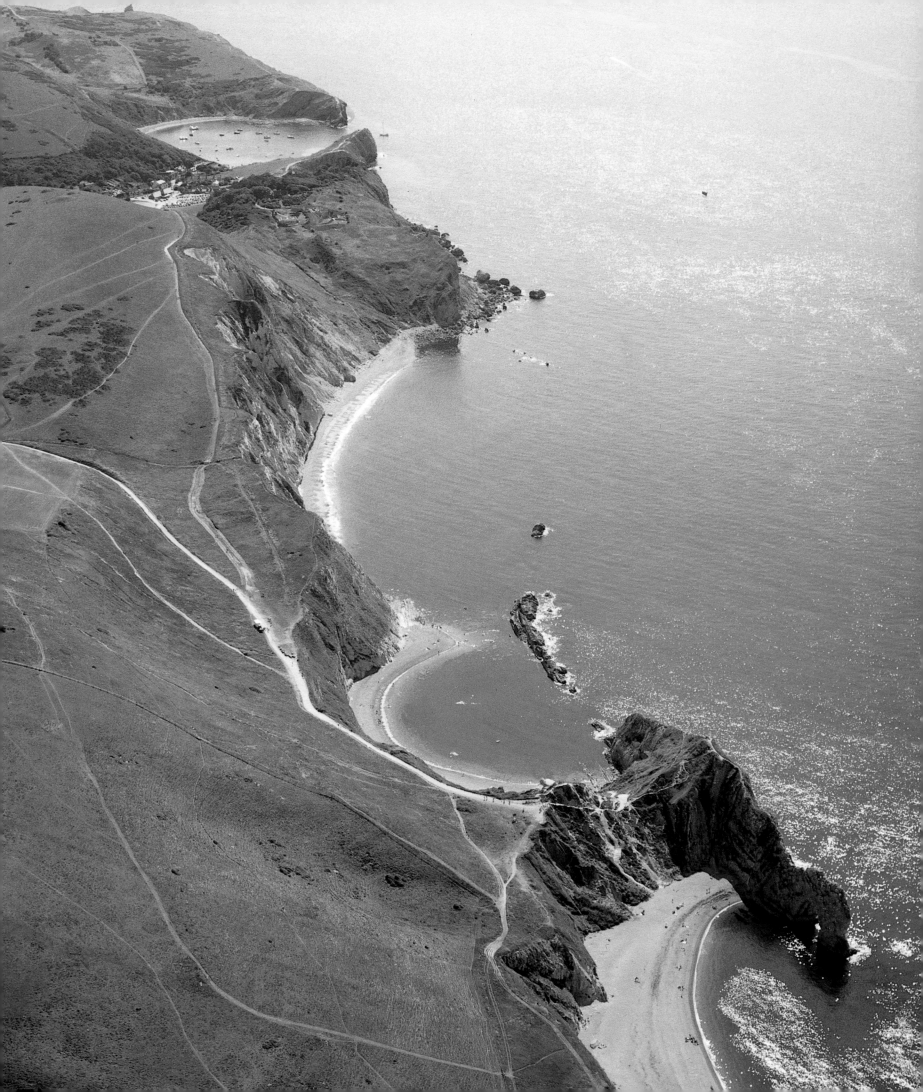

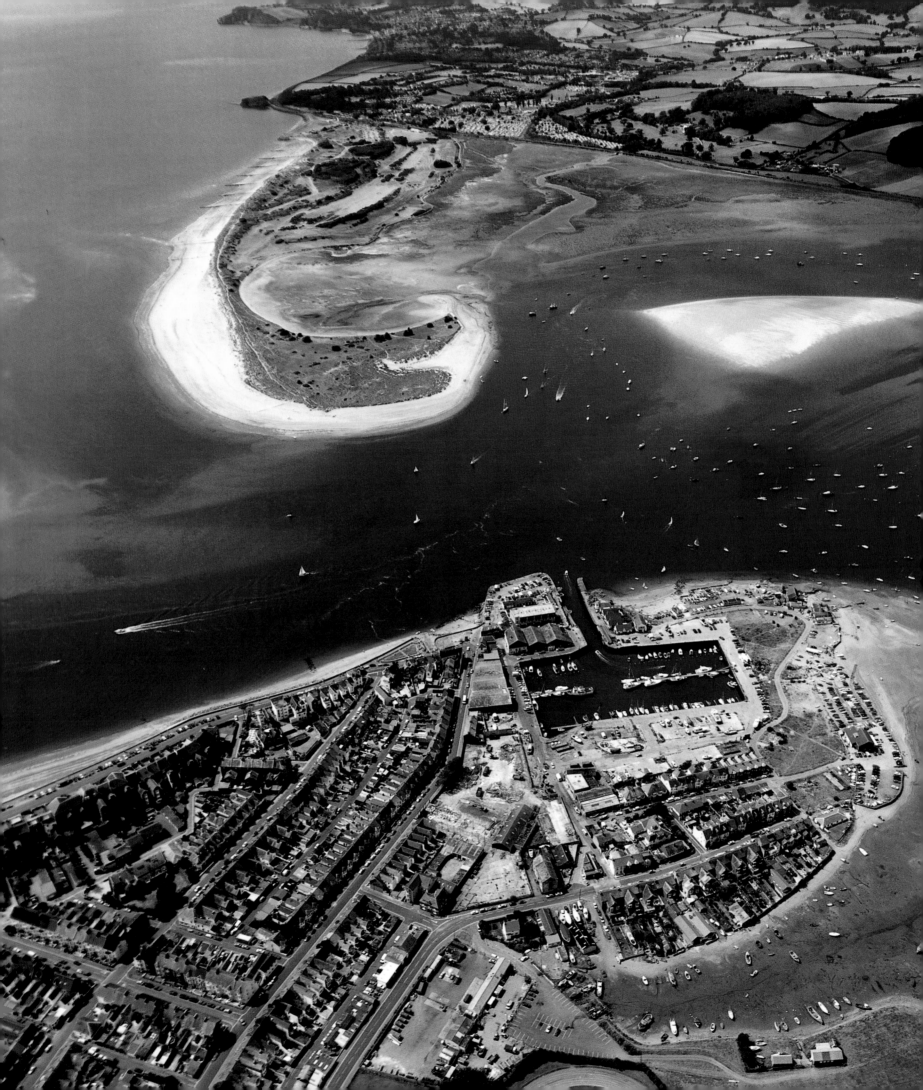

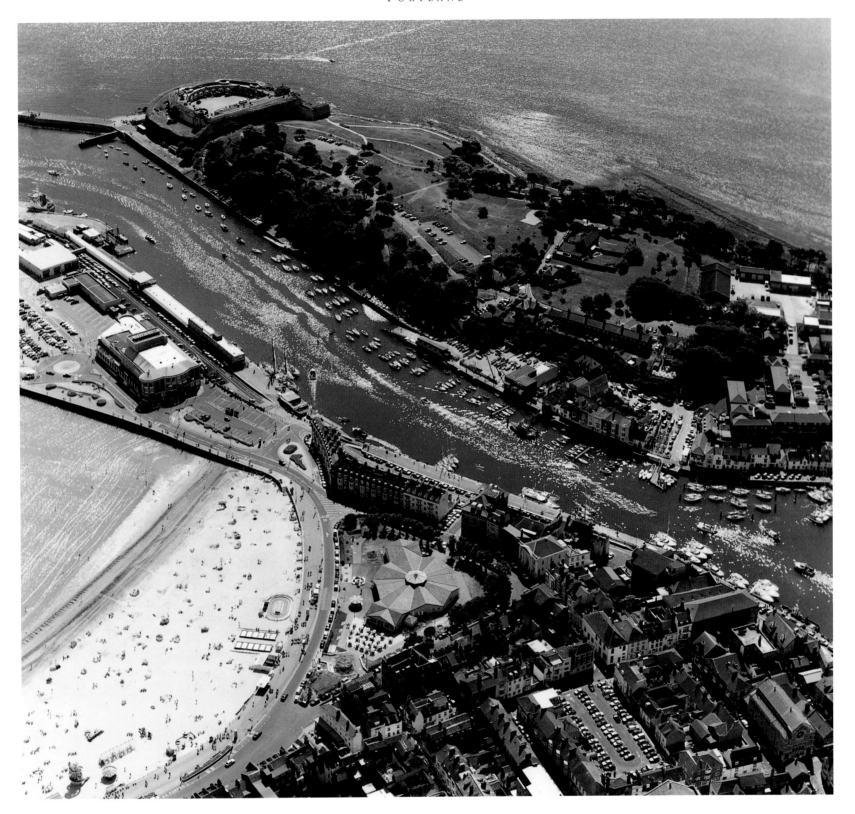

EXMOUTH

The comma of land formed by Dawlish Warren Nature Reserve marks the wide mouth of the River Exe and what was once the site of an important Devon port. In the sixteenth century, Exmouth (*facing page*) enjoyed a thriving maritime existence, so it is quite fitting that Sir Walter Raleigh, one of the greatest explorers of his age, should have been born just up the coast at Budleigh Salterton. Swift and powerful currents make bathing unsafe along some parts of Exmouth's coast, but there are plenty of attractions for the holiday-maker as well as some lovely, sandy beaches.

WEYMOUTH

Weymouth (*above*) first became a popular holiday resort when George III paid a visit during his tour of the south coast in 1789. While France was in the maelstrom of the French Revolution, George III was creating a minor revolution of his own by becoming the first monarch to use a new-fangled contraption called a bathing machine. As he immersed himself in the sea, a local band – perhaps fearful of strong currents or freak waves – struck up *God Save the King*. God did His stuff and the King survived the experience and presumably enjoyed it because he kept a summer residence, called Gloucester Lodge, between 1789 and 1805.

CHESIL BEACH

Geology in action, Chesil Beach is one of nature's curiosities. In an ideal world, every schoolchild, grappling with the concept of the world's tides and the effects of erosion, should be taken to Chesil Beach and allowed to explore it for themselves. They may find it difficult to come up with explanations for the 10-mile long strip of shingle that contains pebbles which are automatically graded in size by the sea so the largest ones are found by the Isle of Portland and the smallest ones at the Abbotsbury end, but they can take comfort from the fact that the answer has stumped some of the world's best geologists too. No one knows

how or why this clever pebble-sorting happens, and that helps to maintain the magic of this wonderful, atmospheric place. The lagoon enclosed by Chesil Beach is called the Fleet, and has experienced more than its fair share of tragedy over the centuries. The strip of pebbles is more than 40 feet high in some places, which has spelled destruction for many a ship when caught in the teeth of a night-time gale. In 1824, a terrible gale drove the huge sloop *Ebenezer* into the Fleet and safety, but two other ships, *Carvalho* and *Colville*, were reduced to matchsticks with all hands lost overboard.

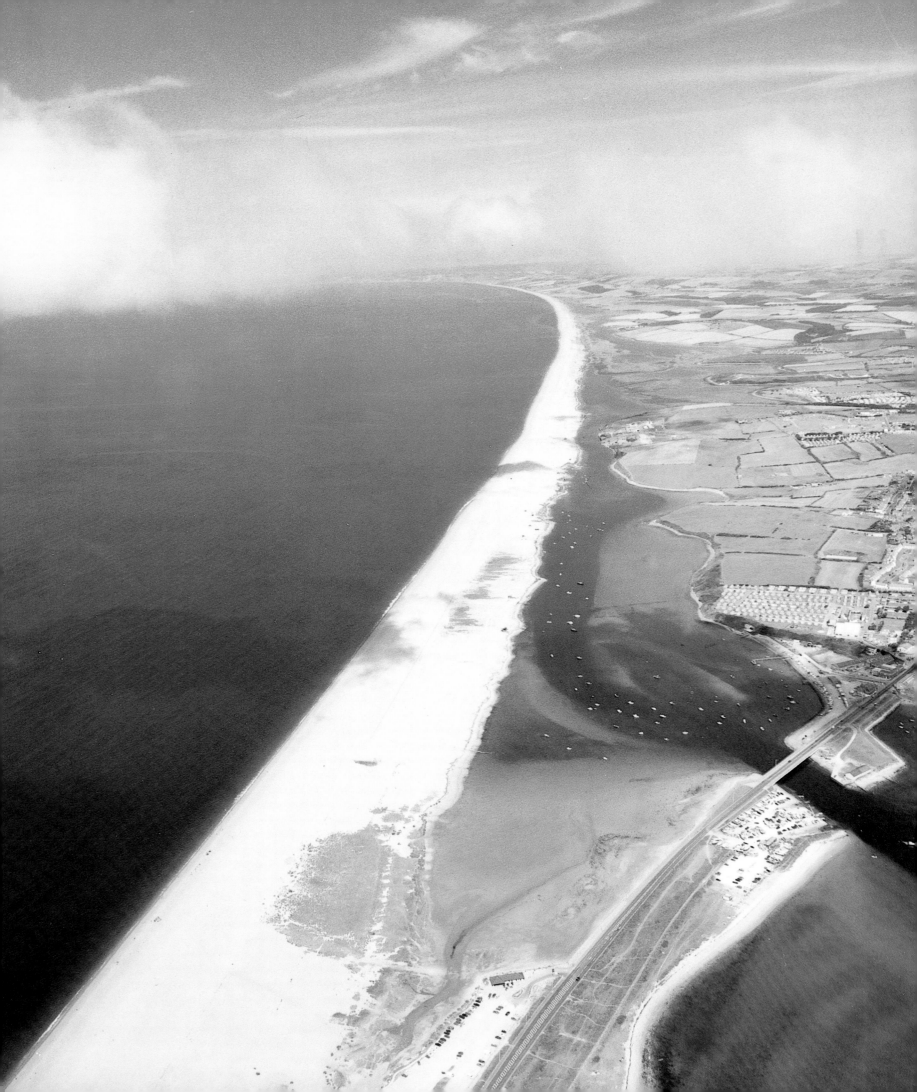

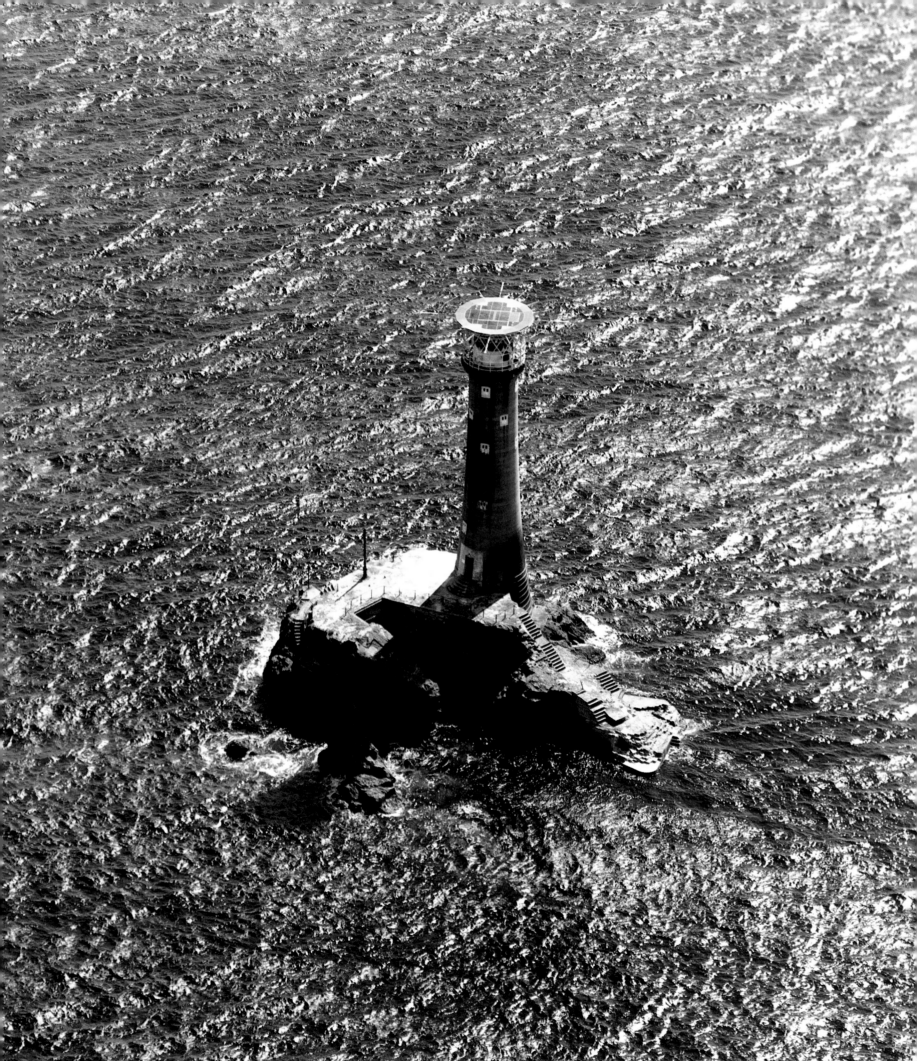

PLYMOUTH

T HE GREAT PORT OF PLYMOUTH has given its name to this sea area, which runs along the south coast of England from near Dawlish in Devon to Land's End in Cornwall. It contains the bustling tourist towns of Torquay, Paignton and Brixham which together make up the area known as Torbay and which attract many visitors each year who are drawn here by the wonderful weather and balmy beaches. There are also many smaller, much loved Cornish villages and towns. The town of Dartmouth has proud seafaring traditions, including the prestigious Britannia Royal Naval College. On 4 June 1944, over 400 boats sailed from Dartmouth to take part in the D-Day landings. Plymouth is another town with strong marine associations. It was from here that Sir Francis Drake sailed to fight successfully the Spanish Armada in 1588 and where, in 1620, the Pilgrim Fathers sailed to America in the *Mayflower*. The RNLI stations along here are at Teignmouth, Torbay (which has two lifeboats), Salcombe, Plymouth, Looe, Fowey, Falmouth (two lifeboats), The Lizard, Marazion, Penlee and Sennen Cove (two lifeboats). There is also a lifeboat station at St Mary's on the Isles of Scilly.

LAND'S END

About 1 mile off the south-west tip of Britain stands Longships lighthouse (*facing page*), complete with helicopter pad, built on one of the small reefs that rise up out of the sea here. The original lighthouse was built in nearby Sennen Cove at the end of the eighteenth century and moved to Longships reef block by block. Sennen Cove is also home of the nearest lifeboat station to Land's End, and its crew were involved in a courageous rescue of the fishing boat *Julian Paul* in December 1994. The weather conditions were so atrocious that the Penlee lifeboat was called out. The coxswains of both boats were each awarded the Bronze Medal.

THE LIZARD

The southernmost point of the British mainland, the Lizard (*above*) is a craggy peninsula jutting out into the English Channel. It is composed of a mixture of hard and soft rocks, although its green serpentine rock is most characteristic. Also characteristic of Cornwall is the strange tale of the old man of Cury and the mermaid. Apparently the old man once rescued a mermaid who had been stranded by the sea. To thank him for helping her back into the water, she granted him three wishes. Several years later, so the story goes, she returned to find him and took him back to her watery home.

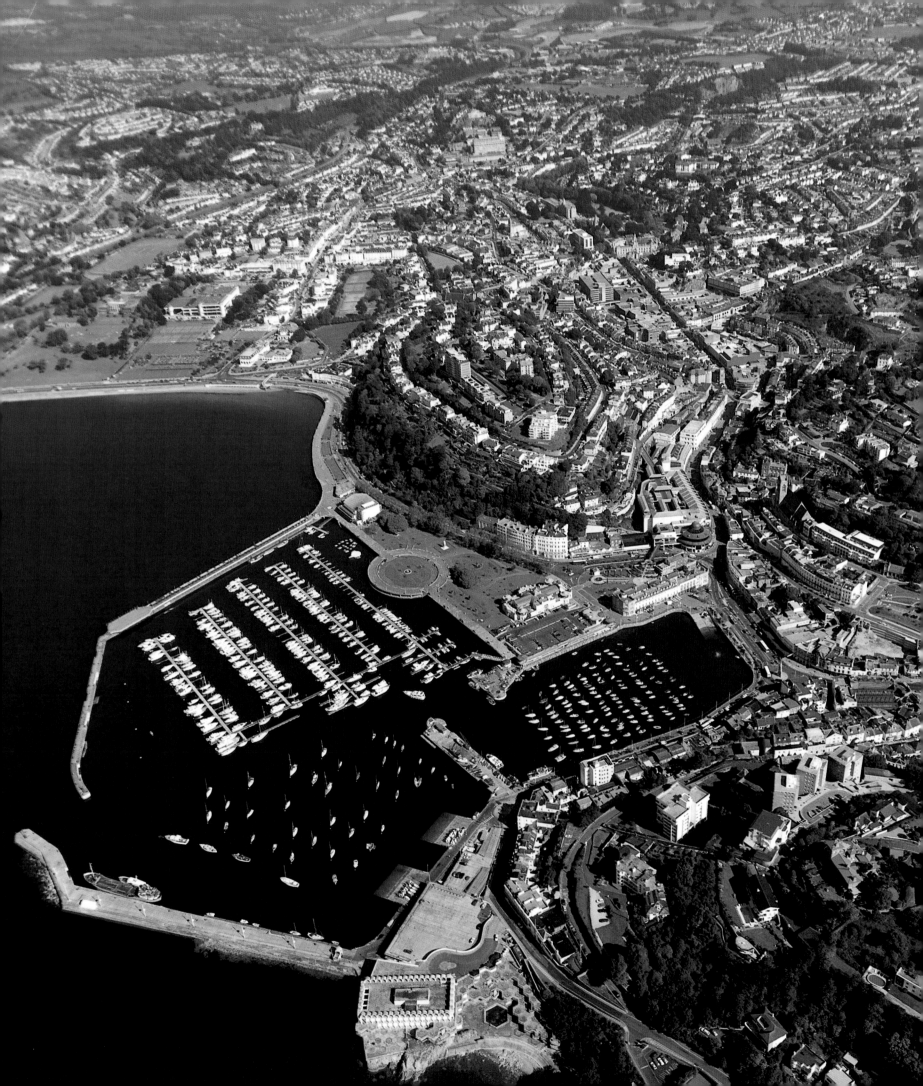

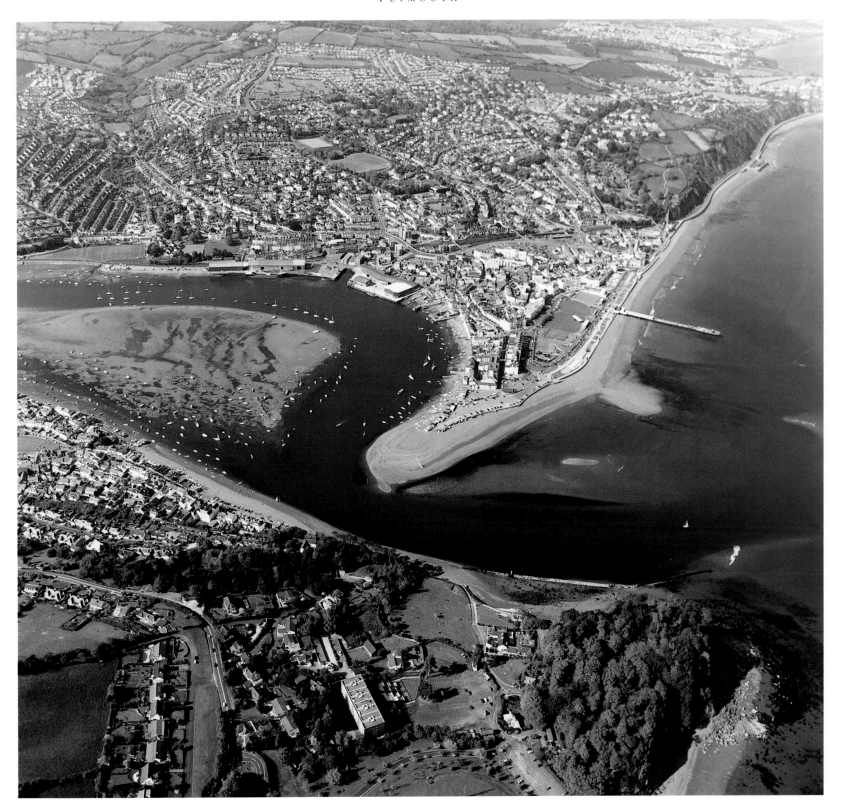

TORQUAY

The bustling town of Torquay (*facing page*) sprawls over the northern headland of Tor Bay and has now melted into neighbouring Paignton. Ferries operate between here and Guernsey and Alderney in the summer, and the harbour teems with yachts and other pleasure craft. In fact, Torquay caters for all sorts of water sports, from sailing and fishing to water-skiing, diving, windsurfing, para-gliding and many more. It is also a good hunting ground for people interested in subtropical plants because Torquay's climate is so mild that palm trees and other lush vegetation flourish here. No wonder it is one of Britain's foremost seaside resorts.

TEIGNMOUTH

The River Teign splits Teignmouth (*above*) into two halves, with the majority of the town situated on the north bank. Despite being a natural port, the town only really developed in the beginning of the nineteenth century but, as the photograph shows, it has grown steadily ever since. John Keats lived here in 1818 while completing his poem *Endymion*, and the novelists Fanny Burney and Jane Austen also visited here. The narrow estuary is home to many pleasure craft, although sailors around these shores need a quick hand on the tiller as the currents are deceptive and fast.

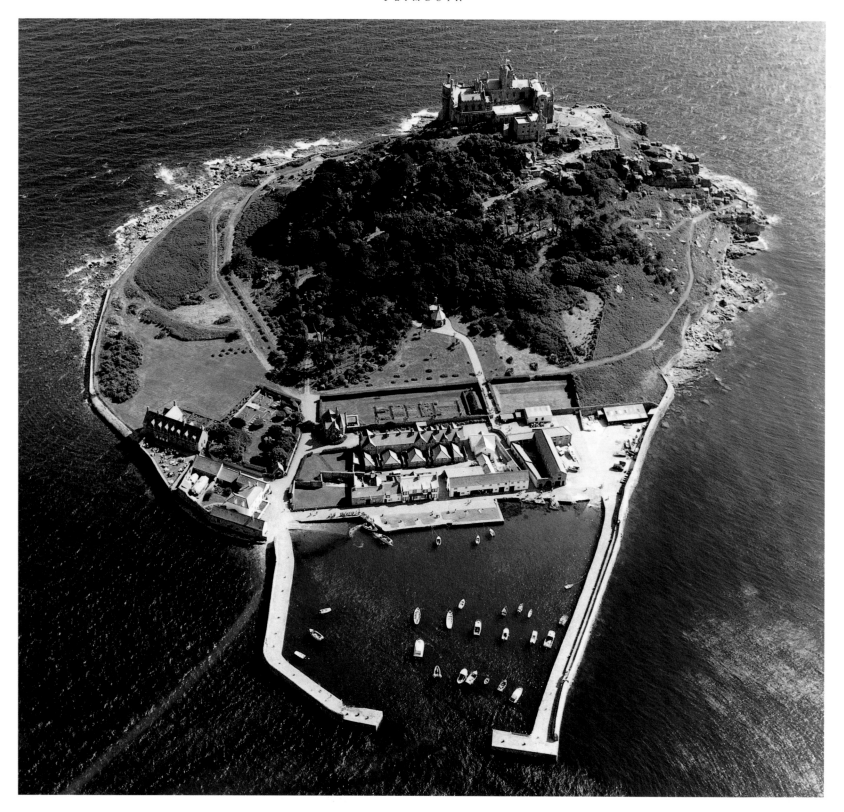

ST MICHAEL'S MOUNT

Not far from the Cornish coast at Marazion, and linked by a causeway at low tide, lies the romantic-looking granite island of St Michael's Mount (*above*) which was once an important Roman trading station. In AD 495, the Archangel, St Michael, apparently materialized to local fishermen here, and it is from him that the island got its name. In 1070 it was given to monks from Mont St Michel in Normandy, and sixty years later the first priory was built on the island. The priory was rebuilt in the fourteenth century, and it is this fortified building which still stands today. The island is now the property of the National Trust.

ST AGNES

The Isles of Scilly comprise over 100 islands and islets, although few of them are inhabited by anything but wildlife. In fact, most of the human inhabitants of the islands live on the largest island of St Mary's. Another of the islands, St Agnes, is shown here, joined by a sand bar to the neighbouring island of Gugh. Other islands include St Martin's, Tresco, Bryher, Samson and St Helen's. Britain's tallest lighthouse stands on Bishop Rock at the south-west tip of the chain of islands, its beam so strong that it is visible from nearly 30 miles away. The lighthouse is vital because reefs and islands make these seas treacherous.

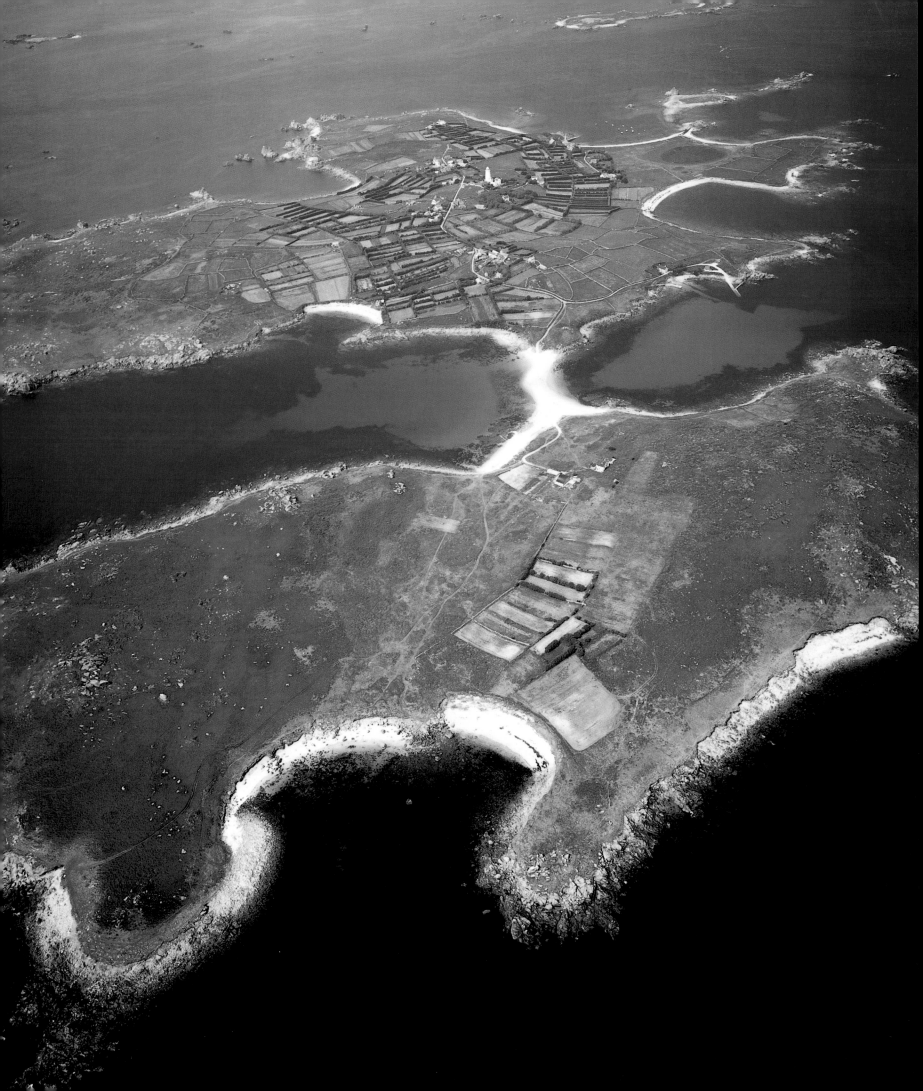

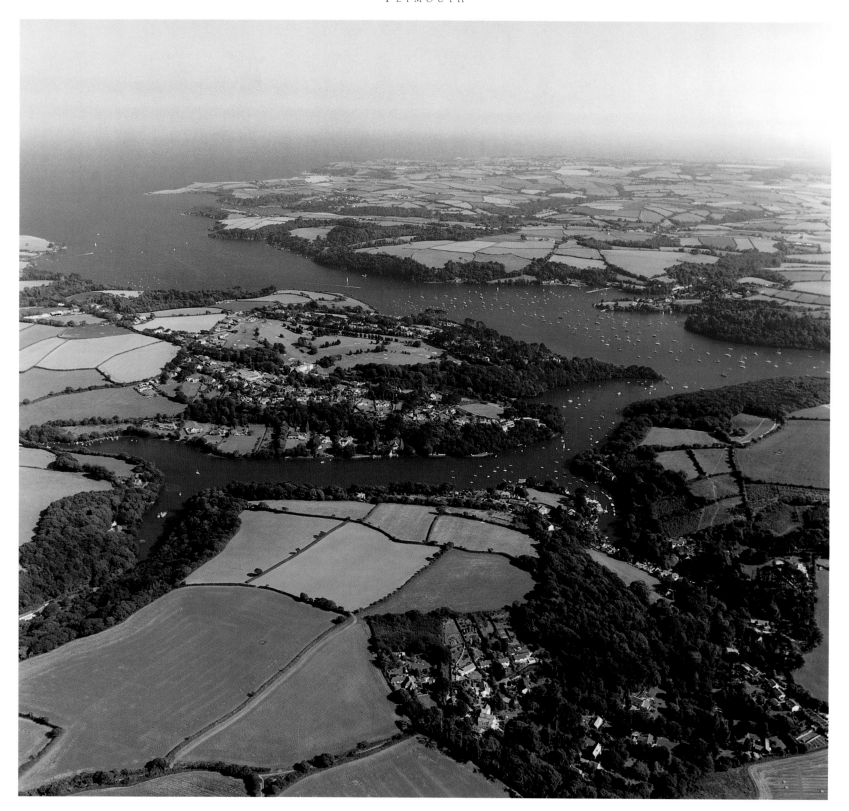

HELFORD RIVER

The wide mouth of the Helford estuary sweeps out into Falmouth Bay, past idyllic creeks, wooded shores and tiny hamlets. It is a haven for yachtsmen, as the photograph shows, and also for walkers searching for tranquil places. One of these can be found at Frenchman's Creek, which was immortalized in Daphne du Maurier's eponymous novel. Another writer associated with this area is Charles Kingsley, who went to school in Helford. The tiny port of Gweek, at the head of the estuary, was once a favourite spot for smugglers who were attracted by its out-of-the-way setting and undeterred by its Customs House.

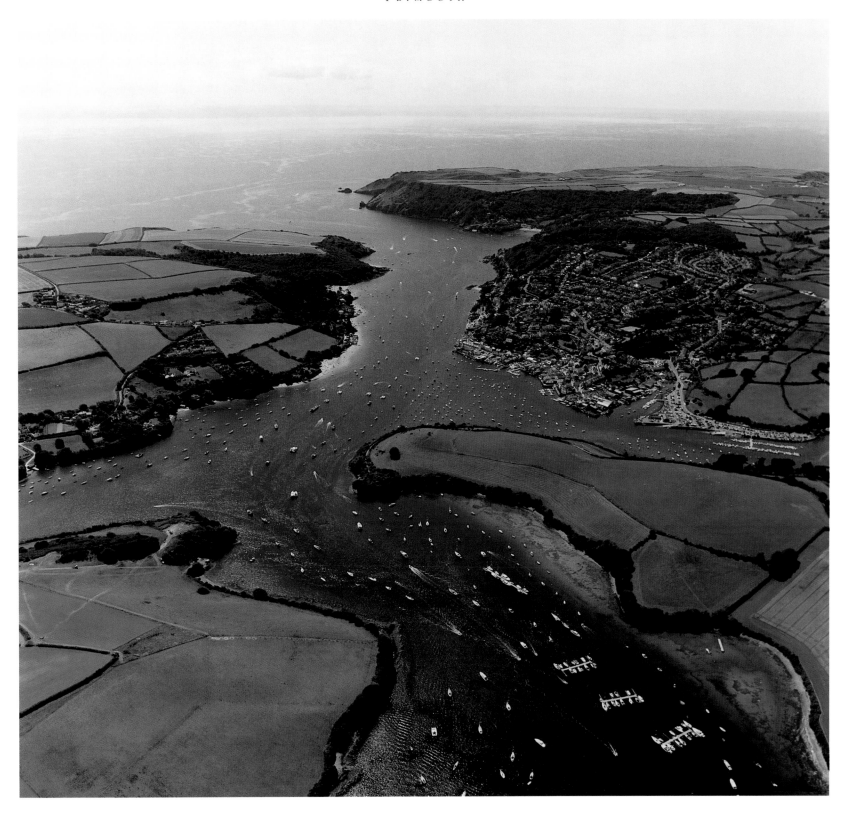

KINGSBRIDGE ESTUARY

Several rivers flow into Kingsbridge Estuary in the South Hams district of Devon. The holiday town of Salcombe (which has the distinction of being Devon's most southerly resort) is shown in this photograph on the right-hand side of the estuary mouth but it is not the only town to lie along this stretch of creek-riven water. Kingsbridge, which was established by charter in the thirteenth century, nestles at the head of the estuary and was once a thriving, inland port. Other very pretty and picturesque settlements also line the estuary, including East Charleston, West Charleston, Frogmore, South Pool and the evocatively named Goodshelter.

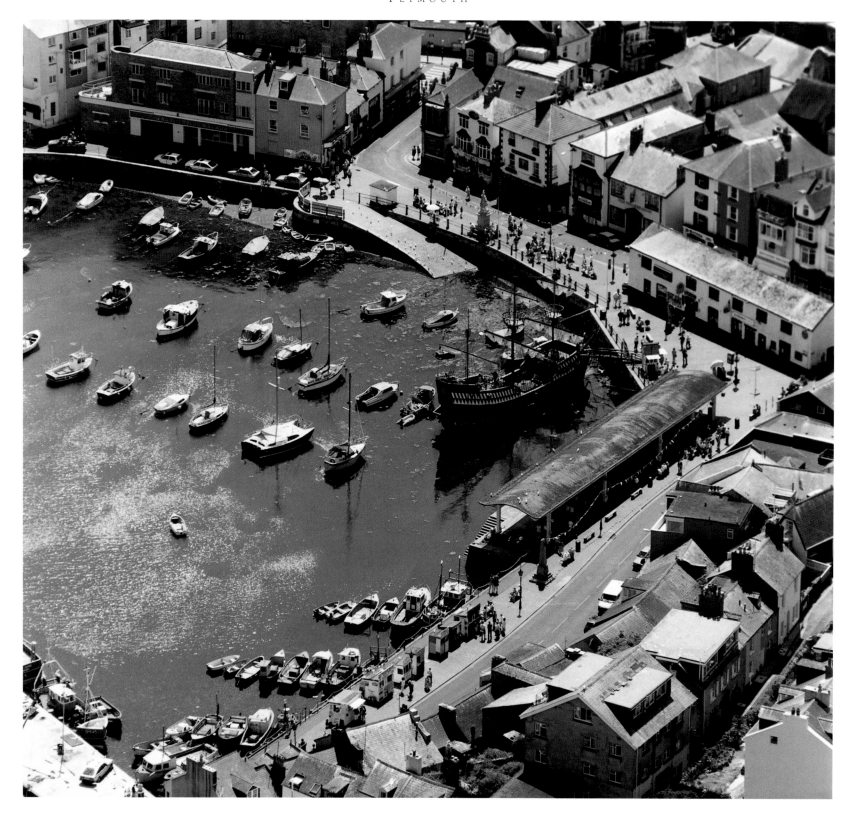

BRIXHAM

In 1850 Brixham (*above*) claimed to be England's most important fishing port, with a fleet of more than 270 ships, but by 1939 the town's fishing industry was in serious trouble. A subsequent revival has been dealt another body blow by recent EC regulations. Brixham now relies heavily on tourism, which shows no signs of drying up. A replica of Sir Francis Drake's ship, the *Golden Hind*, stands proudly in the harbour. Drake sailed in her to the South Seas between 1577 and 1580. Of an original fleet of five ships, the *Golden Hind* was the only one to survive the journey.

FOWEY

With its twisting streets, busy atmosphere and picture-postcard views, Fowey (*facing page*) is one of the most popular resorts in Cornwall. It has been a busy port since the Middle Ages, and the brave, local sailors were known as Fowey Gallants. Although they were kept busy in a succession of medieval campaigns, especially the Siege of Calais in 1346, they also found time to develop a profitable sideline in piracy and smuggling in the English Channel. At times, they even raided the French coast, and at one point their campaign was so successful that French sailors burned the town in retaliation in 1457.

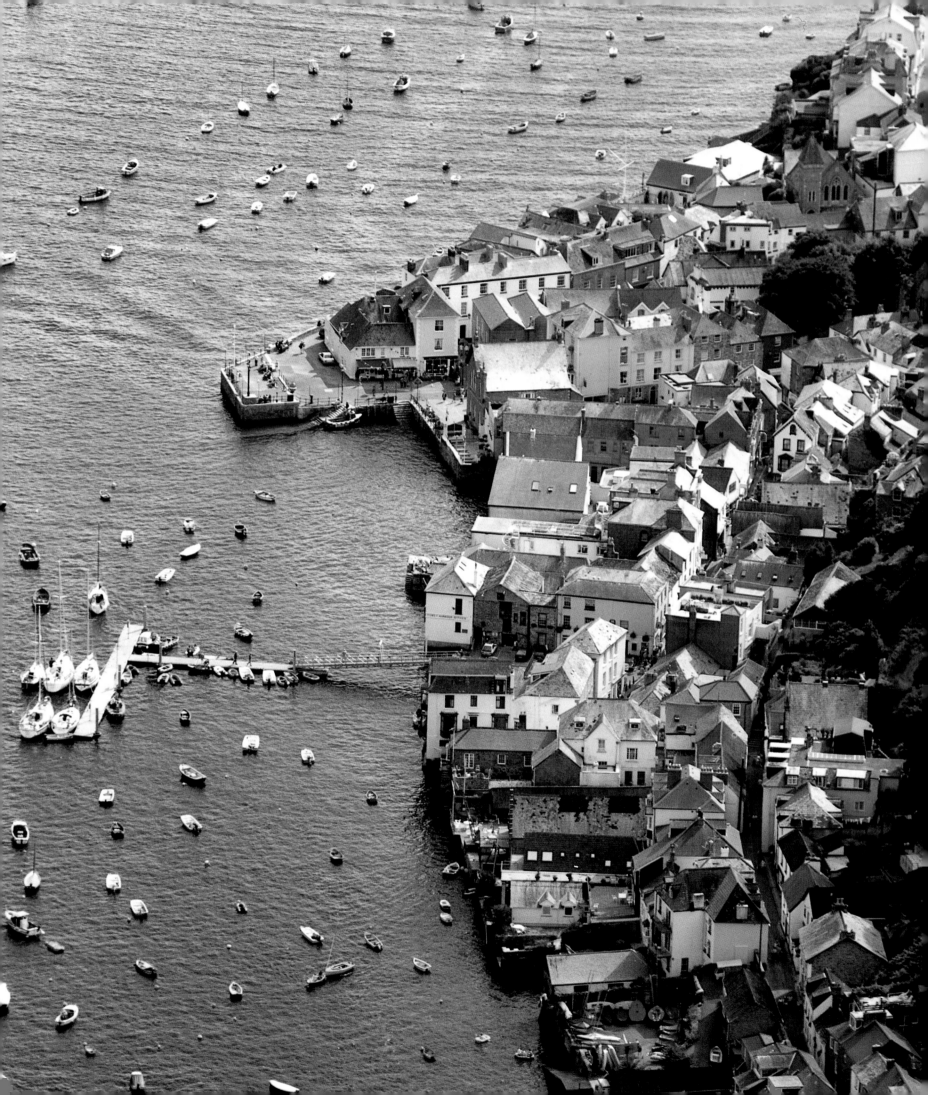

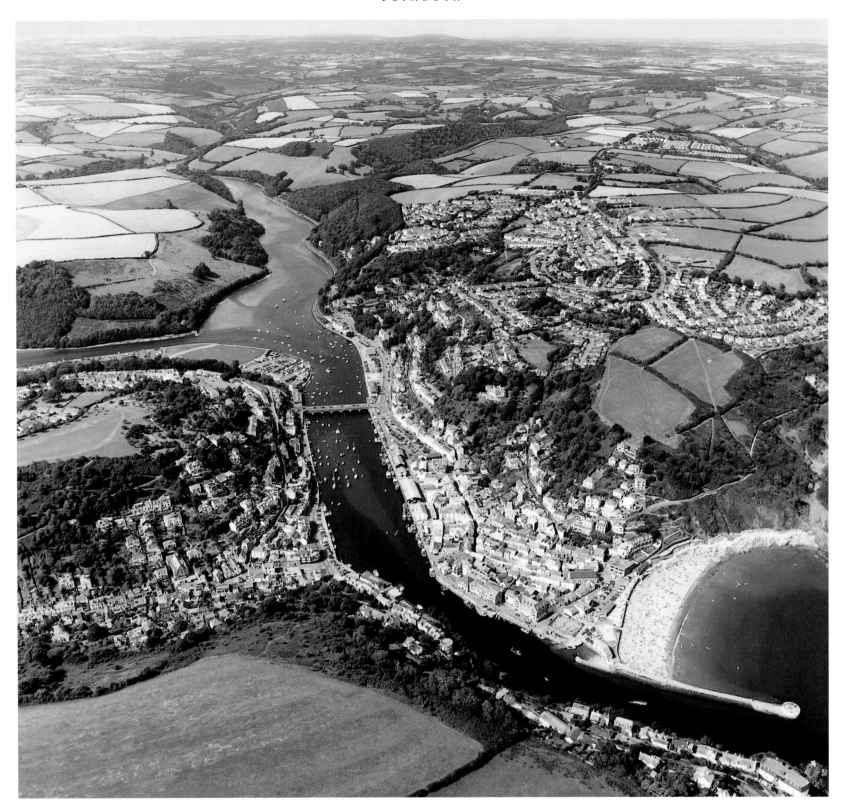

LOOE

Looe is divided into the separate resorts of East and West Looe (named after two rivers of the same name), which are linked by a seven-arched bridge which spans the estuary in which the rivers converge. Until 1832, however, East Looe and West Looe were completely separate towns and each had its own Member of Parliament. In those days, the bridge was the original fifteenth-century one and a small hermitage was sited half-way across it. Today, shark-fishing is big business here. However, bathers need not worry about replaying gory scenes from *Jaws* on the beach as the sharks do not swim close to the shore.

PORTHCURNO

Porthcurno is the home of what must be one of the most atmospheric theatres in Britain – the Minack Theatre. Sitting here, perched on top of the cliff, watching a play being performed while the sea pounds away at the rocks below is an unforgettable experience. This open-air theatre was started in 1932 and it has been going strong ever since. Other attractions in the area include the huge Logan Rock – all 60 or so tons of it – which wobbles precariously when given a hefty shove. To the west of Porthcurno is the pretty seaside village of Porthgwarra and, if you continue around the headland, Land's End.

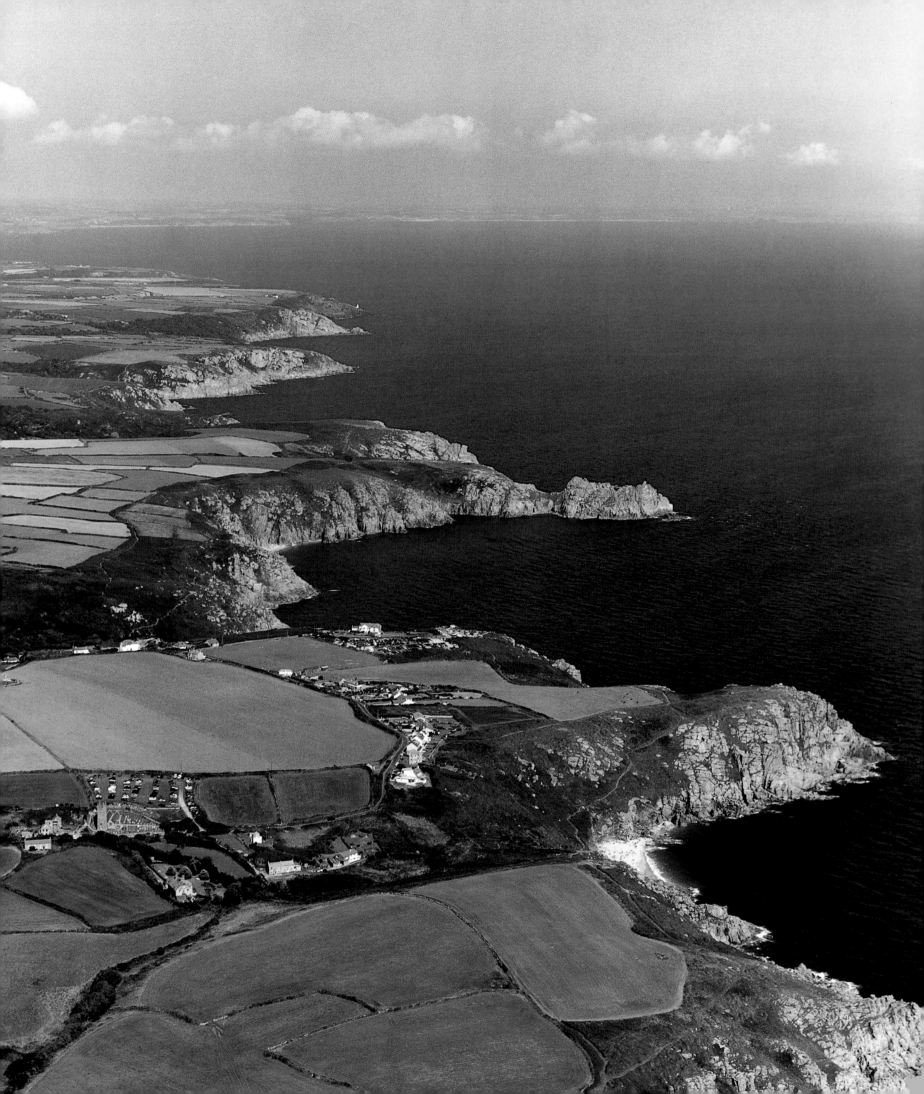

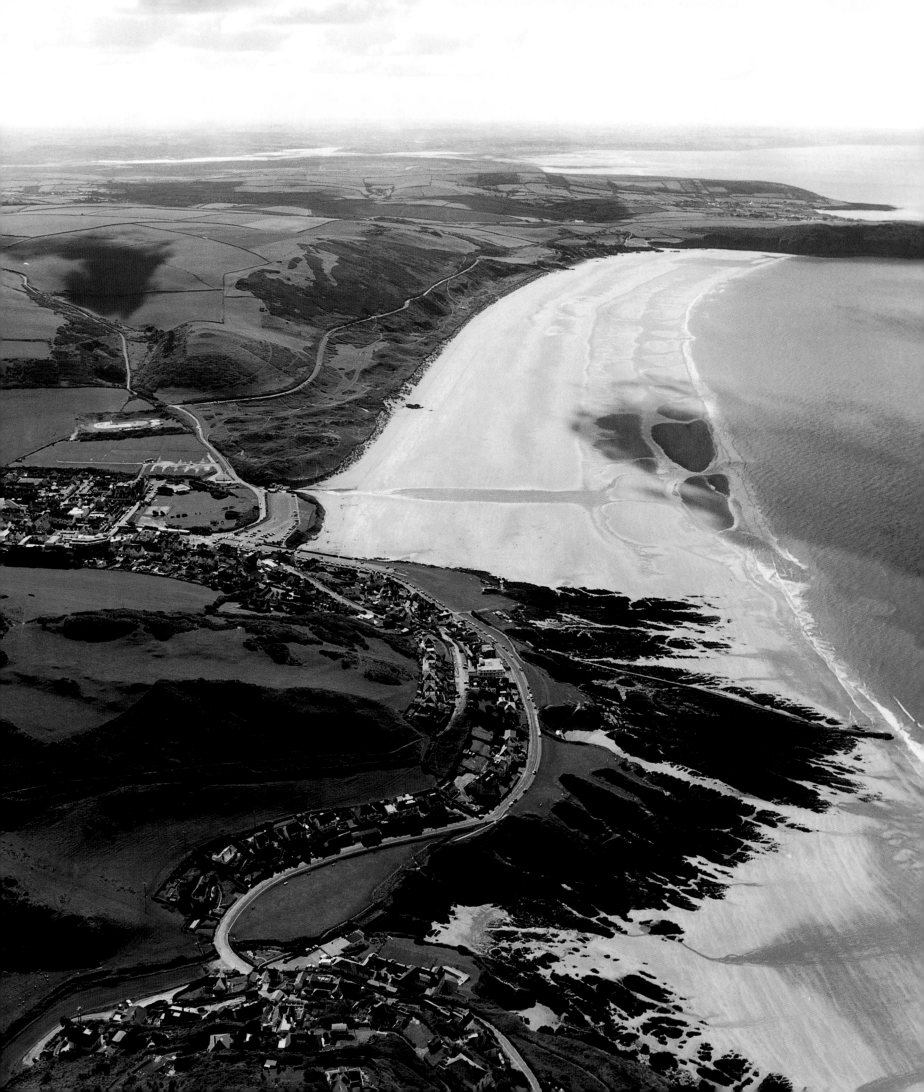

LUNDY

Taking its name from the small island lying off the west coast of Devon, the sea area of Lundy stretches from Land's End in Cornwall up to Goodwick in Dyfed. It includes the counties of Cornwall, Devon, Somerset, Avon, Gwent, South Glamorgan, West Glamorgan, Mid Glamorgan and Dyfed. The RNLI stations situated along the coastline are found at St Ives (which has two lifeboats), St Agnes, Newquay (two lifeboats), Padstow, Rock, Port Isaac, Bude, Appledore (two lifeboats), Ilfracombe (two lifeboats), Minehead (two lifeboats), Weston-super-Mare (two lifeboats), Penarth, Barry Dock, Atlantic College, Porthcawl, Port Talbot, The Mumbles (two lifeboats), Horton and Port Eynon, Burry Port, Tenby (two lifeboats), Angle (two lifeboats), Little and Broad Haven and St Davids. The sea area of Lundy encompasses many moods: the classic tourist resorts of such places as St Ives, Newquay, Bude, Ilfracombe and Tenby; the industrial ports of Swansea, Port Talbot and Milford Haven; and the mining of tin and copper which once flourished in Cornwall and is now confined to a handful of places, including Newquay and St Just. This is also the land of legend, of Cornish 'piskies' and the semi-mythical King Arthur who is believed to have been born at Tintagel.

WOOLACOMBE

The holiday resort of Woolacombe in North Devon (*facing page*) lies snugly ensconced between the two promontories of Morte Point and the charmingly named Baggy Point which is shown in the photograph. Between them is a long, gently curving swathe of sand with the gorse-covered slopes of Woolacombe Down rising behind. As might be expected, Woolacombe Sand attracts many visitors each summer, drawn here by the fine weather, the good bathing and the wonderful walks around the headlands. The popular resort of Ilfracombe lies to the north-east, and the lively town of Barnstaple to the south-east.

THE MUMBLES

This part of the Gower peninsula is aptly named because the people who have discovered it do not want to let anyone else in on the secret. The little town of Mumbles (say it quietly) is tucked into the western corner of Swansea Bay, enclosed by Mumbles Head and looking out over the Bristol Channel. The modest pier doubles as a lifeboat station for one of the town's two lifeboats. Walkers looking for exercise can attempt the walk to Worms Head at the south-western tip of the peninsula. However, it is tough going, and local writer Dylan Thomas called it 'the very promontory of depression'.

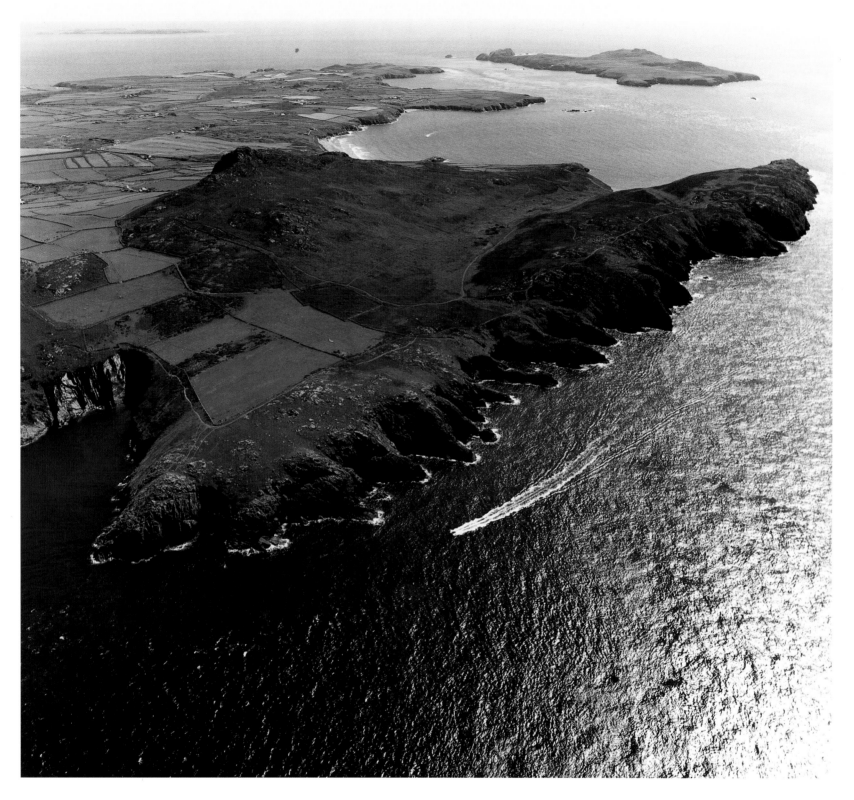

ST DAVID'S HEAD

Looking like the tip of a rocky comb lying in the sea, St David's Head (*above*) juts out belligerently into the stretch of water called Ramsey Sound which flows between it and Ramsey Island. Beyond the island is the part of the Irish Sea which bears the wonderful name of Bishops and Clerks. This is a link with the tiny cathedral city of St David's, a couple of miles inland, which was founded in the sixth century by St David, patron saint of Wales. The cathedral that bears his name was built in the eleventh century and became an important place for pilgrimage in the Middle Ages.

TREVOSE HEAD

A rough patchwork of fields colours the top of Trevose Head (*facing page*) in north Cornwall. It stands 250 feet above the crashing waves and is formed by a ridge of rock. The white-painted lighthouse, which is open to visitors, was built in 1847 and its searching beam has enough candlepower to be seen 27 miles away. On a clear day, anyone standing on this spot also has the exhilarating privilege of being able to see for many miles. The Cornwall North Coast Path runs all around this part of the coast and provides spectacular views of tiny coves, forbiddingly rocky outcrops and huge areas of sandy beach.

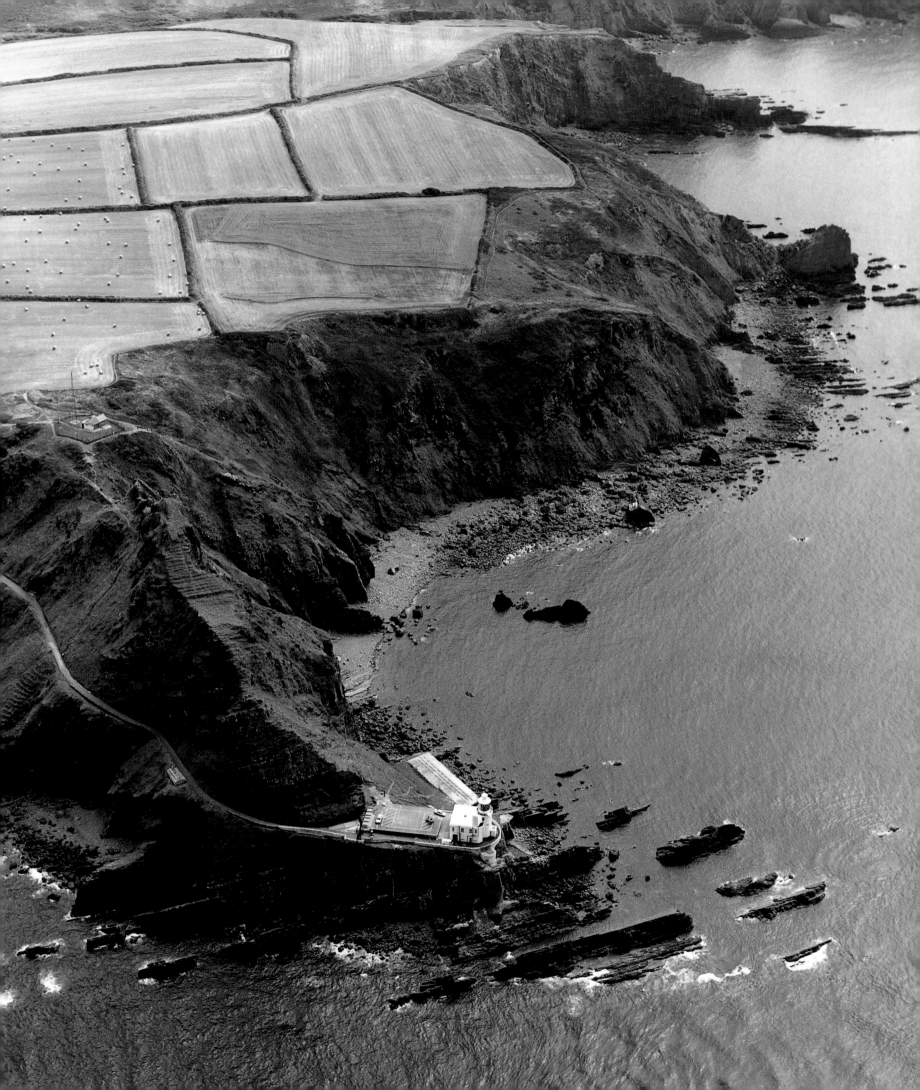

APPLEDORE

The maritime links of this pretty fishing village go back for more than 1000 years, and fishermen have lived here since Anglo-Saxon times. One of the village's finest moments was when many of her sailors and vessels took part in the defeat of the Spanish Armada in 1588. Those traditions are remembered today in the North Devon Maritime Museum, including the village's nineteenth-century association with Canada. During a European timber shortage, local Devon shipbuilders sailed to Prince Edward Island, made their ships from the island's timber and then sailed them back to Appledore where they were completed.

MINEHEAD

Look carefully along Minehead's beach at low tide and you may be able to see some of the distorted stumps of what was once a forest. It is a pertinent reminder of the way the sea is gradually retreating from this Somerset coastline – Minehead is now stranded 1/2 mile away from the sea, separated from the water by a huge sandy beach – an enticing attraction for holidaymakers each summer. Today the town of Minehead is a popular seaside resort but in earlier times it enjoyed a thriving trade importing Irish wool for use by the weavers of Taunton. To the south-west lie the wild, open and mysterious spaces of Exmoor.

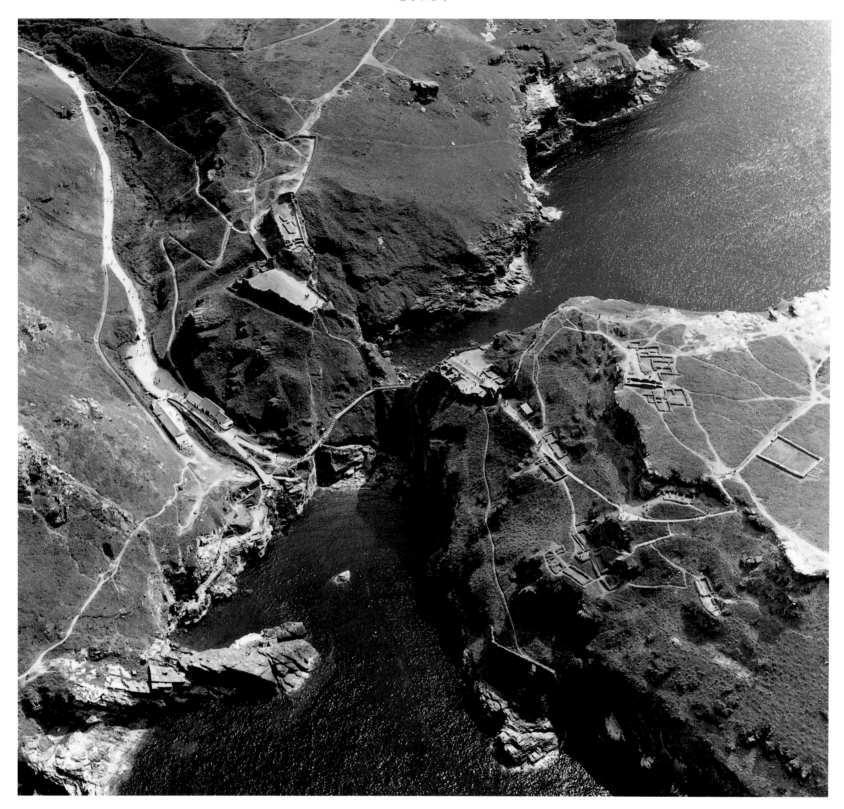

TINTAGEL

The Holy Grail may or may not have been lost forever, but for thousands of people each year the next best thing to finding it is visiting Tintagel (*above*). As this photograph so clearly shows, the mainland part of what was once Tintagel Castle is joined to The Island, on which stand the ruins of a Celtic monastery. It was at Tintagel, so legend has it, that King Arthur was born, despite the fact that the castle was not built until 1145. Beneath the castle is Merlin's Cave – the wizard who helped the young king to become a wise and brave ruler – where, it is said, his petrified body lies waiting for Arthur to summon him once more.

BEDRUTHAN STEPS

Another Cornish legend is attached to the huge rocks, known as Bedruthan Steps, which decorate the shoreline north of Newquay. The story goes that these gigantic boulders were used by the giant, Bedruthan, as stepping stones when he was reluctant to get his feet wet. Geologists with a more practical turn of mind claim that these granite boulders are the result of the erosion by the sea of the softer rocks that once surrounded them. The rocks are reached by a flight of immensely slippery steps from the headland, which can be almost as perilous as bathing in these waters.

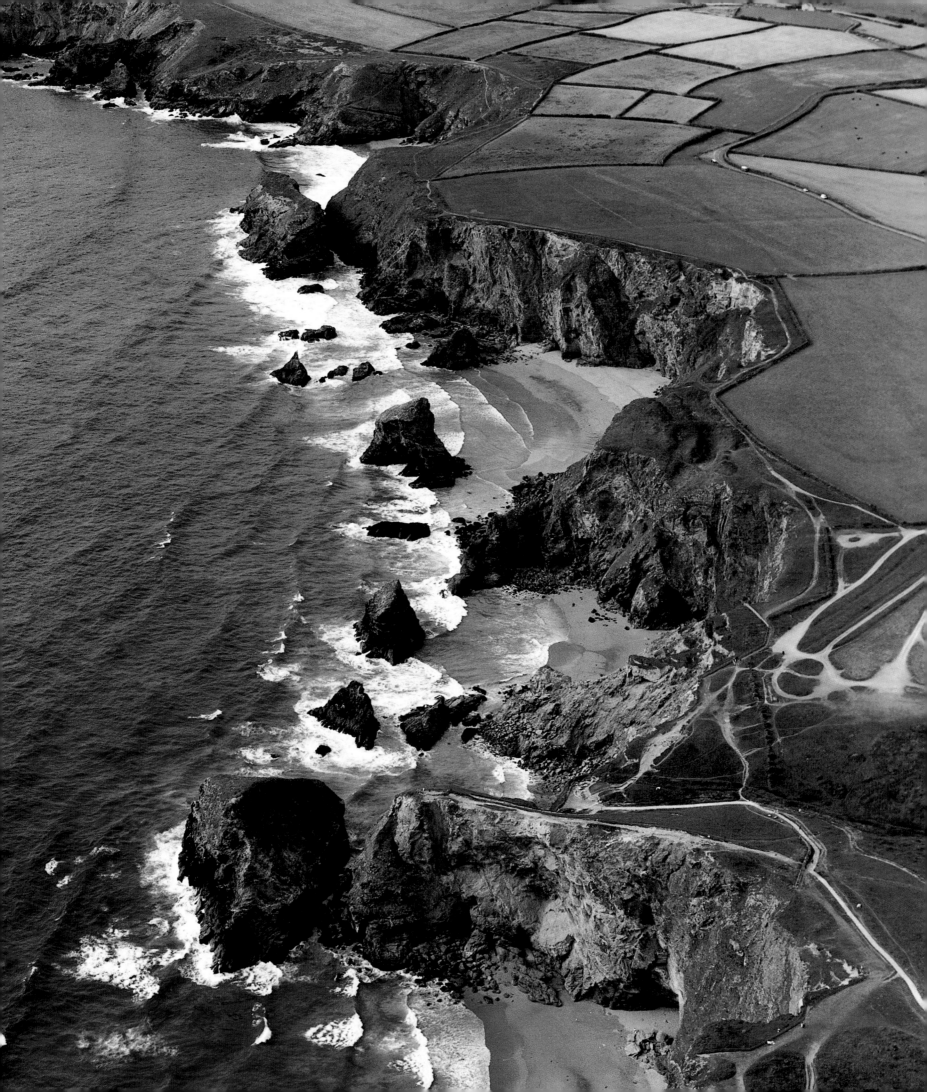

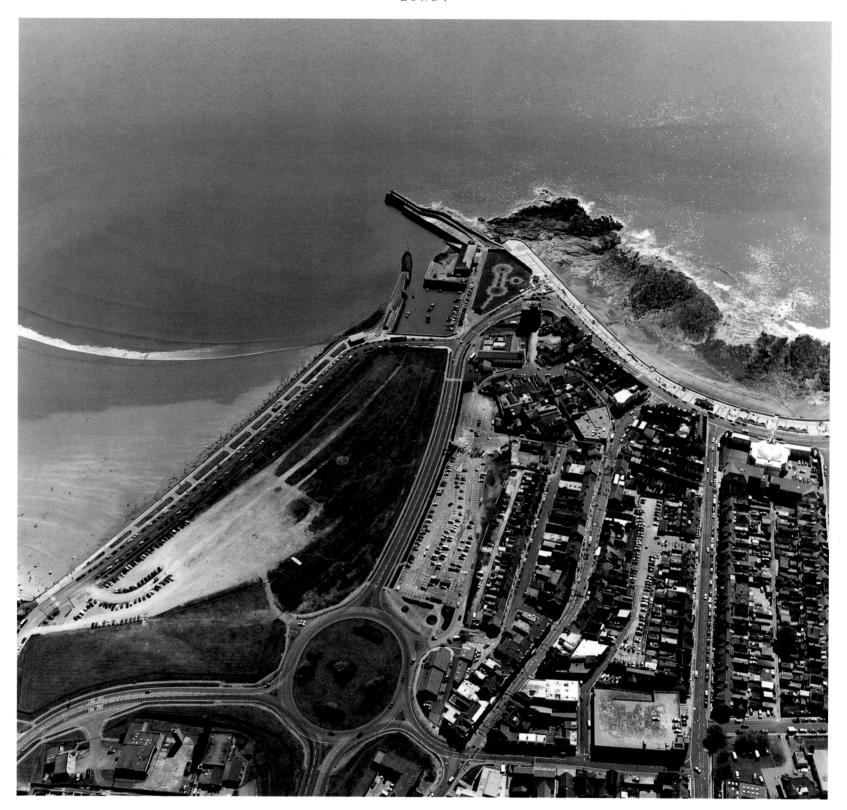

PORTHCAWL

Porthcawl (*above*) shares a common history with several other coastal towns in South Wales. It achieved prosperity as a port for the local coal in the nineteenth century and then became a holiday resort when the trade began to go into decline. Porthcawl also suffered from competition provided by the expanding coal port of Barry, and the old dock was closed in 1906. It has now been filled in and part of it is a car park for the thousands of tourists who have made Porthcawl the most popular holiday resort in South Wales. Among its attractions are shark-fishing, surfing, a massive amusement park and a fine golf course.

TENBY

'You may travel the world over, but you will find nothing more beautiful: it is so restful, so colourful and so unspoilt.' So said the painter Augustus John, who was born in Tenby (*facing page*) in 1878 and grew up here with his sister, Gwen. The medieval streets are among the best preserved in the whole of South Wales and the town has the added distinction of a twelfth-century castle romantically and most picturesquely placed on the headland overlooking Carmarthen Bay. Another fortress, built in double-quick time at the behest of Lord Palmerston in the 1860s, adorns the nearby St Catherine's Island.

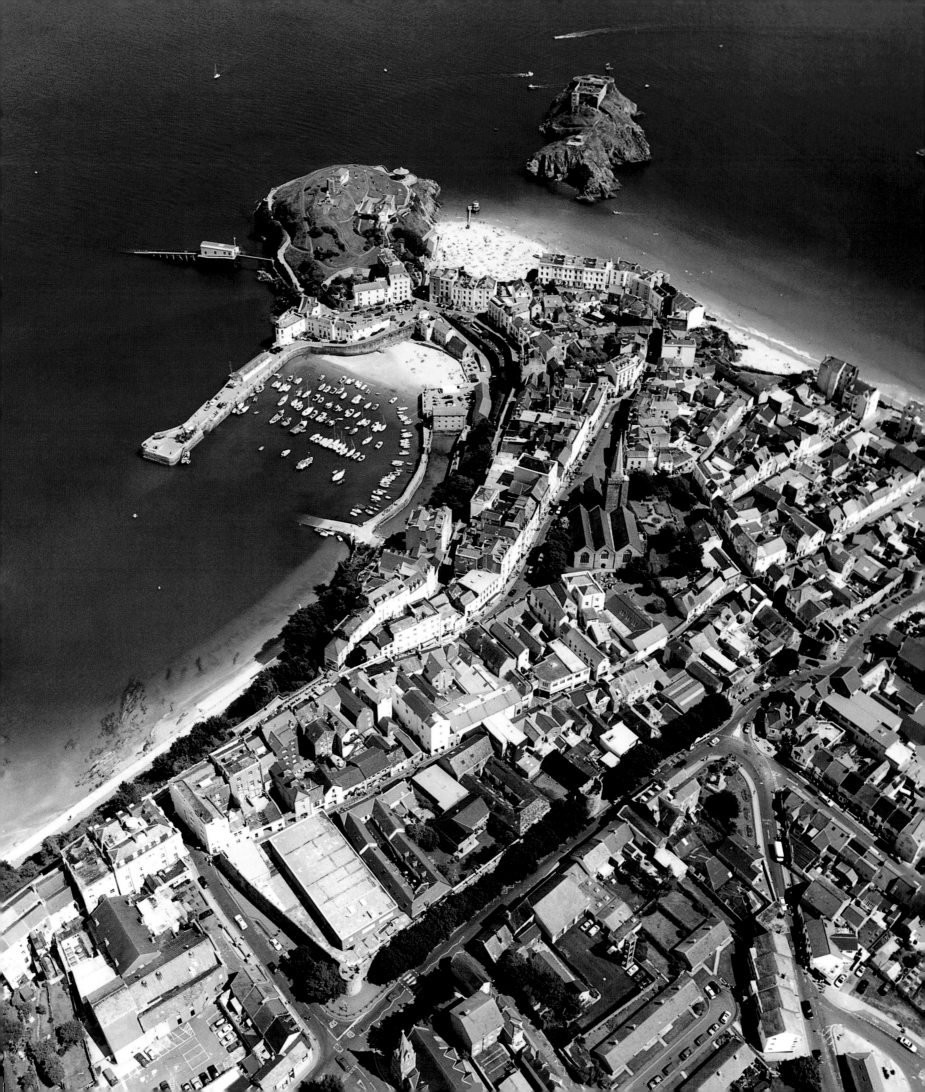

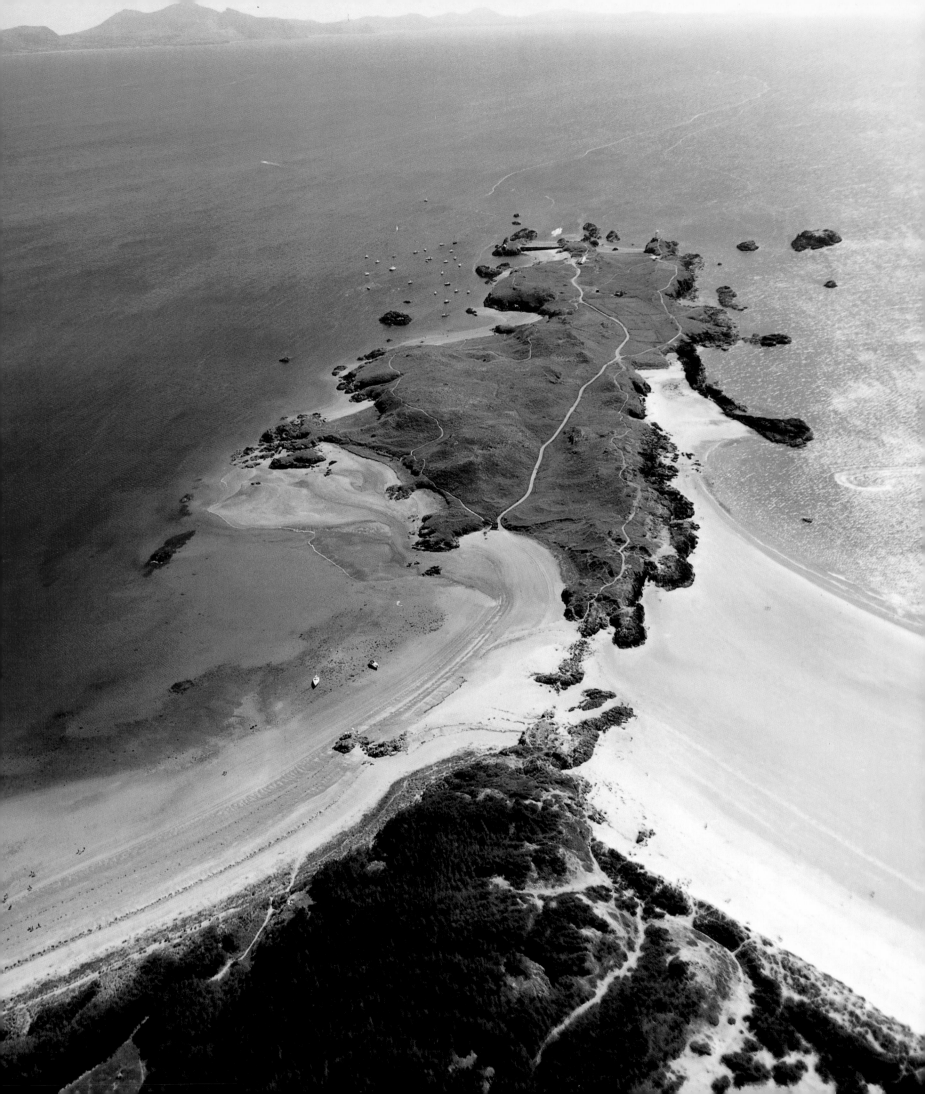

IRISH SEA

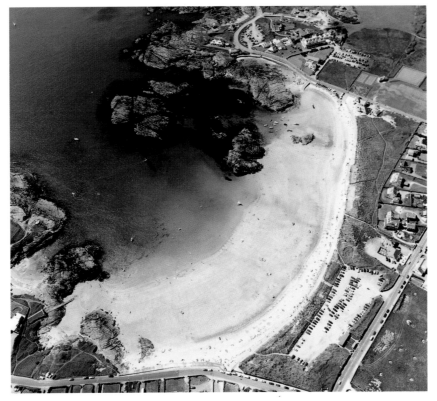

A S ITS NAME SUGGESTS, the sea area of Irish Sea encompasses the waters of the same name. It has many Celtic associations because on mainland Britain it lies between Goodwick in Dyfed and south of Portpatrick in Dumfries and Galloway, and north of Belfast Lough in Antrim on the Northern Irish coast down to Southern Ireland. Irish Sea offers a wide variety of scenery, including the mountains of Snowdonia and the natural splendours of Strangford Lough. The many RNLI stations on mainland Britain are at Fishguard (two lifeboats), Cardigan, New Quay (two lifeboats), Aberystwyth, Borth, Aberdovey, Barmouth (two lifeboats), Criccieth, Pwllheli (two lifeboats), Abersoch, Porthdinllaen, Trearddur Bay, Holyhead (two lifeboats), Moelfre (two lifeboats), Beaumaris, Conwy, Llandudno (two lifeboats), Rhyl, (two lifeboats), Flint, West Kirby, Hoylake, New Brighton, Lytham St Anne's, Blackpool, Fleetwood (all three of which have two lifeboats each), Morecambe, Barrow (two lifeboats), St Bees, Workington, Silloth, Kippford and Kirkcudbright. The Isle of Man has RNLI stations at Port Erin, Peel, Ramsey, Douglas and two lifeboats at Port St Mary. In Northern Ireland there are RNLI stations at Bangor, Donaghadee, Portaferry and Newcastle (two lifeboats).

LLANDDWYN ISLAND

This is a very special place (*facing page*), a National Nature Reserve that lies a few miles west of the Menai Strait in Anglesey. Although it is called an island, strictly speaking that is not an accurate description because it remains linked to the mainland by a causeway even at high tide. By tradition, it is the island for lovers because the patron saint of Welsh lovers is St Dwynwen, who founded a convent here after her heart was broken. A church was built on the site 1000 years later. The island is also home to a nineteenth-century lighthouse which replaced a stone tower built in 1800 as a navigational aid to local shipping.

TREARDDUR BAY

This beautiful sandy bay (*above*) is found on the west side of an island off an island off an island – Holy Island, off the Isle of Anglesey, which lies off the island of Britain. All three are joined by bridges. Trearddur Bay consists of a long sandy beach and is enjoyed by fishermen, sailors, surfers and skin-divers alike. The local rigid inflatable lifeboat is stationed here, in a lifeboat house off the beach. The first lifeboat station was built here in 1967. Holy Island is a popular name for British islands – another Holy Island lies off Arran, and it is an alternative name for Lindisfarne in Northumberland.

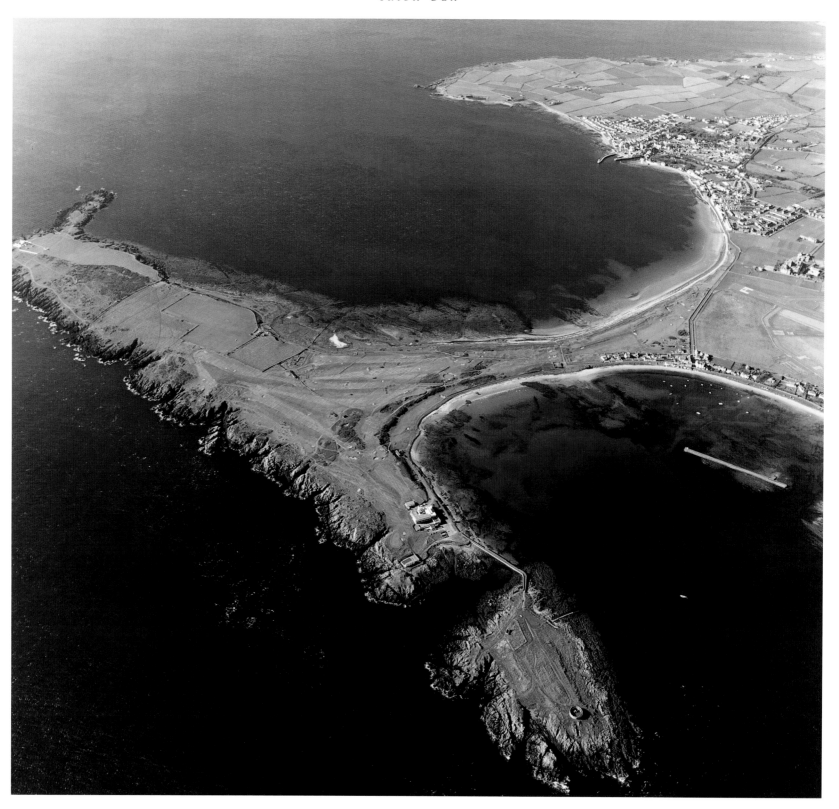

LANGNESS

Looking like an inverted T, the rocky headland of Langness sticks out into the sea east of Castletown on the Isle of Man. The bay known as Derby Haven lies to the right of the headland, and Castletown Bay extends to the left. Both ends of Langness give magnificent viewpoints over the surrounding coastline. The little island off the coast of Langness is called St Michael's Island and is home to the old Derby Fort. Nearby Castletown was once the capital of the Isle of Man (an accolade that now belongs to Douglas), and it has a medieval fortress, Castle Rushen, to prove it. This stands on the site of an original Viking stronghold.

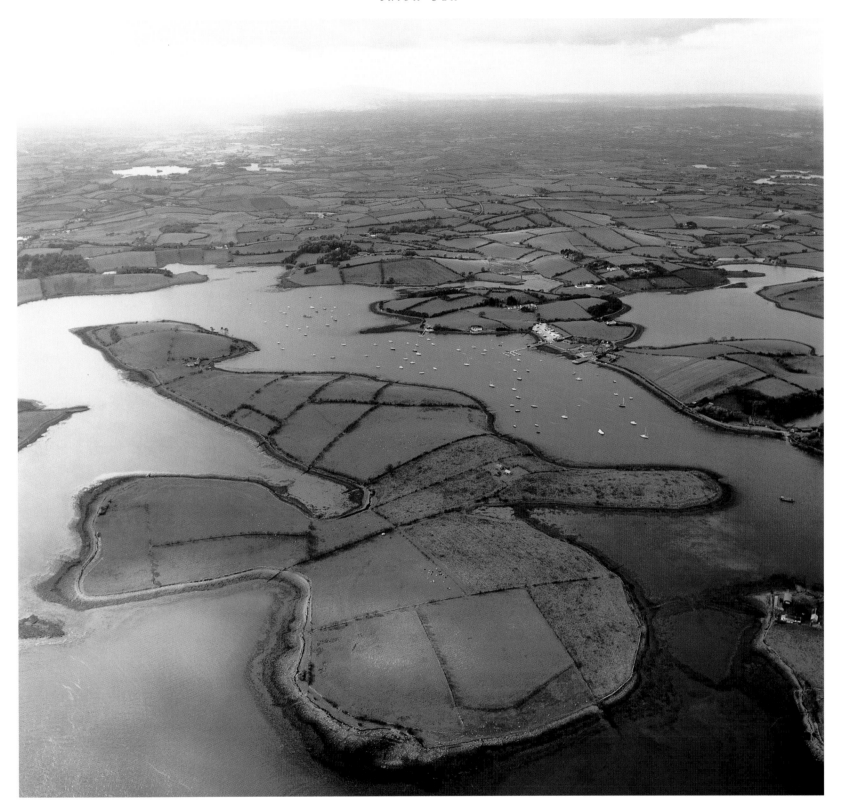

Strangford Lough

This is one of the largest sea inlets in the British Isles, with a coastline that twists and turns for about 150 miles. Over 120 islands are dotted about in its waters. The wildfowl found here have attracted people to this part of Northern Ireland for centuries – prehistoric settlers used to hunt in the marshes and today over 40 species of bird visit the lough at different times of the year. Some fine houses have been built on the shores of Strangford Lough, including the eighteenth-century Mount Stewart with its marvellous gardens and Castleward House, built in the 1760s, which has a mixture of classical and Gothic styles.

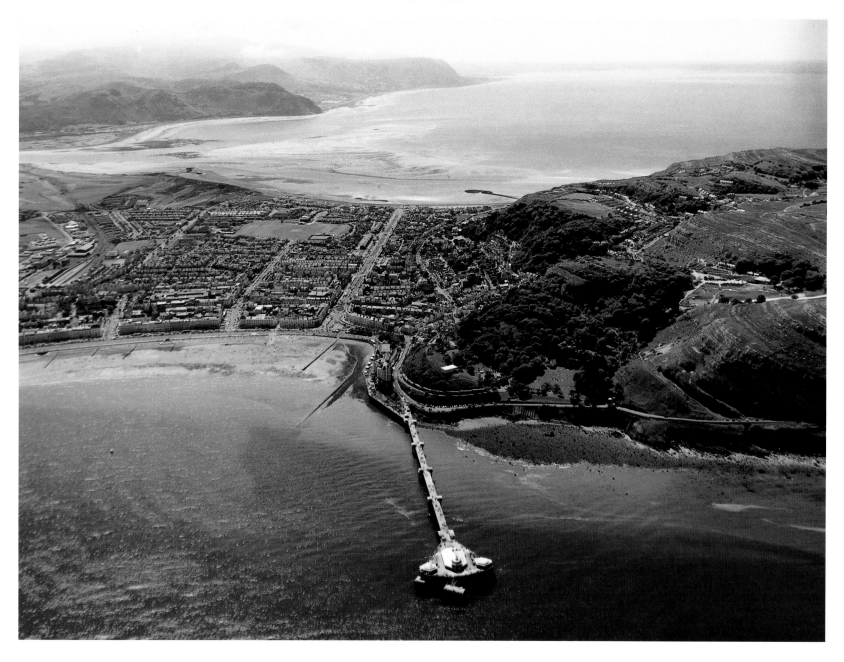

BLACKPOOL, LLANDUDNO AND PEEL

With its huge Pleasure Beach amusement park, its brash tower and no less than three piers, Blackpool (*left*) is the epitome of the cheerful, northern seaside resort. You either love it or hate it, and luckily for Blackpool millions of people come here every year to ride donkeys along the sands, stroll along the Golden Mile or travel the 518 feet to the top of the tower which, for many years, was the tallest building in Britain. Llandudno (*above*) lies between Liverpool Bay and Conwy Bay, and is one of the major Welsh holiday resorts. Its position gives it two sandy beaches, and North Shore is shown here. The site on which the town is built was originally marshland, transformed into wide promenades and elegant streets in the middle of the nineteenth century. Peel, on the Isle of Man (*facing page*), is a small but stunning fishing town, sometimes called the 'sunset city' because of the warm red sandstone used for many of the older buildings. The ruined Peel Castle and St Germain's Cathedral stand on the tiny St Patrick's Isle shown in the photograph. The Round Tower is the earliest remaining fortification, built in either the tenth or eleventh century as a refuge from marauding Vikings.

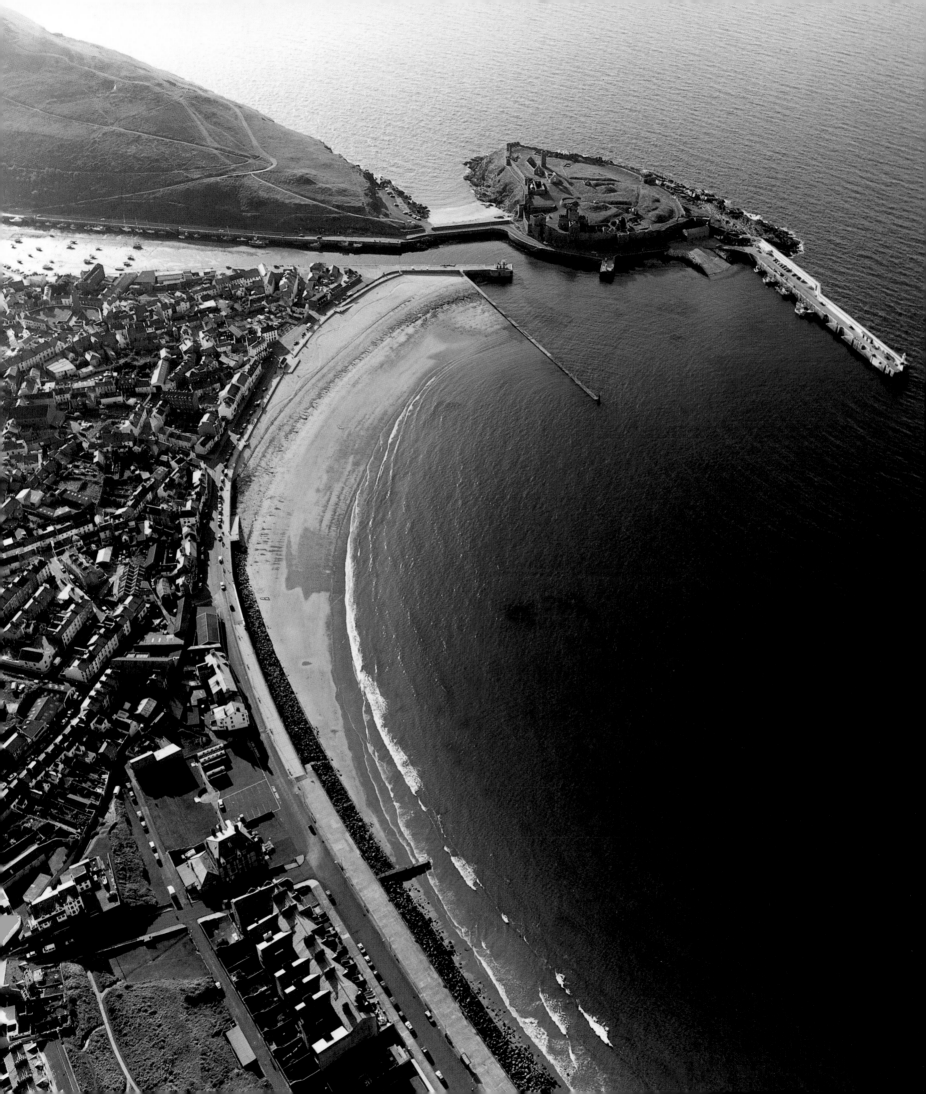

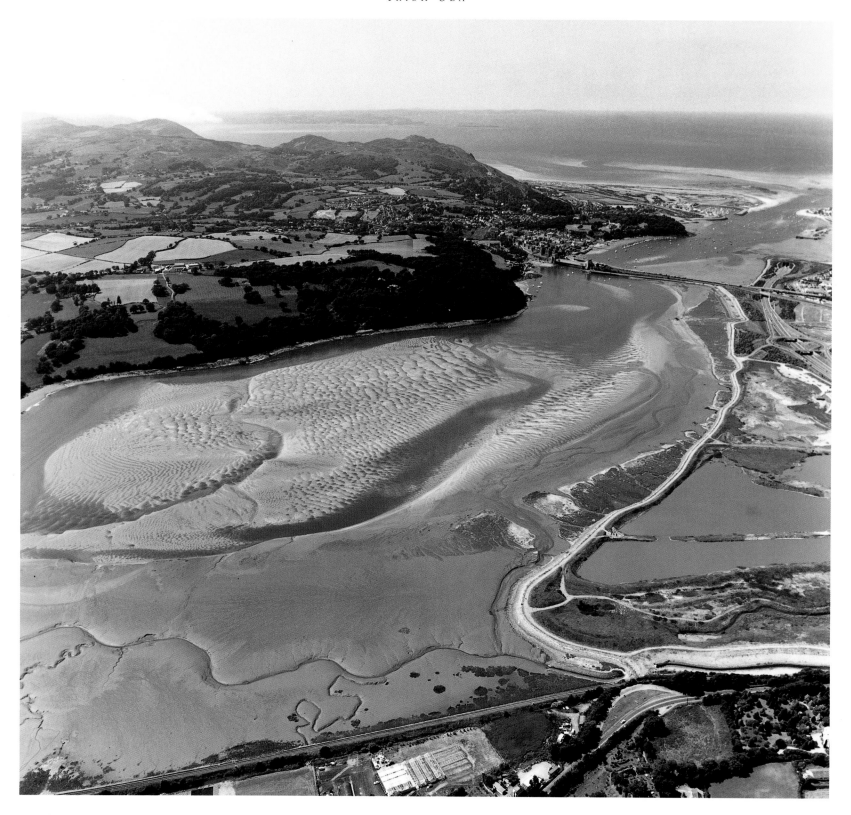

CONWY

The medieval town of Conwy (*above*) sits at the head of River Cony's estuary as it flows into Conwy Bay. The battlements of Conwy Castle are an imposing sight and an evocative reminder of the time in the thirteenth century when Wales was under the unforgiving boot of Edward I. This extremely aggressive king built a chain of defensive castles along the north coast of Wales in an attempt to subdue the Welsh. The castle was completed in 1292 and its walls are up to 15 feet thick. Conwy is also famous for the smallest house in Britain, a tiny, two-roomed building on the quayside.

BEAUMARIS

Edward I built his last Welsh castle at Beaumaris (*facing page*) on the Isle of Anglesey and, unlike Conwy Castle, it was never invaded because it was such a well-designed stronghold – invaders would have had to overcome 14 separate obstacles before reaching the inner ward of the castle. The town of Beaumaris stands just north of the mouth of the Menai Strait, facing a vast acreage of sand banks called Lavan Sands. It was this excellent defensive position that persuaded the castle's architect, Master James of St George, to choose this site. The castle also had a tidal dock for shipping.

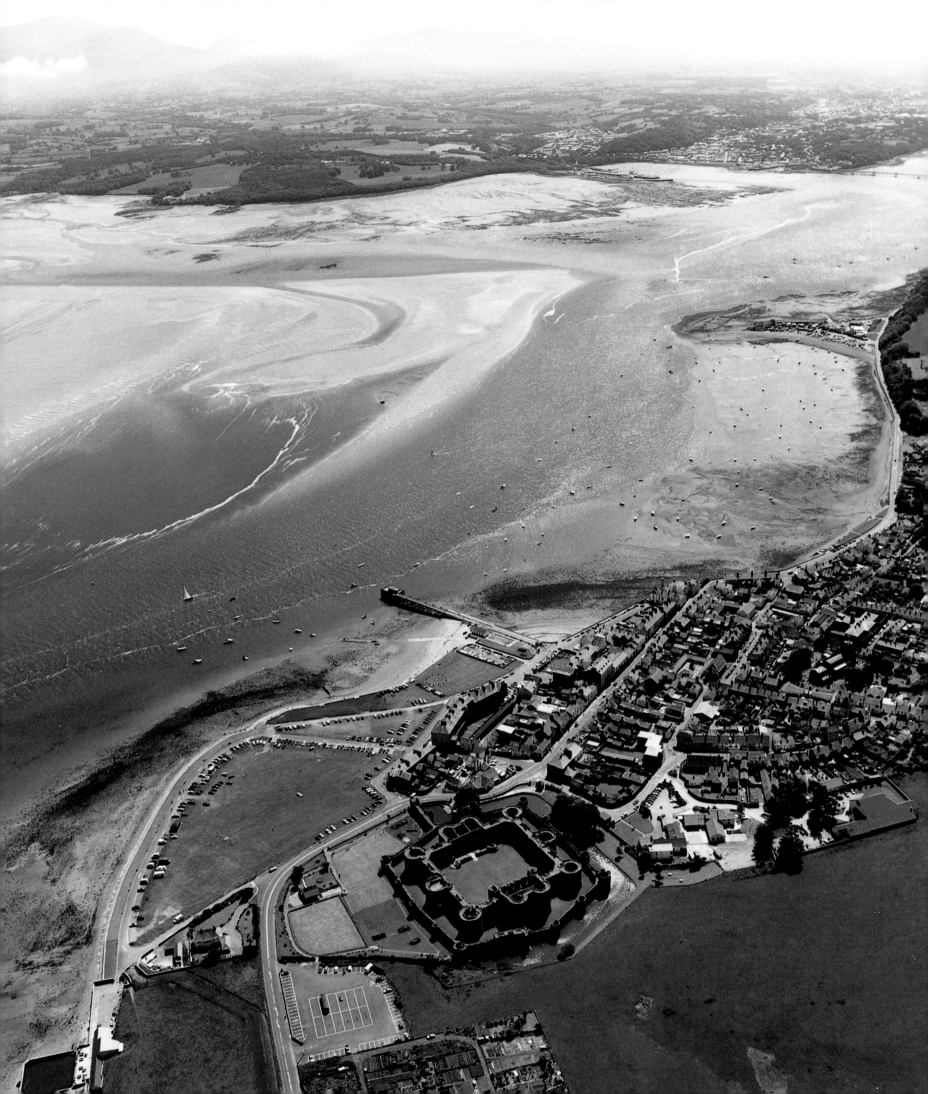

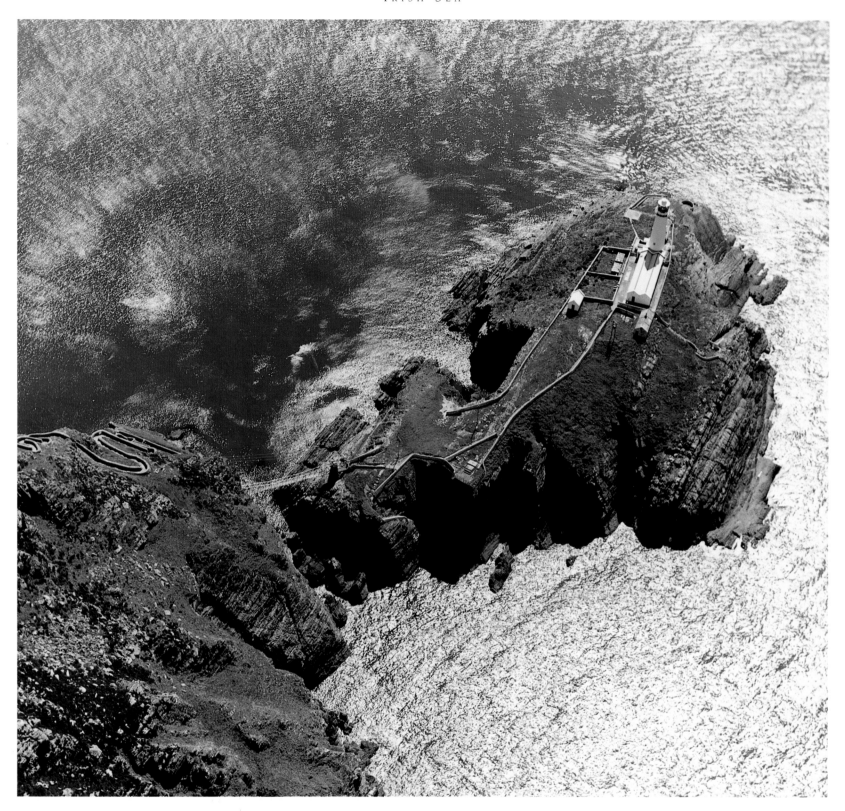

SOUTH STACK

A modest pedestrian's suspension bridge links the tiny island of South Stack (*above*) with Holy Island off the Isle of Anglesey. South Stack is best known for its 90-feet tall lighthouse, now operated automatically. It was built in 1809 and was notable for two special features – an inverted fog-bell and a mobile lantern, which could be lowered down the cliff face to within 50 feet of the sea whenever the lighthouse itself was obscured by fog. To the north lies North Stack, and it was near this headland that a steamer was rescued, in atrocious conditions, by the Holyhead steam lifeboat *Duke of Northumberland* in 1908.

LITTLE ORME'S HEAD

Llandudno's North Shore beach fits snugly between two headlands – Great Orme's Head lies to the west and Little Orme's Head (*facing page*) to the east. Great Orme's Head is a popular tourist attraction, with its cable car and funicular railway which both operate between the foot of the 679-feet tall cliffs and the summit. The limestone cliffs at Little Orme's Head, on the other hand, may only be 464 feet tall and you have to use shanks's pony to travel between the summit and the seashore, but the views of Snowdonia and, on clear days Cumbria, are just as breathtaking and exhilarating.

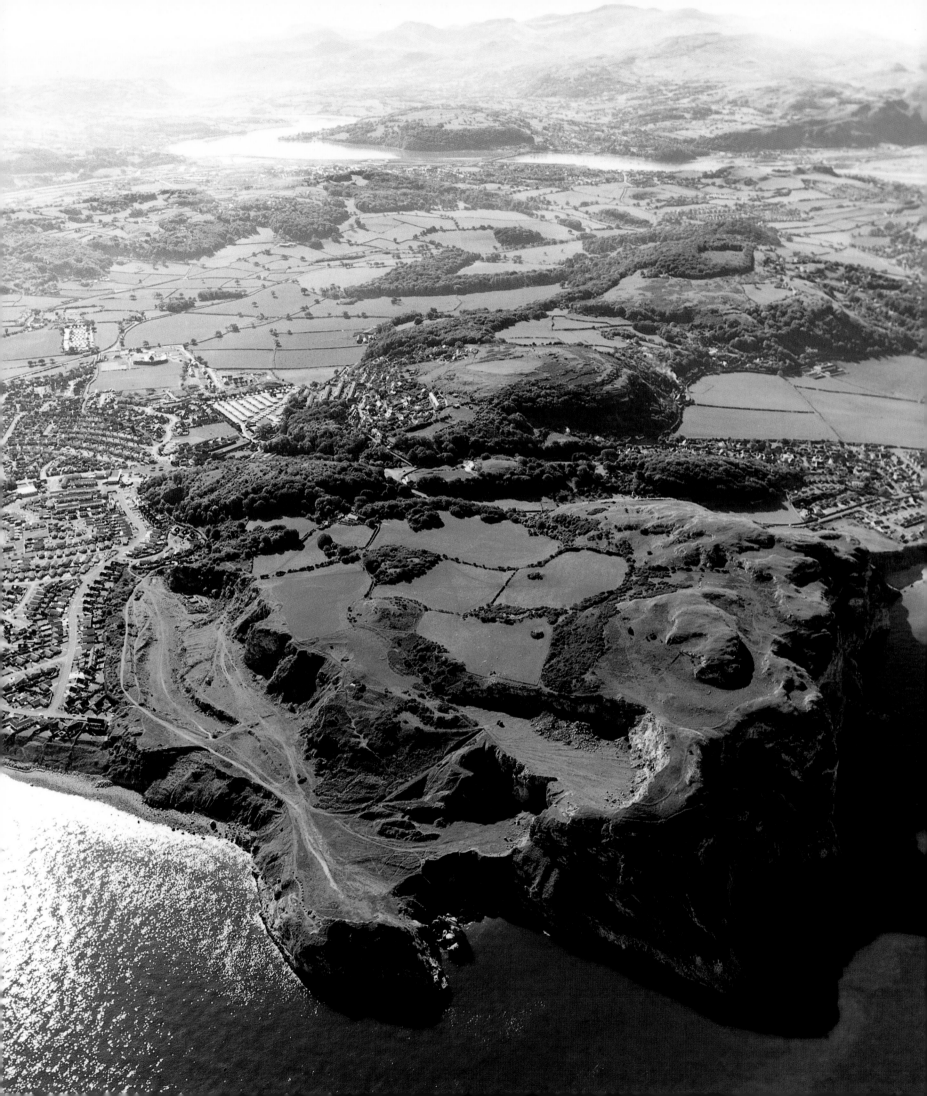

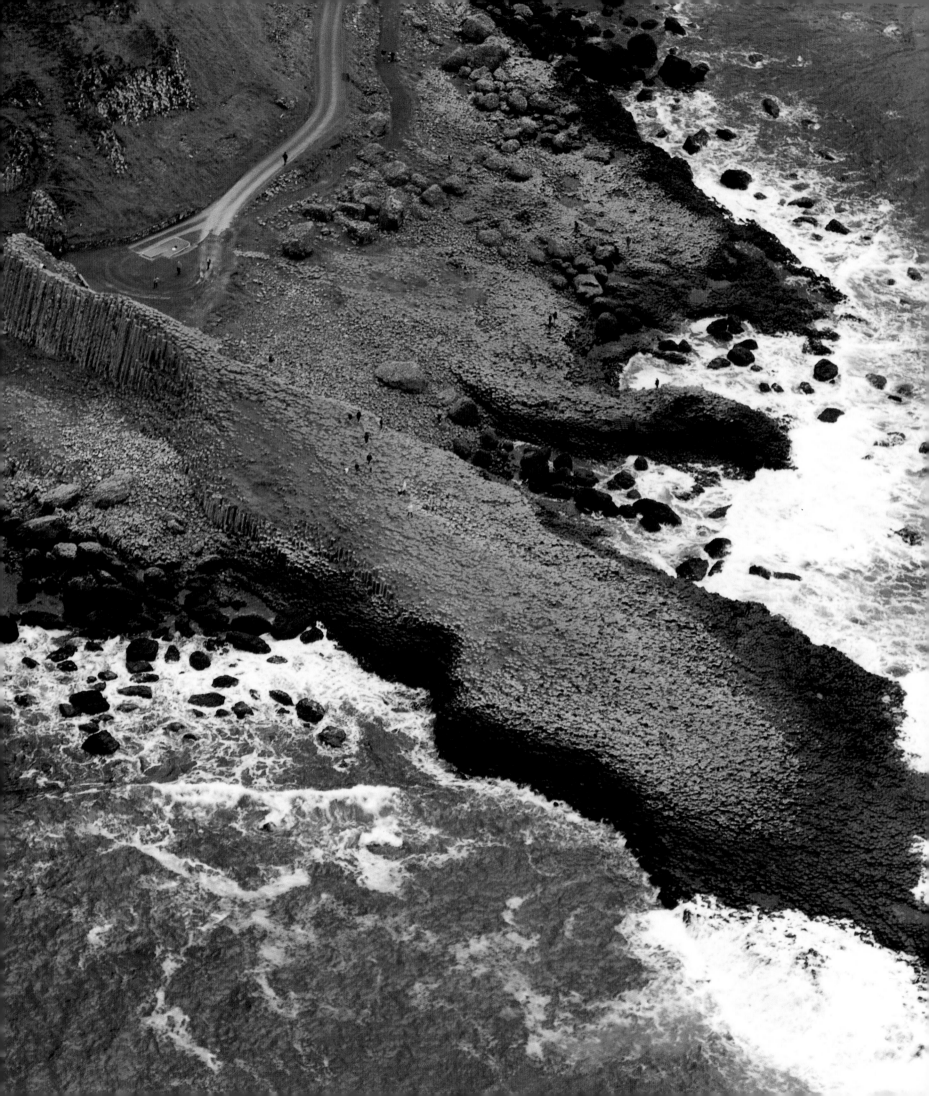

MALIN

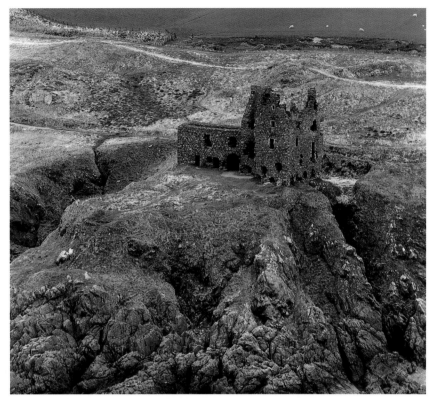

F ROM SOUTH OF PORTPATRICK on the Rhins peninsula in Dumfries and Galloway to south of Mallaig in the Highland region, the sea area of Mallaig follows the twists and turns of Scotland's convoluted west coast, as well as many of her islands. These are the Inner Hebridean islands of Mull, Iona, Ulva, Staffa, Coll (so windswept that trees cannot grow on it), Tiree, the Treshnish Isles, Jura, Islay, Arran, Colonsay and many tiny islets too numerous to mention. It also includes part of the coast of Northern Ireland, from Londonderry in County Londonderry round to north of Belfast Lough in County Antrim. Because of this, Malin has the distinction of including what many people consider to be some of the most spectacular coastal scenery in the whole of Britain – rugged, craggy, wave-lashed and remote. Malin's RNLI stations on the British mainland are Portpatrick, Stranraer, Girvan, Troon, Largs, Helensburgh, Tighnabruaich, Campbeltown (which has two lifeboats) and Oban. RNLI stations in the Inner Hebrides are at Tobermory on the island of Mull, and on the islands of Arran and Islay. In Northern Ireland, there are RNLI stations at Portrush (which has two lifeboats), Red Bay and Larne (two lifeboats).

GIANT'S CAUSEWAY

This astonishing formation of basaltic rock on the coast of northern Antrim is the stuff of legend. The story goes that the Giant's Causeway (*facing page*) was created by Finn MacCool, an Ulster hero who was in a hurry to reach Scotland. He flung down thousands of basaltic columns to form stepping stones across the sea, which re-emerge at the Scots island of Staffa. These columns, clearly visible to the left of the photograph, are called the Giant's Organ. Geologists, however, have a different theory – they believe that the basalt rocks were formed by the outpourings of lava from a volcano about 60 million years ago.

PORTPATRICK

Set on the west coast of the Rhins peninsula in Dumfries and Galloway, for centuries Portpatrick (*above*) was the terminal for the ferry from Donaghadee in Northern Ireland. Couples eloping from Ireland would catch the ferry and marry in Portpatrick, but sadly this romantic journey came to an end in the middle of the nineteenth century and the ferry service transferred to nearby Stranraer. Another relic of the past is the ruined fifteenth-century Dunskey Castle, perched high on top of the cliffs south of Portpatrick. The town's lifeboat station, as with many others, is open to visitors during the summer months.

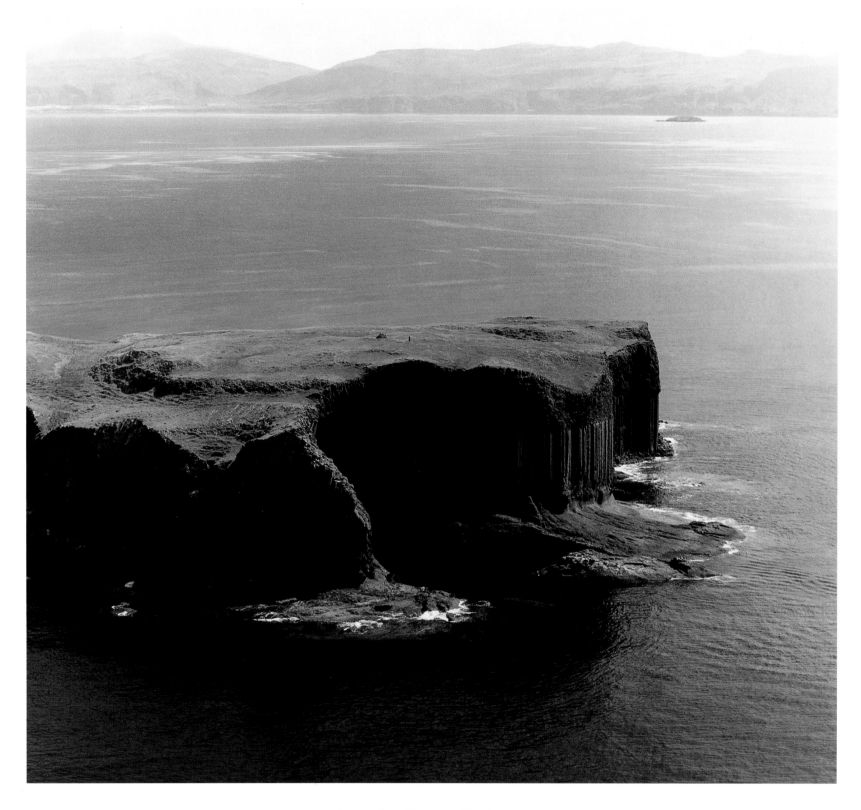

STAFFA, AILSA CRAIG AND HOLY ISLAND

Scotland's coastline is decorated with hundreds of islands, some so small and inhospitable that they are only home to a few seabirds, others that are large and fertile enough to support whole communities. Some, of course, were rendered uninhabited during the notorious Highland Clearances of the eighteenth century. The curious island of Staffa (*above and facing page, bottom left*) was inhabited until about 200 years ago but today it is only home to wildlife. It rears out of the water west of the island of Mull, considered by many to be even lovelier than Skye. Staffa has five caves, the most famous of which is Fingal's Cave with its columnar walls of basalt pillars. Fingal's Cave inspired the composer Mendelssohn to write the overture 'The Hebrides'. He described the cave as 'like the interior of a gigantic organ for the winds and tumultuous waves to play on'. The granite island of Ailsa Craig (*facing page, top*) sits in solitary splendour in the Firth of Clyde, 10 miles west of Girvan. It is the core of a long extinct volcano and its granite was once used to make Scots curling stones. The brooding presence of Holy Island (*facing page, bottom right*) lies off the island of Arran. Holy Island takes its name from St Molios, an Irish missionary who lived in a cave here.

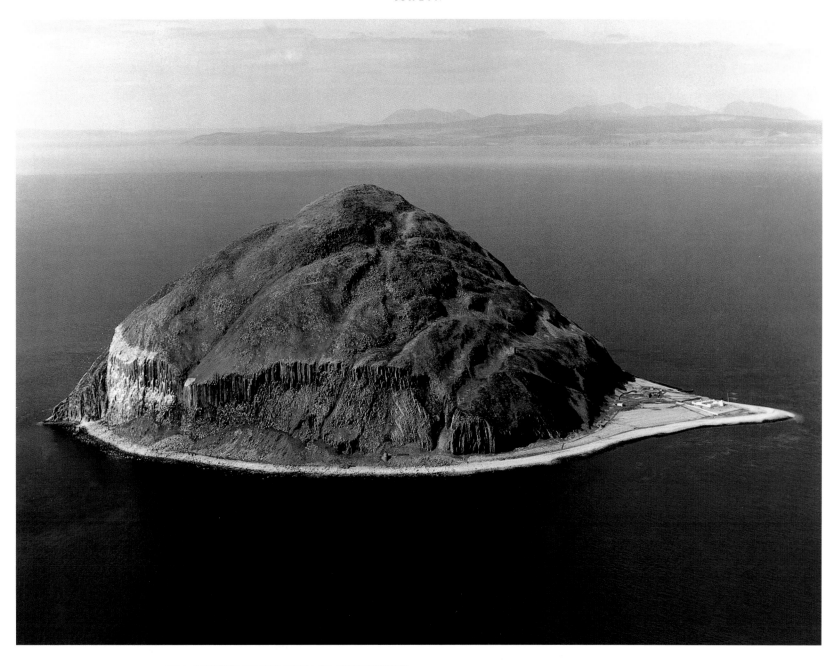

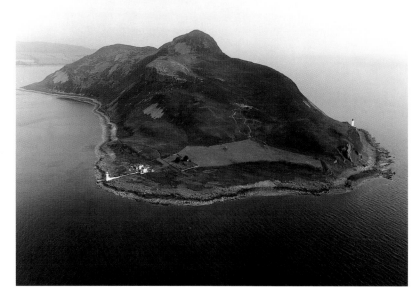

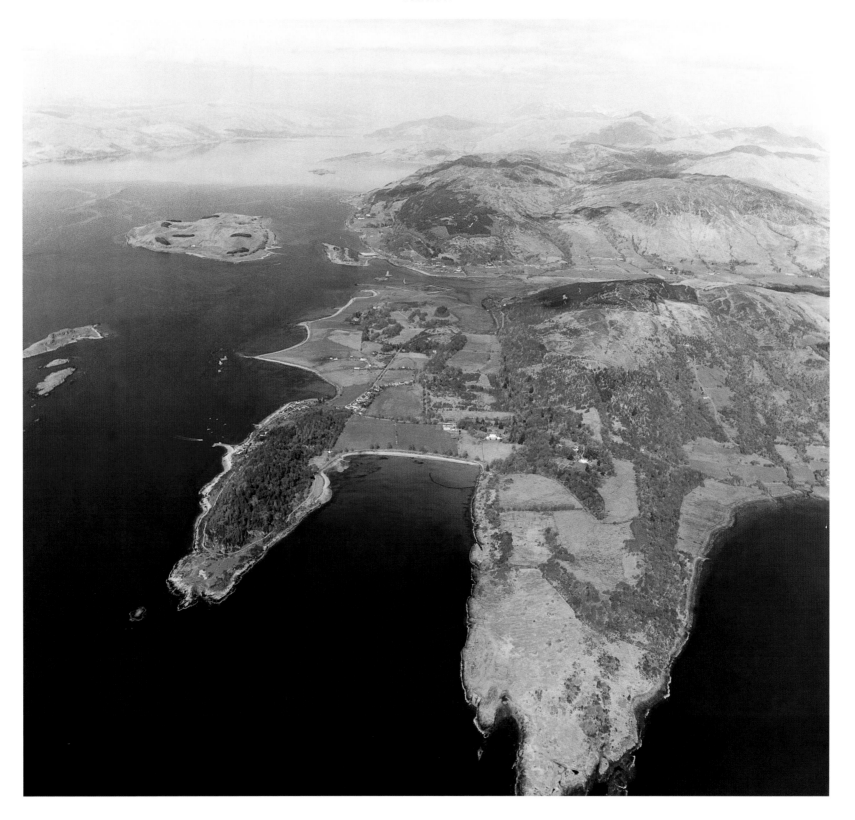

LOCH LINNHE

Like a long finger pointing far into Scotland, Loch Linnhe cuts a deep gash through Highland and Strathclyde. At the tip of the loch is Fort William, famous for the nearby mountain Ben Nevis, while the Appin range of mountains lies further south on the eastern shoreline and is shown in the photograph (*above*). Yet Loch Linnhe has its lighter moments too. The pretty village of Port Appin, with its collection of stone cottages, looks out to the tiny island of Shuna and the much longer one of Lismore, as well as many small islets scattered higgledy-piggledy across the loch.

LISMORE ISLAND

The elongated shape of Lismore Island (*facing page*), 10 miles long, sprawls in the middle of Loch Linnhe. It belongs to the Inner Hebrides, like the neighbouring islands of Mull, Kerrera and Luing. Motorists wanting to reach the island have to catch the ferry from nearby Oban, while foot passengers can take the quicker ferry that leaves from Port Appin. As the photograph shows, Lismore is a quiet, peaceful place, as might be expected from its fame as one of the earliest Christian sites in the country. St Moluaig, who founded several religious communities throughout Scotland, was buried on the island in 592.

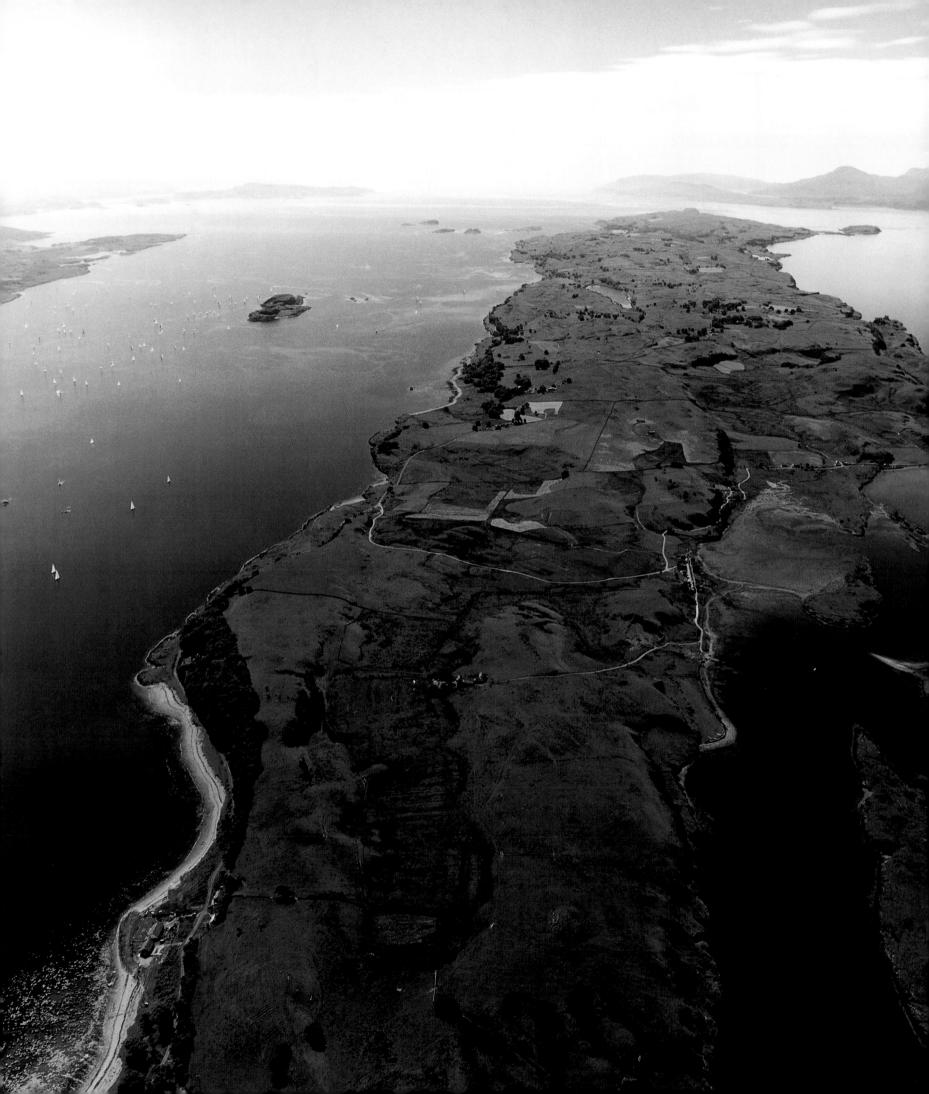

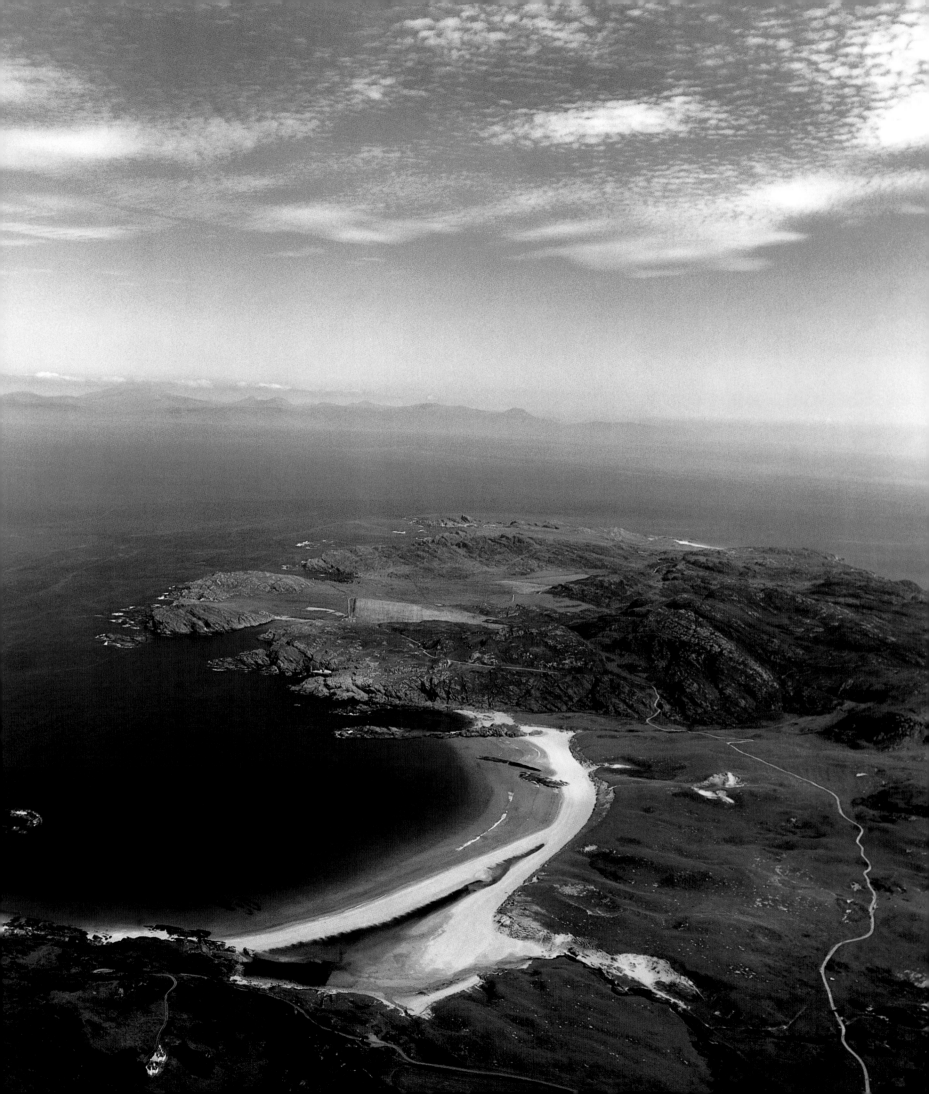

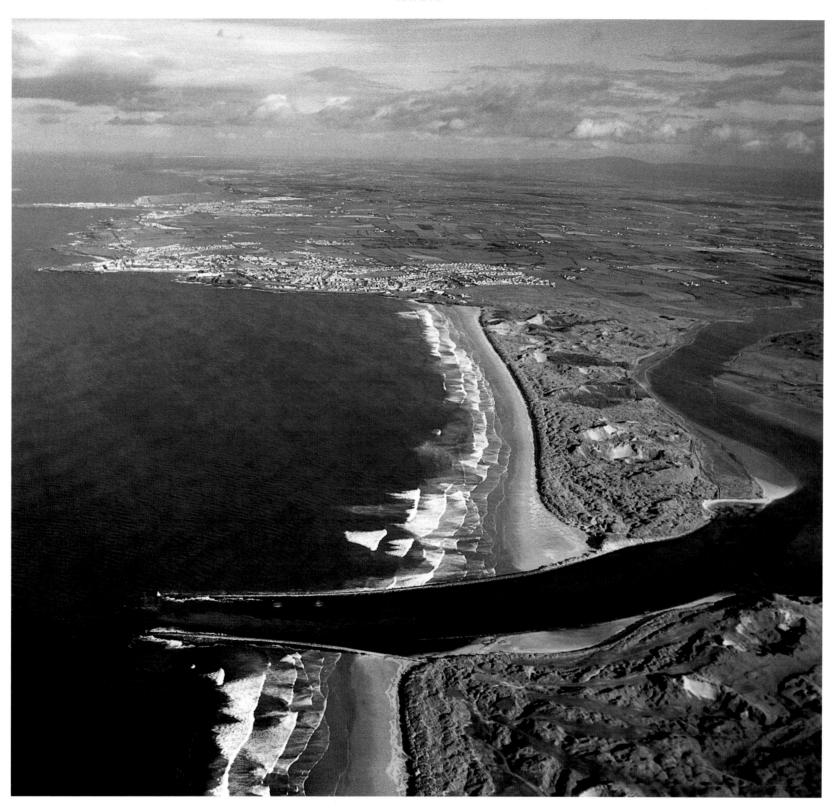

KILORAN BAY

Until the 1880s, the golden sands of Kiloran Bay on the Inner Hebridean island of Colonsay (*facing page*) had held a secret for centuries – the remains of a Viking ship, complete with warlord and horse. Archaeological discoveries in the caves situated at either end of Kiloran Bay prove that Colonsay has been inhabited for over 6000 years. Despite this, not a great deal is known about the history of the island, although near Kiloran Bay is the site of an early Celtic chapel, Kilcatrine, whose well was apparently used by St Columba, founder in the sixth century of the church and monastery at Iona.

COLERAINE

People have lived in the Northern Irish town of Coleraine (*above*) since 7000 BC, drawn here by the triple benefits of its defensive position, close proximity to Scotland and the plentiful supply of fish that swim in the River Bann. As the river meanders its way down to the Atlantic Ocean at The Barmouth, it meets a spectacular coastline of long sandy beaches and towering, craggy rocks. The 3-mile-long bay to the east of The Barmouth is called Port Stiobhaird, or Portstewart, and is particularly famed for the quality of its sunsets. One of them inspired the 1930s song 'Red Sails in the Sunset'.

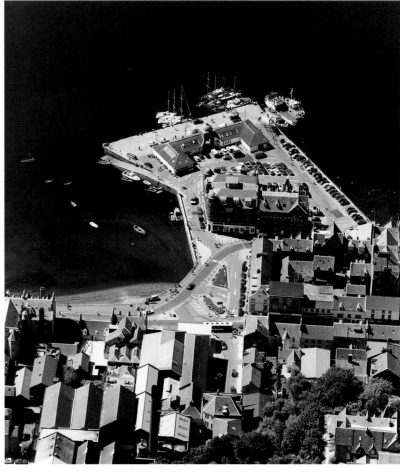

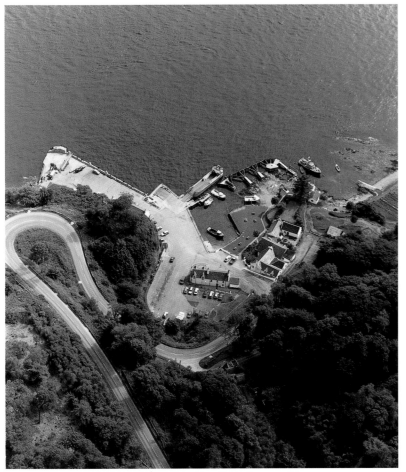

ISLAY, CRINAN CANAL AND OBAN

Unlike many of its fellow islands in the Inner Hebrides, Islay (*left*) is doing very nicely indeed, thank you, courtesy of its flourishing whisky industry. If you like your whisky peaty, smoky and served as a single malt, Islay is the place to go. If you can't get there in person, you can always be an armchair traveller with the help of a bottle of Lagavulin, Laphroaig, Ardbeg or Bowmore. Islay was Scottish until the Vikings took over both it and the other Western Isles in around 850. The Norwegians were driven out 200 years later, after a sea battle off the coast of Islay in which Somerled, then king of Argyll, defeated his brother-in-law, Godred, Norse king of the Isles. Life would have been much easier for all concerned if the Crinan Canal (*top left*) had existed at that time, because although it is only 9 miles long it cuts out what would otherwise be a 120-mile sail around the Mull of Kintyre. The port of Oban (*above*) sits on the Firth of Lorn. It has a transient atmosphere, perhaps because most people who visit are on their way either to or from somewhere else. It is from Oban that you take the ferry to Coll, Tiree, Mull, Iona, Barra, South Uist, Lismore and Colonsay – a fantastic way to experience the desolate beauty of the west coast of Scotland.

MALLAIG

Like Oban, Mallaig (*facing page*) is a departure point for many of the Western Isles. You can sail to the evocatively named islands of Rhum, Muck, Eigg and Canna from here, and you can also board the West Highland train to travel on a breathtaking journey from Mallaig to Glasgow, through staggeringly beautiful scenery. Ferries from Mallaig also sail to Skye. If you prefer to spend some time catching your breath here before moving on, Mallaig has a suitably peaceful atmosphere which can come as a welcome respite from the rollercoaster excitement provided by the hairpin bends of the road which leads to Mallaig.

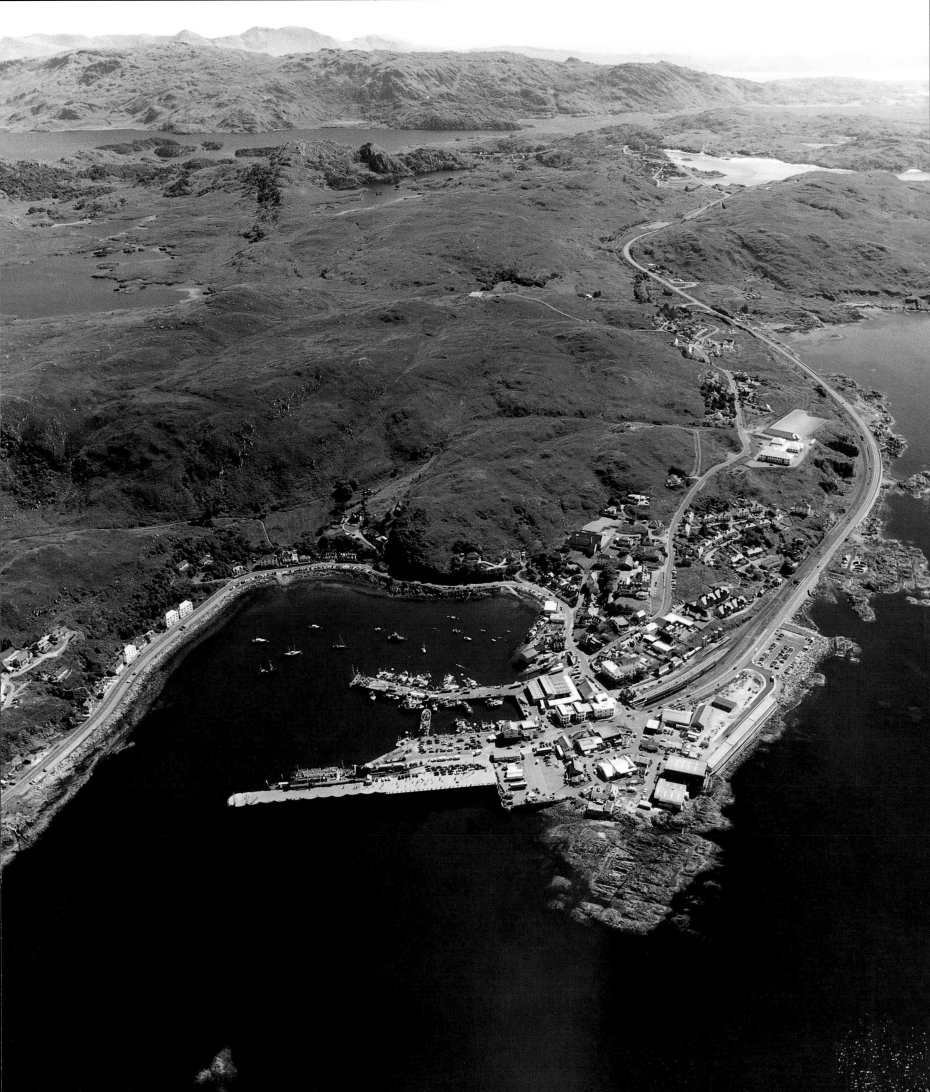

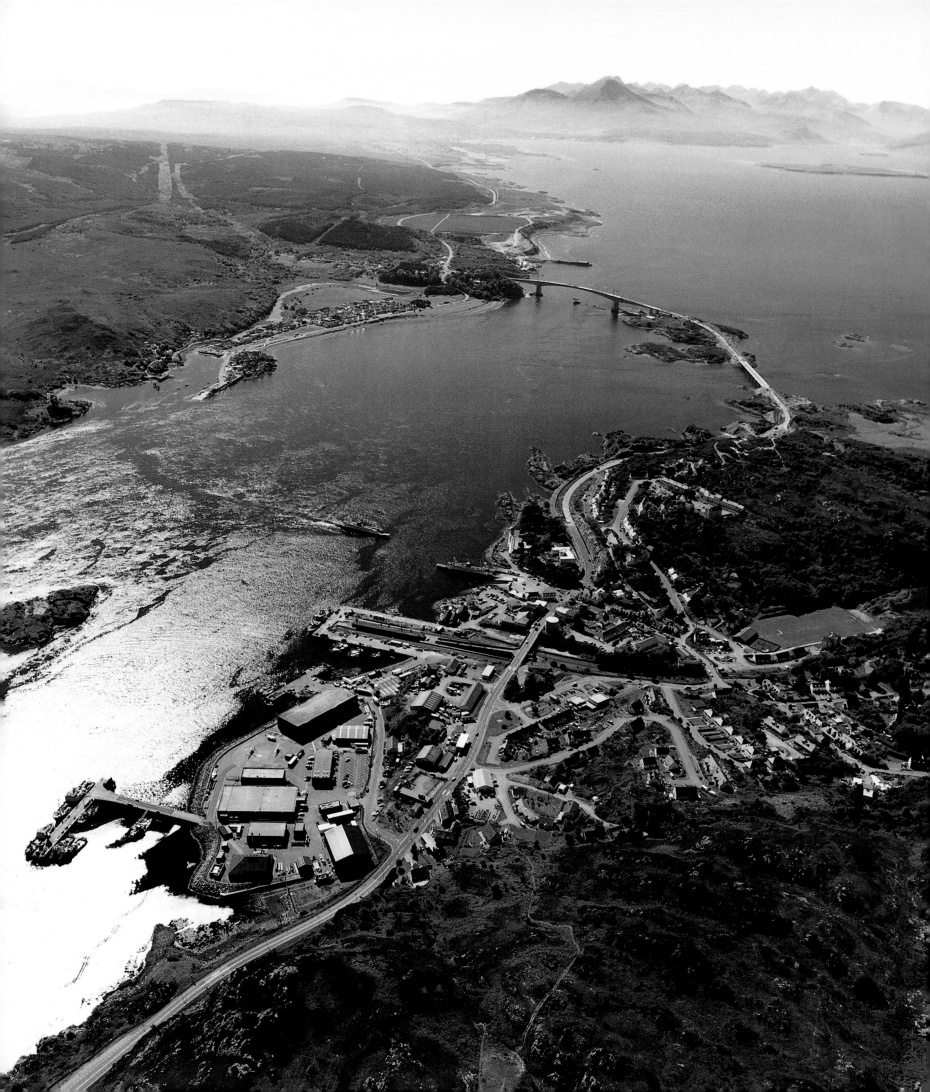

HEBRIDES

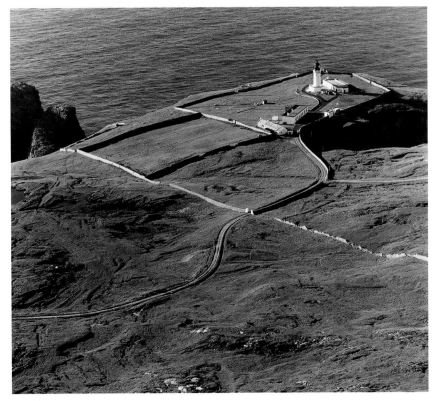

F ROM SOUTH OF MALLAIG in the Highland region to east of Cape Wrath, the sea area of Hebrides includes some magnificent, not to say breathtaking, scenery. There are mountains more than 750 million years old whose often barren slopes and snow-capped summits are beautiful but inhospitable. There are several islands, including Skye, the so-called Isle of Clouds (the Vikings gave it this name because of the pall of clouds that so often hover over it), Scalpay, Raasay, Rona, Pabay, Rhum, Muck, Eigg, Canna, the Summer Isles, Eriskay, Barra, Vatersay and Mingulay, plus the combined islands of Lewis and Harris, and North Uist, Benbecula and South Uist. This is a part of the country that is frequently best viewed from a boat since one is then able to peer into sandy coves and little bays that are virtually inaccessible by foot. The strands of history are thickly woven in this part of Scotland, with the tale of Bonnie Prince Charlie, born to disappointment, associated with many of the villages and towns. The RNLI stations on this area of coastline are found at Mallaig, Kyle of Lochalsh (newly completed) and Lochinver. There is also a lifeboat at Stornoway on Lewis, on the island of Barra and at Portree on Skye.

SKYE

Anger and outrage greeted the opening of the Skye Bridge (*facing page*) in the summer of 1995, with islanders refusing to pay the toll required and mourning the end of Skye's existence as an island. Many traditionalists will prefer to take the ferry between the mainland and Skye, yet the new bridge certainly gives spectacular views of the jagged Cuillin Hills, shown on the horizon in this photograph. The history of Skye is inextricably interwoven with that of Bonnie Prince Charlie, the Jacobite pretender to the Georgian throne. After his disastrous uprising of 1745 he sheltered here the following year before sailing for Europe.

CAPE WRATH

The name of the north-western point of mainland Britain has nothing to do with the ferocity of its seas, although you might easily think so when watching them lash against the rocks. Instead, Cape Wrath (*above*) derives its name from the ubiquitous Vikings who sailed as far as here before turning south for the Hebrides. They called it *hvraf*, meaning 'a turning point'. There is little to see here, other than the lighthouse standing at the summit of a sheer rock face 360 feet tall, and only a twisting track links Cape Wrath with the outside world – a ferry at the Kyle of Durness.

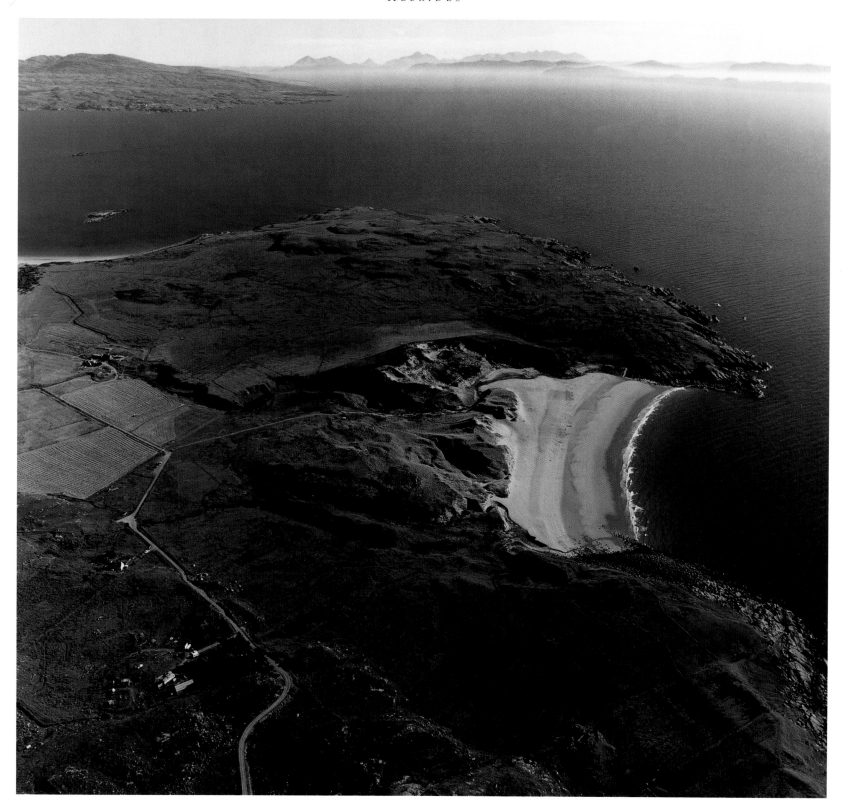

REDPOINT

As with all unspoilt places, there is risk in advertising them too loudly for fear that the next time one returns they will be overrun by sightseers. Perhaps that is an unlikely fate for Redpoint since it is only accessible by a narrow, switchback road that ends abruptly and then becomes a footpath across peat bogs. Redpoint itself is a headland with two bays of machair – white shell sand backed by dunes of marram grass. The larger of the two bays is bisected by an islet and has a shoreline decorated with rocks of Brobdingnagian proportions. The views around here are spectacular, whether they are of the old-fashioned red telephone box that stands improbably by the side of the road or the breathtaking seascape that stretches in a vast blue arc from Loch Torridon and The Minch up to the Inner Sound. There are islands scattered in the water almost as far as the eye can see – Skye, which really lives up to its Norse name of the Isle of Clouds when seen across The Minch, Scalpay, Raasay, Rona and, on very clear days, the distant smudges of Harris and Lewis to the far north. Not even the sinister sight of the occasional nuclear submarine's conning tower breaking the surface of The Minch can spoil the magic of this beautiful, remote place.

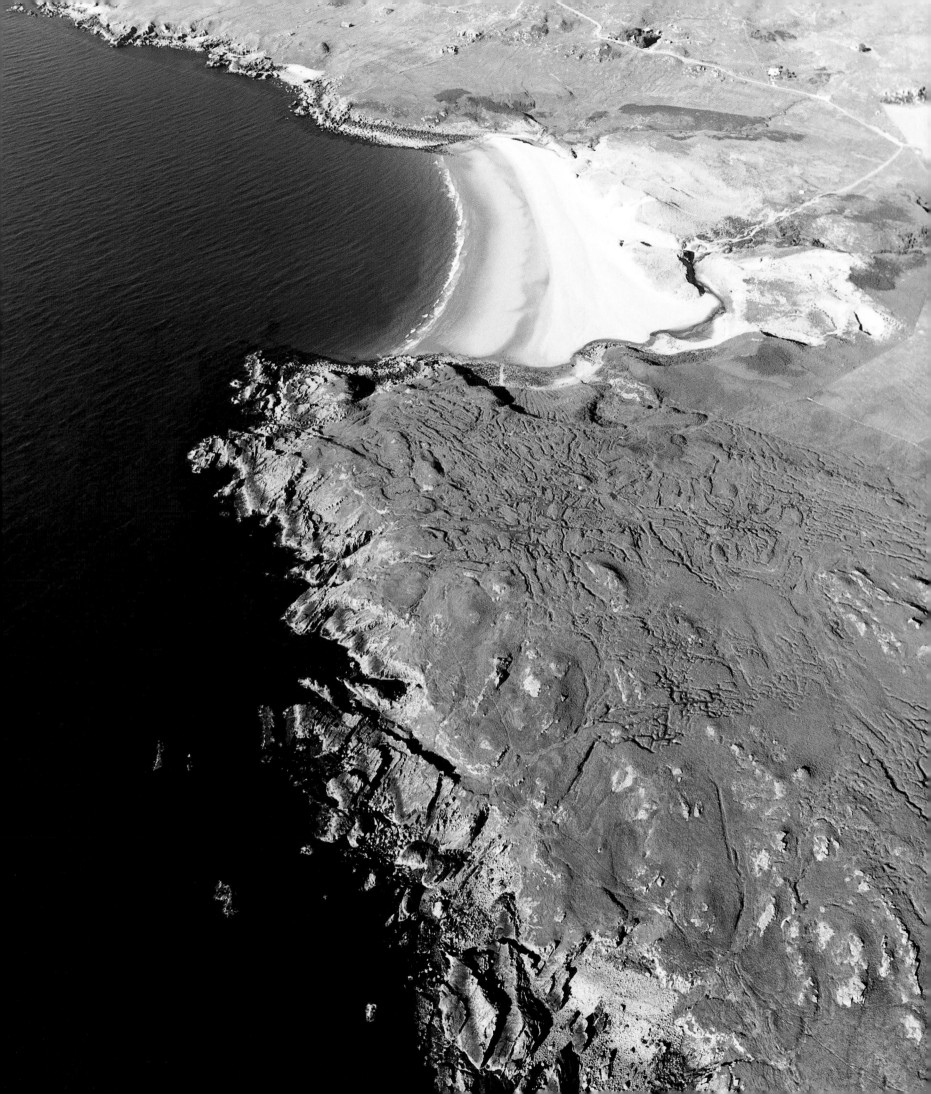

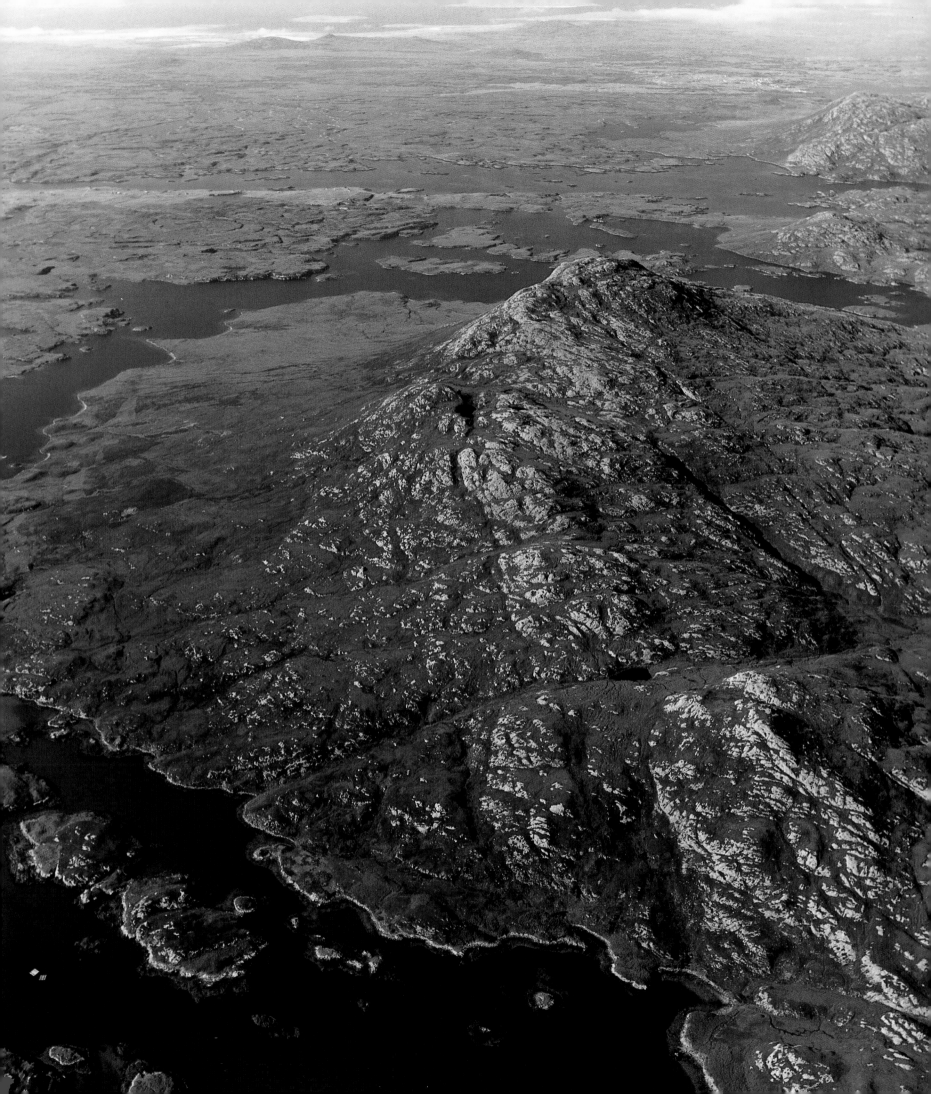

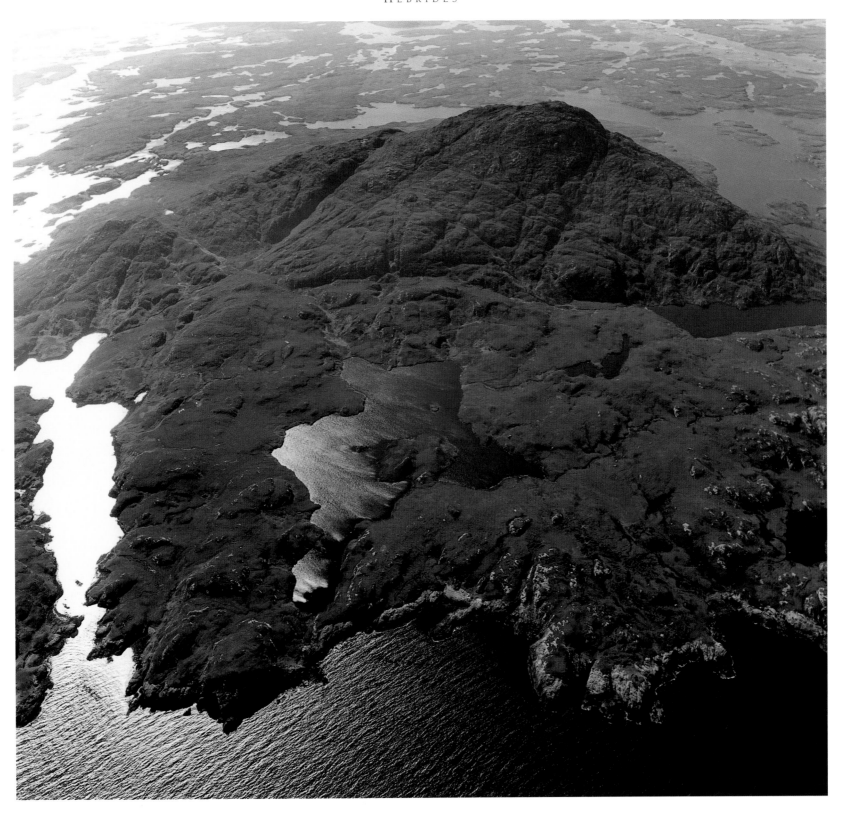

NORTH UIST

The island of North Uist comprises part of what are known locally as the Uists – the three islands of North Uist, Benbecula and South Uist. Although they all have separate identities and characters, they are linked by a series of bridges. The Uists, along with the neighbouring island of Lewis and Harris, belong to the Outer Hebrides and are far removed in both their landscape and their way of life from the rest of Britain. They are sparsely populated, with few villages and many reminders of a more ancient world, such as the three standing stones known in Gaelic as the Na Fir Bhreige, 'the three false men'. The story goes that these are all that remains of three men who deserted their wives and were turned to stone as punishment. Also on the island are the remains of the thirteenth-century Teampull na Trionad, the Trinity Temple, the monastery and college in which many island chiefs were taught. The founder was Beatrice, daughter of Somerled. In the twelfth century Somerled expelled the Norsemen who lived on these islands and became the first Lord of the Isles. His nine male descendants claimed ownership of the Hebrides until 1493. In certain areas of the island, the spirit of the Norsemen seems to live on through the unchanging scenery.

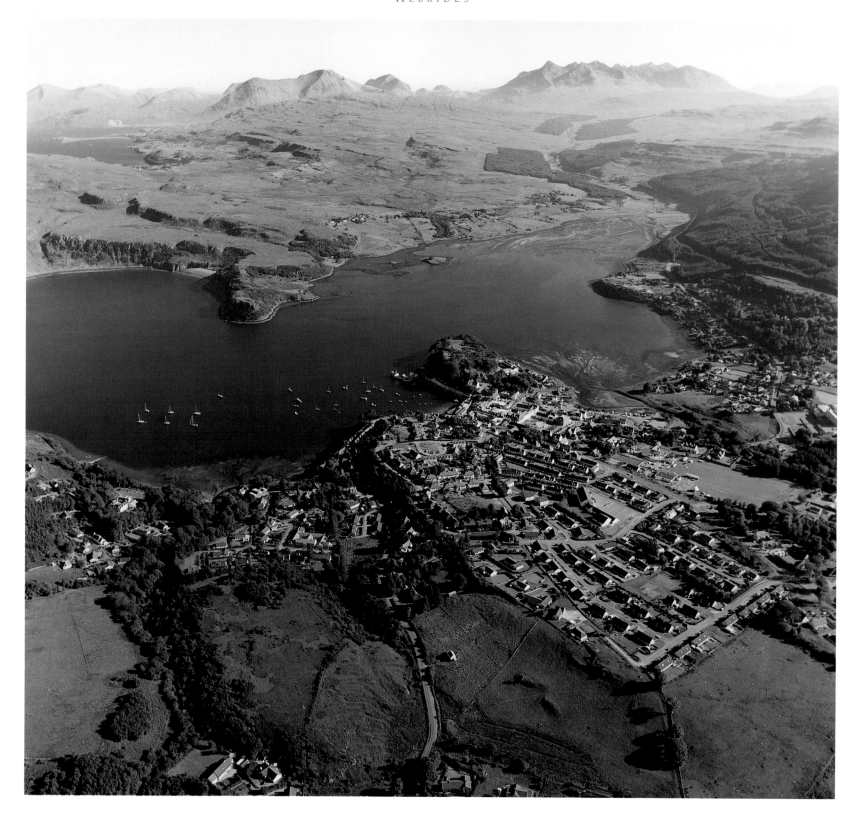

PORTREE

The so-called capital of Skye, Portree (*above*) lies in a sheltered bay on the east coast of the island, directly facing the island of Raasay. It takes its name from the Gaelic Port-an-Righ, meaning 'king's port', which refers to a visit made in 1540 by James V who succeeded in persuading the chieftains of Skye that it was time to swear allegiance to the Crown. Other notable visitors include Bonnie Prince Charlie and Flora Macdonald, and in 1773 the literary double act of Dr Johnson and James Boswell. One of the lifeboat stations at key locations in this part of Scotland is sited in Portree.

PLOCKTON

You might think you were in the Mediterranean if you were to stroll along the shoreline at Plockton (*facing page*), with its pretty houses, palm trees (courtesy of the mild climate of the North Atlantic Drift), charming fishing boats and the deep blue waters of Loch Carron with their wooded islets. Yet across the loch towers a rugged landscape of ancient, rocky outcrops and deep green trees – the spectacular Applecross Forest with its old drovers' road that takes you up to 2000 feet above sea level before plunging you down again through a series of hairpin bends.

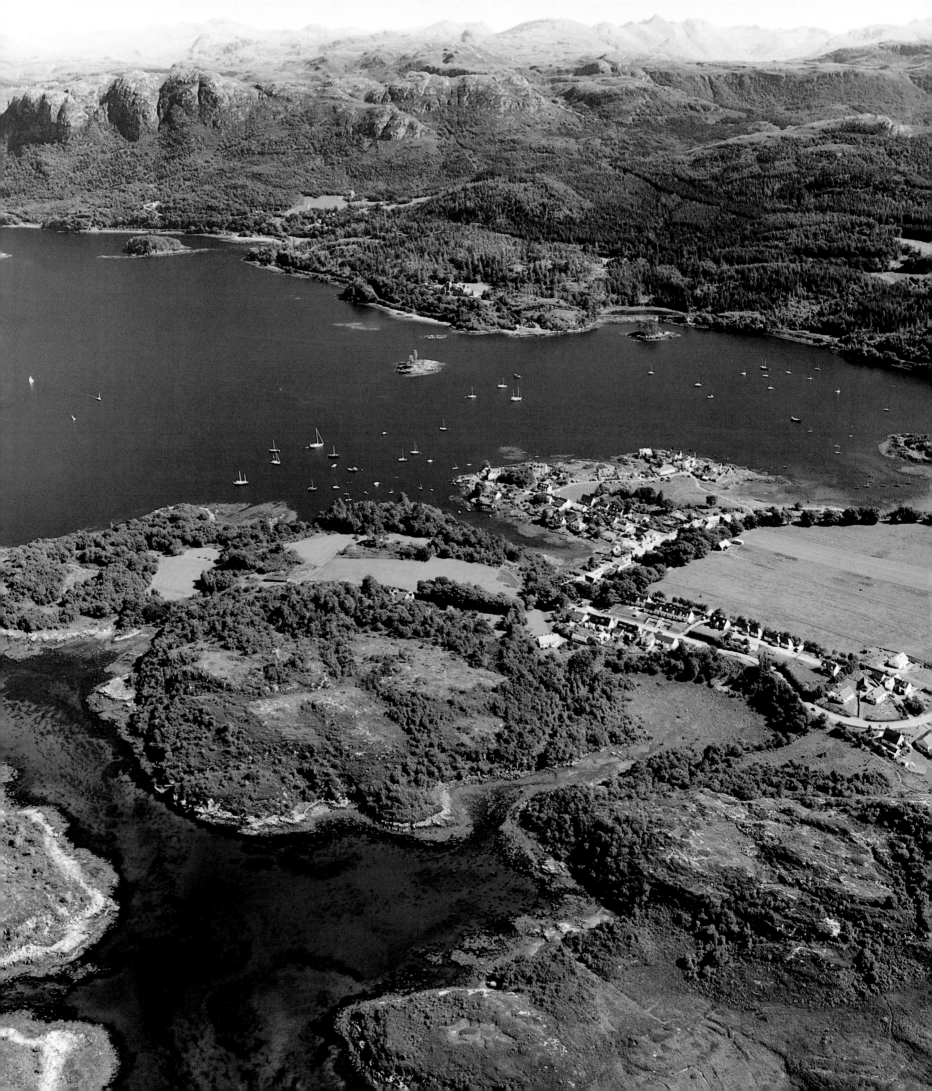

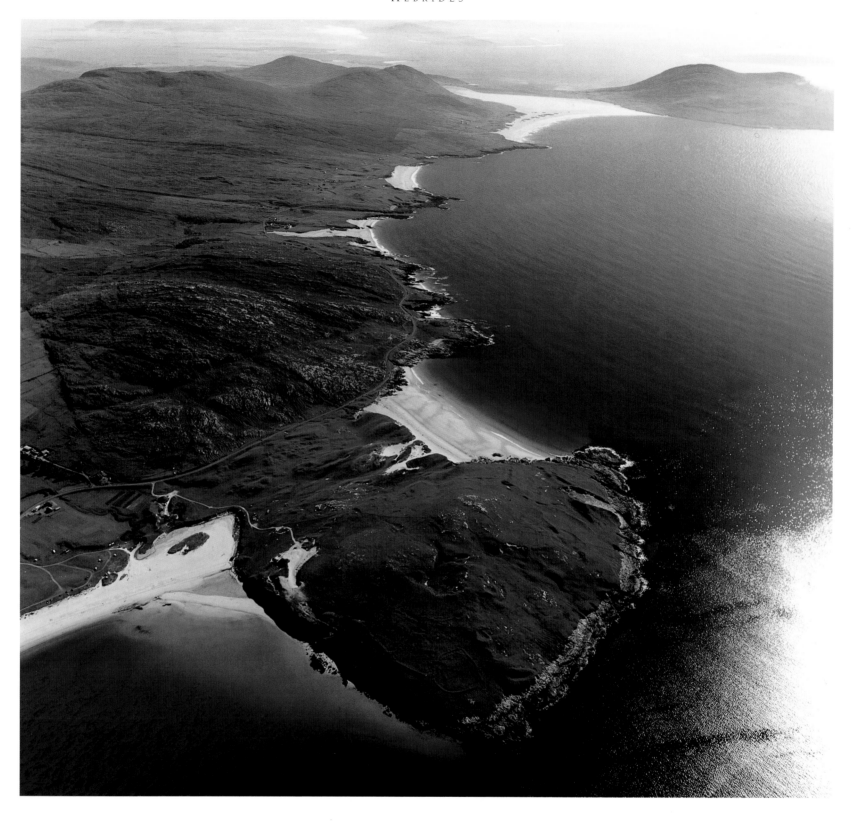

SOUTH HARRIS

This magnificent landscape of sandy bays, jewel-like seas and green hills is found on the island of Harris in the Outer Hebrides. It is joined with the island of Lewis to make what is known locally as the 'long island'. Despite its beautiful appearance, vast areas of the island are extremely inhospitable, consisting of bare rock or sodden peat bog. These photographs show the coastline around Tràigh Luskentyre in South Harris. It is found on the west coast of Harris, with the Sound of Taransay overlooking the island of the same name. It is spectacularly beautiful here yet the weather is not always as clement as it appears in these photographs. In fact, you need to be extremely hardy to live here. At the tip of the long island (and the northernmost point of the Outer Hebrides) stands the Butt of Lewis lighthouse which, as well as providing a landmark for shipping, makes weather observations for the Met. Office – on average, it records a gale there one day in every six. Lighthouses and coastguard stations around the country not only go about their daily business but also record the weather for the Met. Office – the coastguard station at Stornoway on Lewis is one such example. Stornoway also has a lifeboat station which was founded in 1887.

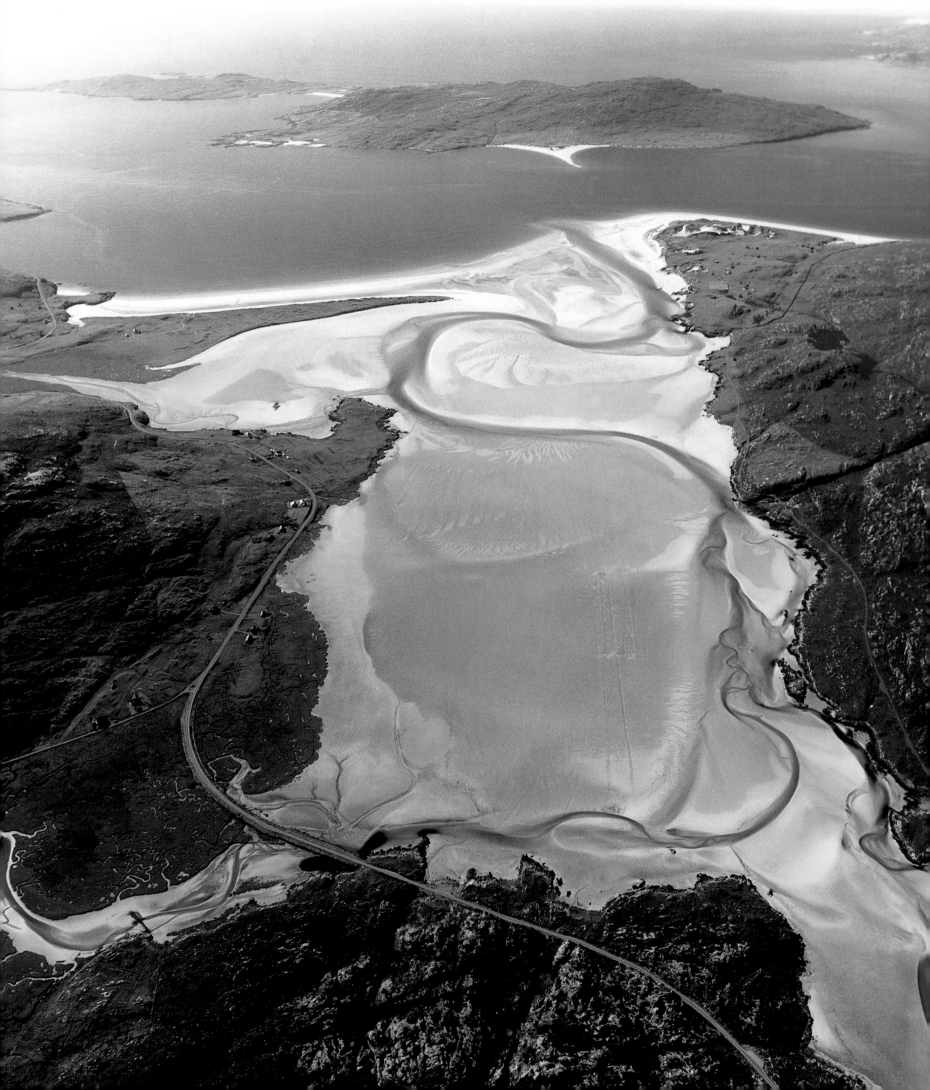

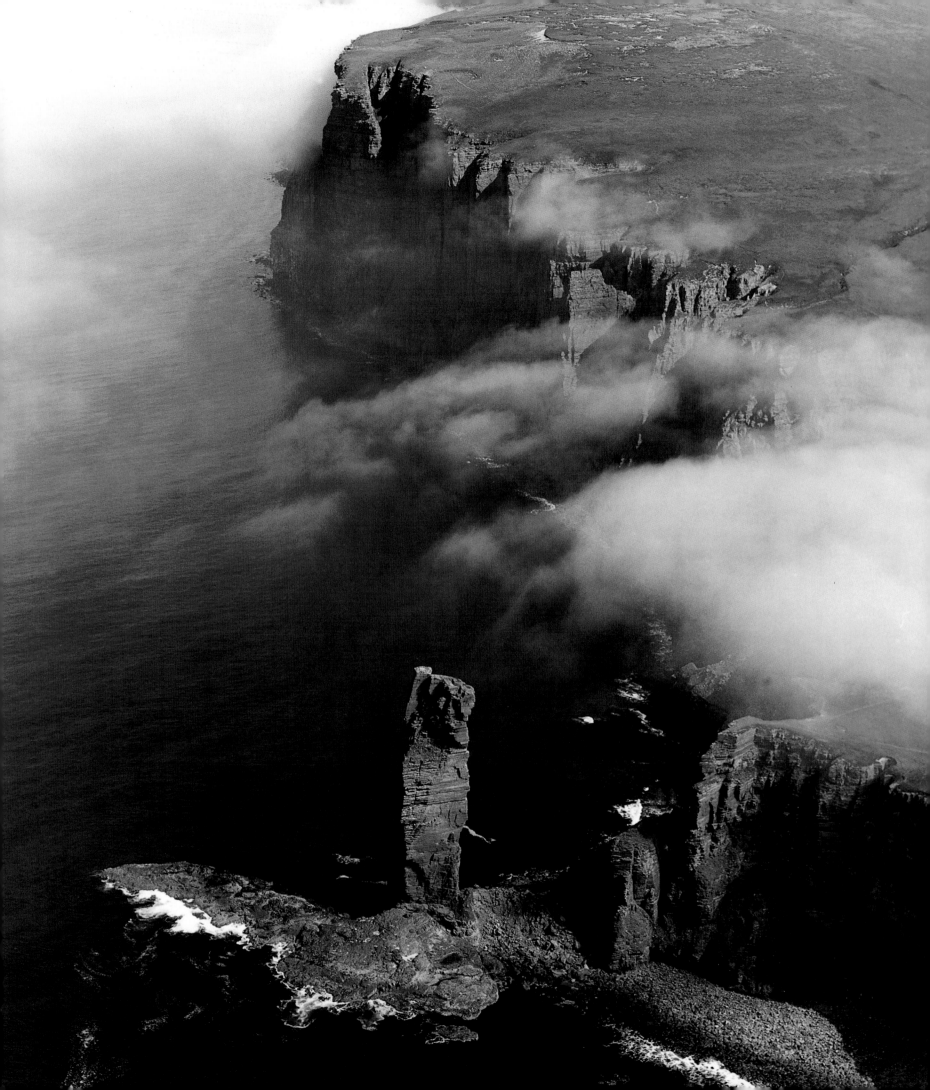

FAIR ISLE

The islands that make up Orkney and Shetland are included in the sea area of Fair Isle, which runs along the north coast of Scotland from east of Cape Wrath to north of Wick, both in the Highland region. This is one of the most sparsely populated areas of Britain, difficult to farm because of its rocky, sometimes barren, terrain and often at the mercy of the weather which can be vicious and relentless whatever the time of year. The area of Fair Isle contains two geographical landmarks – Dunnet Head, which is the most northerly point on mainland Britain, and Shetland, which comprises Britain's most northerly group of islands and lies over 100 miles off the Scottish coast. These islands have not always been British, however – for centuries they were owned by the Vikings, who have left their mark here in many place names and legends of trolls and giants. Today, the islands are being affected by the drilling for North Sea oil to the north-east, with results that are not always happy for the Shetlanders. Shetland has two lifeboat stations, at Lerwick and Aith. The other RNLI stations in Fair Isle are found at Longhope, Stromness and Kirkwall on Orkney, and Thurso on the mainland.

HOY

Hoy is the second largest island in the group known collectively as Orkney (to call it 'the Orkneys' is completely wrong, as any local will tell you through gritted teeth). It is a desolate, beautiful and mysterious place, home of rare wild flowers and teeming bird life. Much of the land is so rough and boggy that it is unsuitable for farming and most of the islanders live in the south-east of the island at South Walls, which is connected to the island by a narrow isthmus. Hoy is best known for the sheer stack of rock, called the Old Man of Hoy, which stands 450 feet high and rises up out of the sea like a finger pointing to the heavens. Until 1966 it had never been climbed successfully and it is still considered to be a most difficult challenge for rock-climbers. Despite its great height, the Old Man of Hoy is dwarfed by St John's Head nearby which, at over 1000 feet high, is the highest perpendicular sea cliff in Britain. A curiosity of the island is the weird Neolithic tomb called the Dwarfie Stone. Its two chambers were carved out of solid rock and legend suggests it was once the home of a malevolent Norse dwarf mentioned in the Norse sagas. Hoy is also home to a Martello tower, built during the Napoleonic wars to protect the Baltic convoys.

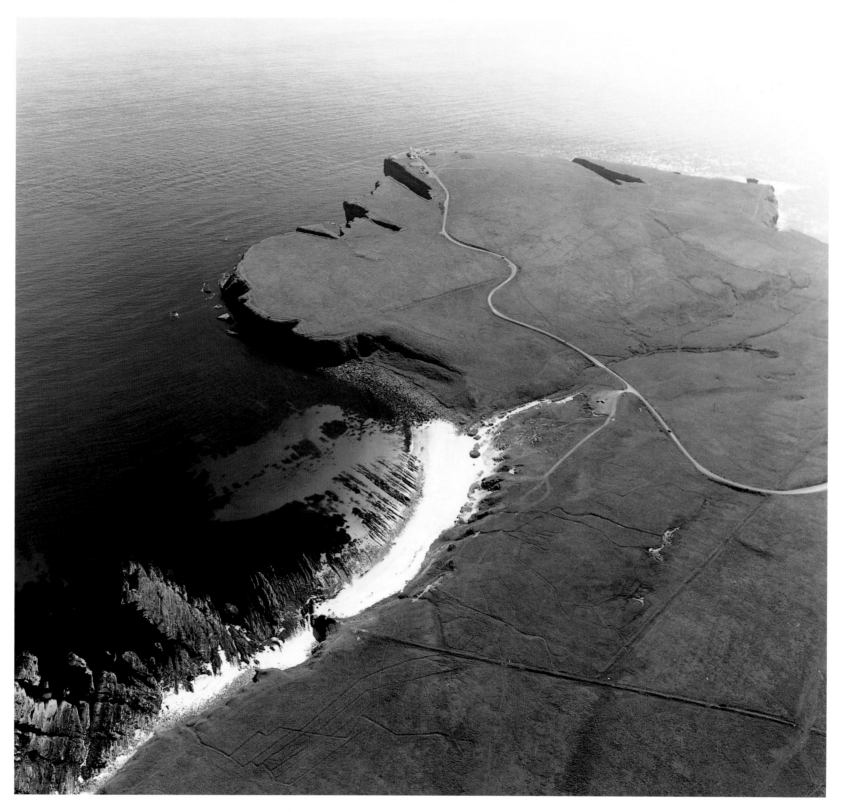

JOHN O'GROATS

Forget what you are told about John o'Groats being the most northerly point on the British mainland. That honour goes to Dunnet Head which lies a few miles to the west. Nevertheless, such finer points of geography do not deter the thousands of tourists who come here. The village earned its name from a Dutchman, Jan de Groot, who started a ferry service from here to South Ronaldsay in 1496, on the orders of James IV. He had just wrested Orkney from the Norwegians and wanted to keep it that way. An alternative story claims that the fare on the ferry was one groat, and that is how the village got its name. If the weather is good, the nearby island of Stroma is clearly visible from the headland. From John o'Groats a road leads out to Duncansby Head (*facing page*), which is the north-east tip of the British mainland. Here, the red sandstone cliffs have gradually been worn into sharp points by the tumultuous seas of the Pentland Firth. This stretch of water is about 14 miles long and roughly 7 miles wide, made perilous by fast tides, sunken reefs and whirlpools. Stones thrown up by the clashing currents have been known to smash the windows of the lighthouse at Dunnet Head, despite its position 300 feet above the teaming sea.

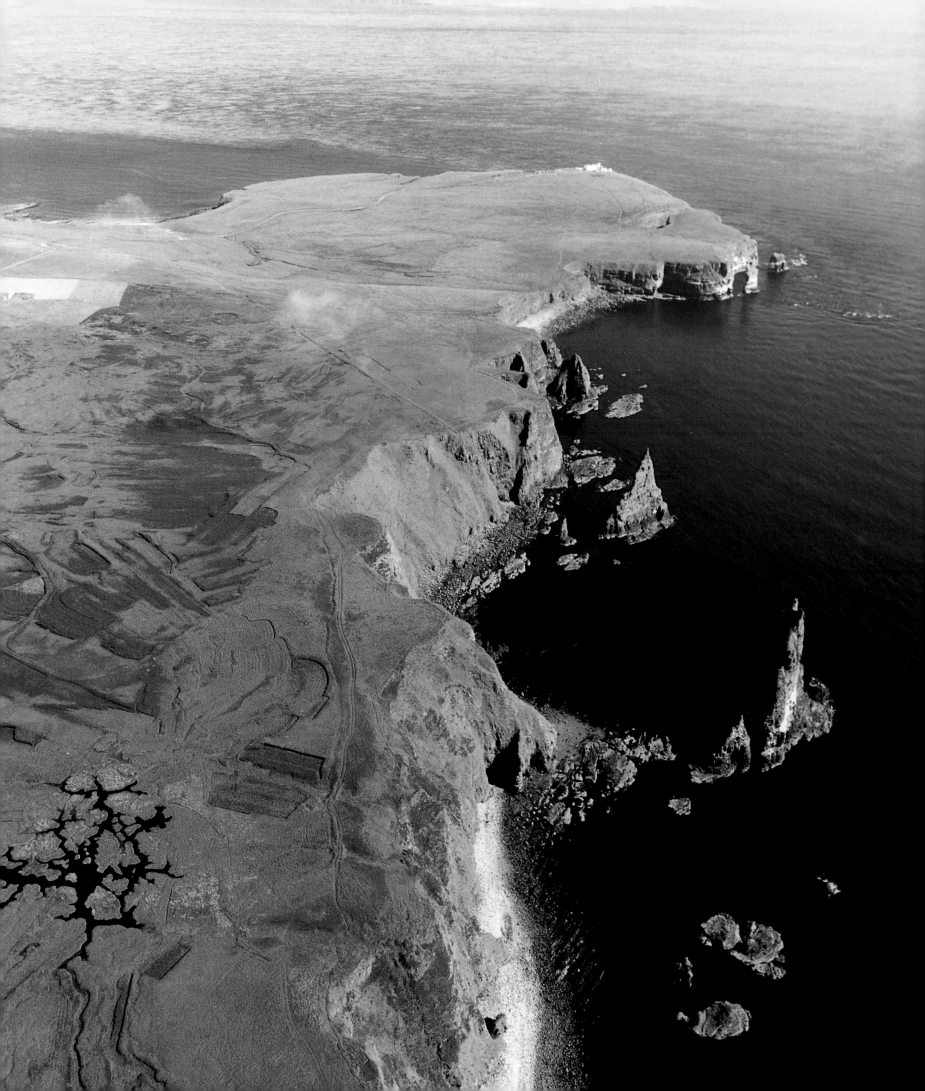

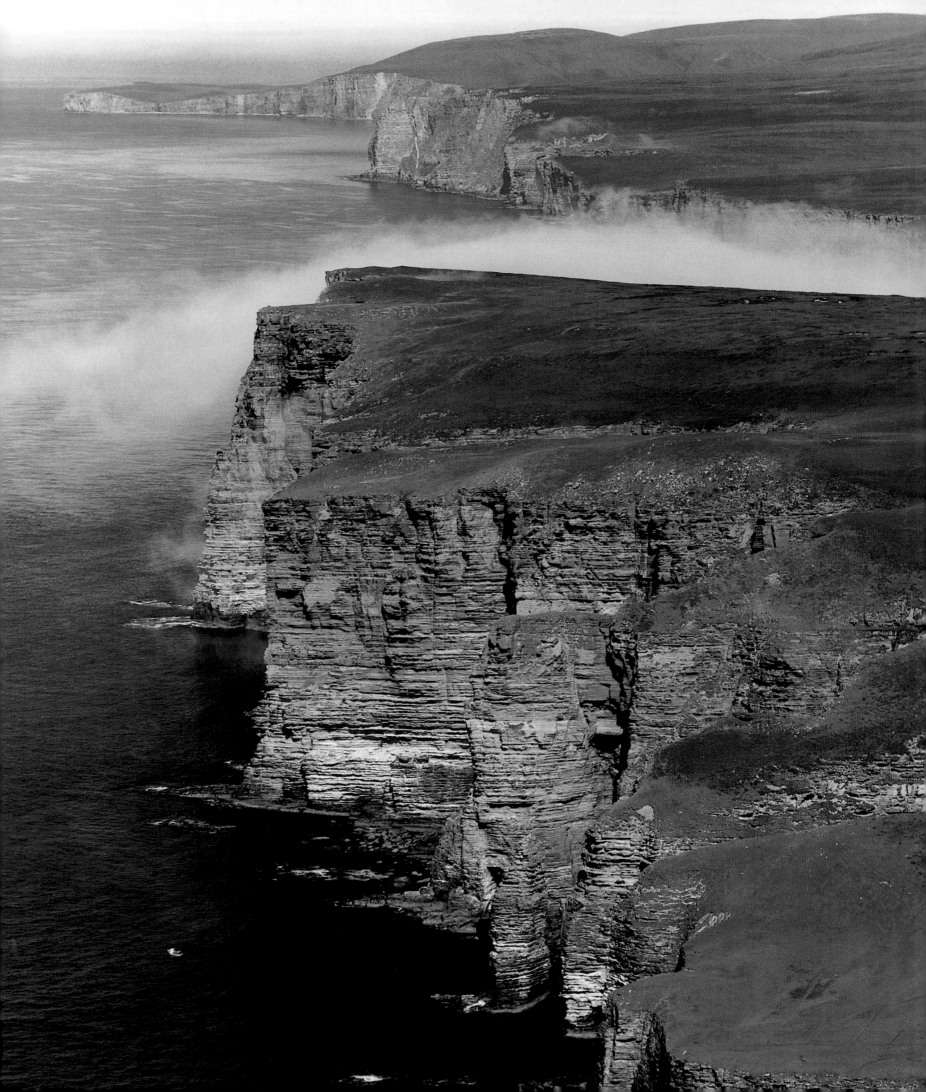

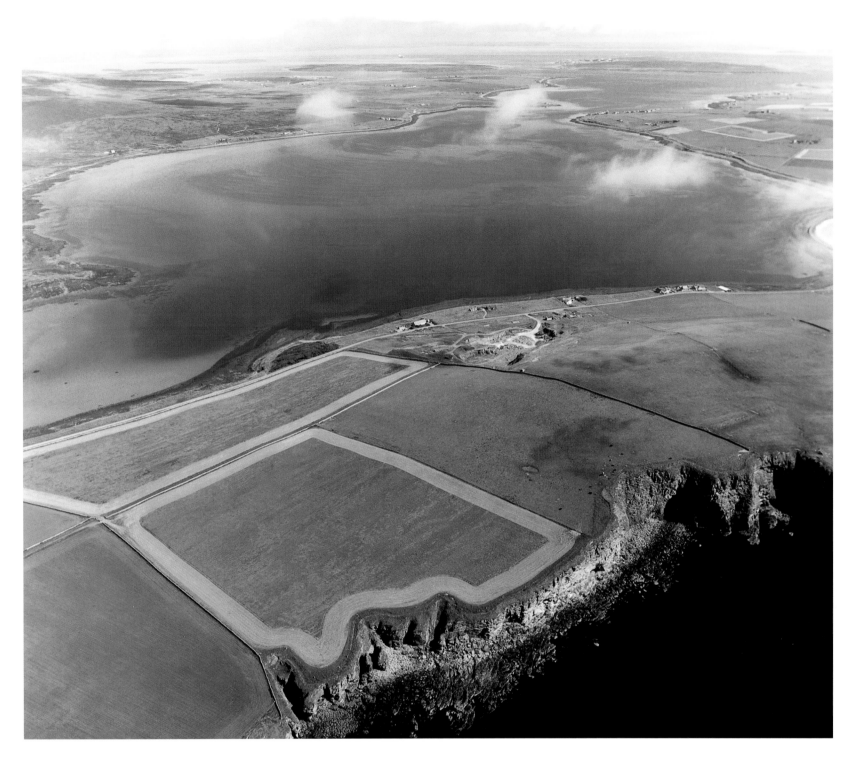

SCAPA FLOW, ORKNEY

This is the land of the midnight sun. In the summer, it never gets dark because the sun sinks no further than just below the horizon. In the winter, however, the process is dramatically reversed. Yet there are few people in Orkney to enjoy the long summer nights or the starry winter skies – only 18 islands in the chain of over 70 are now inhabited. There have been many incomers in the past few years, brought here by the discovery of North Sea oil. This is piped to a terminal on the island of Flotta, but the relationship between the incomers and local inhabitants has not always been easy.

Scapa Flow is an area of water surrounded by Mainland, the largest island in Orkney, South Ronaldsay, Flotta and Hoy. It was considered to be a secure harbour for the Royal Navy and served its purpose well in the First World War; the German fleet scuttled itself here in 1919. However, early in the Second World War a German submarine infiltrated these waters, via Holm Sound, and torpedoed HMS *Royal Oak*. In due course, the British fleet was moved and the gap at Holm Sound was closed up with thousands of massive concrete slabs, known as the Churchill Causeway.

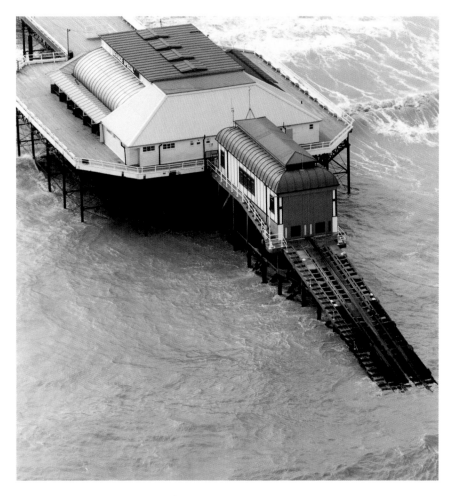

ACKNOWLEDGEMENTS

I would like to thank the following people for their prompt and invaluable help during the writing of this book: Sue Denny, Press and Public Information Officer of the Royal National Lifeboat Institution; Captain J.F.T. Houghton of the Met. Office; Peter O'Connell of Aerofilms; David Fordham for his design; Julian Shuckburgh and Margaret Little for their encouragement; Chelsey Fox for her steadfast support; and Bill Martin for his unfailing enthusiasm.